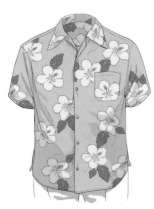

HOW TO CRE
MANGA

THE ULTIMATE BIBLE FOR BEGINNING ARTISTS

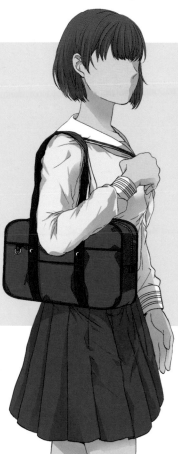

DRAWING CLOTHING AND ACCESSORIES

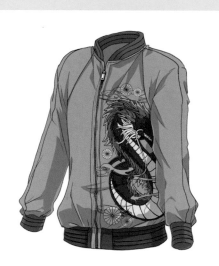

With Over 900 Illustrations

STUDIO HARD DELUXE INC.

TUTTLE Publishing

Tokyo | Rutland, Vermont | Singapore

Contents

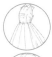
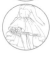

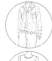
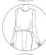

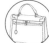
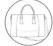
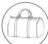

Why We Wrote This Book

When drawing manga characters, unless you're creating only one kind of manga, your creations will need to have many different types of clothing. If they're wearing items you're familiar with, that you can easily draw, you know straightaway what will work. But if you're not familiar with a certain garment or if it's a specialized item, such as formalwear, what your character is wearing can suddenly become a lot harder to draw.

 If you intend to draw a lot of different characters, you'll need to find outfits and looks to suit each one, so factor that into the time you will spend developing and sketching your characters. Draw what you know, then take it from there, challenging yourself to produce more complex pieces. In recent years, more and more clothes have become unisex, with ever-increasing style options for men and women—offering you even more options and flexibility in terms of the wondrous wardrobes you can create.

This book is an illustrated manual in encyclopedia form. It divides contemporary clothing for both sexes, or what was traditionally labeled men's and women's clothes, into categories such as tops and bottoms, providing explanations about the structure and defining features of each piece and offering key pointers for realistically reproducing them. Along the way we supply hints for drawing variations and how to "style" complete outfits. The focus is on contemporary casual and street fashion, but we also cover business and formal wear, school uniforms, kimonos and traditional robes. If there's an item of clothing you're not familiar with, you can look it up in this handy guide to learn about its basic construction, defining features, how to draw it, and available variations on the style.

We hope that when using this book, you'll be inspired to create striking and distinctive ensembles that lift your characters and stories to new levels. Soon you'll be versed in all forms of fashion and freed from the style choices some of us agonize over daily.

—Studio Hard Deluxe

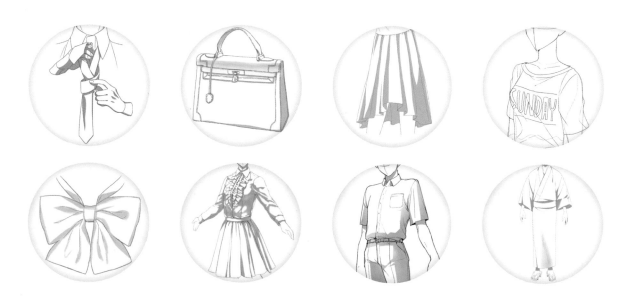

How to Use This Book

In this book, we divide clothing into categories to analyze the structure of each piece and how to draw it. The digital software used is Clip Studio Paint. Only the basic functions such as brushes and layers are touched on, so users of other software can substitute theirs to follow along.

Section title: Items of clothing are divided by type

Common names and defining features of each part of the clothing are given here along with specific things to note

Characteristics of the clothing item and representative types are shown here

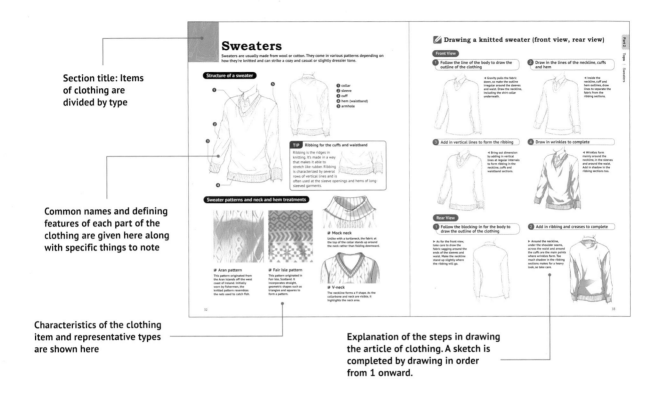

Explanation of the steps in drawing the article of clothing. A sketch is completed by drawing in order from 1 onward.

Tips for drawing clothing variations, the types of characters whom these clothes suit and comments on styling are grouped here

Icons

Explanation of the steps in drawing an article of clothing

Tips for drawing clothing variations, the types of characters whom these clothes suit and hints on how to style the clothing are grouped here

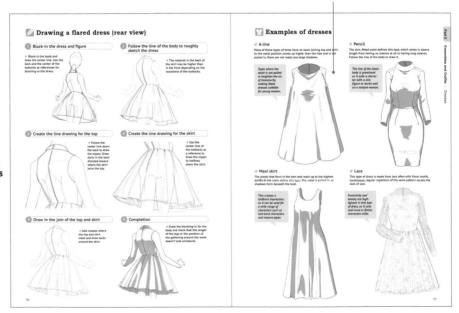

Clothing Basics

Types of Clothing

Noting the Differences

Creases in Clothing

Steps in Drawing Clothing

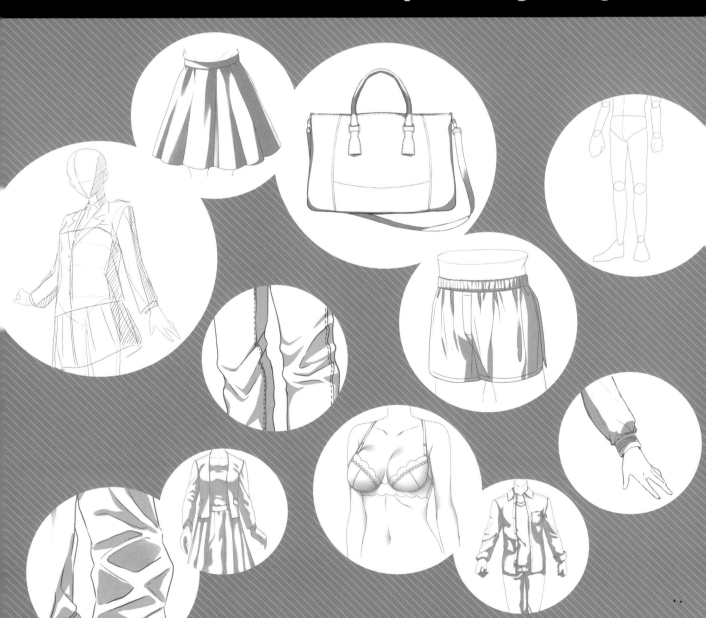

Types of Clothing

There are so many types of clothing: tops and bottoms, outerwear and underwear, shoes and bags. In this section, we look at the categories and outline the items that belong in each.

Part 2 Tops

The general term for clothing worn on the upper body, excluding outerwear. Ranging from thin, short-sleeved items to thick, long-sleeved pieces, this is a category of clothing with a range of options and variety. It includes a lot of casual items such as shirts, and hoodies.

Part 3 Outerwear

This category includes any item worn, mainly as a layer that keeps out the cold. Items in this category are jackets and coats, with the fabric, length and functionality determining the garment's shape and defining its uniqueness.

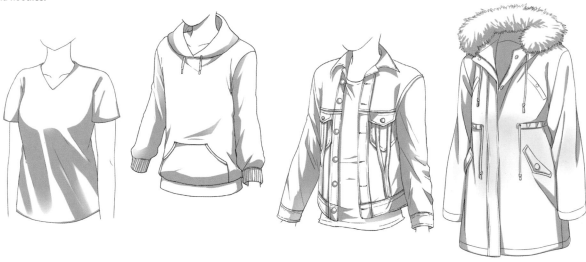

Part 4 Skirts, pants and shorts

With skirts for women and pants for both men and women as typical items in this category, they play as important a role as tops in determining a character's style.

Part 5 Ensembles and outfits

Many of the outfits and ensembles featured in this section are based on overalls and other workwear. In this book, kimonos and other robes are covered as traditional Japanese all-in-one outfits.

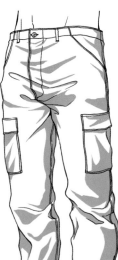
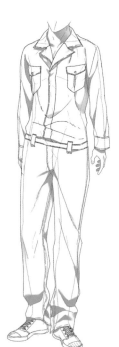
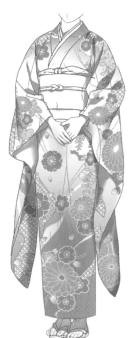

🥟 Part 6 Underwear and underlayers

As they're worn in direct contact with the body in the form of bras, boxer shorts and other foundational layers, underwear helps to make the differences between the male and female form more conspicuous.

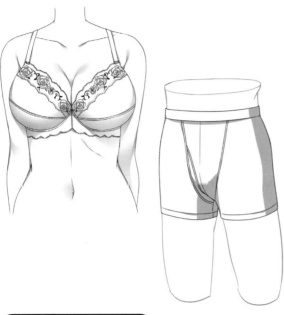

🥟 Part 7 Shoes and bags

Depending on their purpose, the design of footwear and bags can vary significantly, and rather than being purely functional, they help bring an added sense of fashion and flair to your illustration.

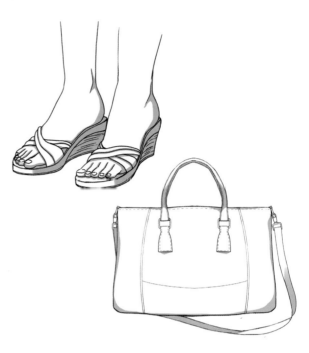

Uniforms and suits

🥟 Part 8 School uniforms

These are the uniforms worn by Japanese middle- and high-school students, with summer or winter uniforms worn depending on the season. Their design varies and may take the form of a military-style suit for boys, a sailor blouse and pleated skirt for girls or a blazer depending on the school.

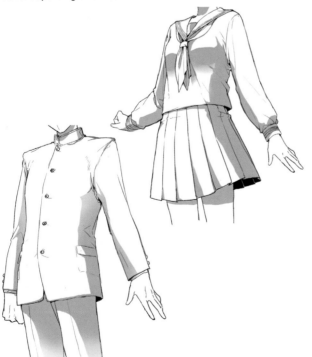

🥟 Part 9 Suits and formalwear

Suits are items of clothing mainly worn in business situations. Formalwear is worn for occasions such as weddings, funerals and special events. In this clothing category, there's a lot more variation for women than for men.

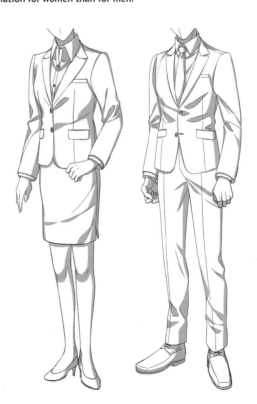

Noting the Differences

Many contemporary pieces can be worn by either men or women, but there are certain tendencies that define the clothing generally favored by each.

Men's apparel

Most pants have hems that reach the ankles, and over all, men's clothing is less revealing. Fabrics tend not to be patterned, and men's outfits typically feature few or neutral colors. Male clothing also tends to favor simple, clean-cut lines over complicated designs.

Women's apparel

When it comes to items worn below the waist, apart from pants, there are also skirts, and, when revealing the legs, tights and other underlayers are worn. Many items are form-fitting, such as blouses and shirts with open necklines or close-fitting garments that reveal the line of the body.

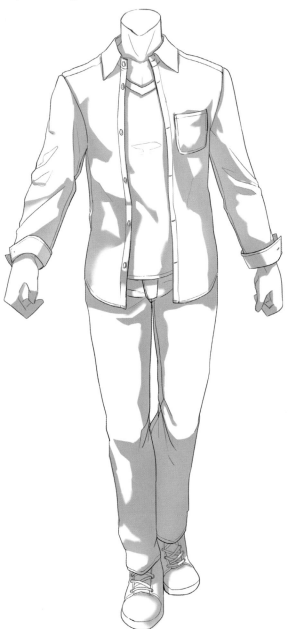

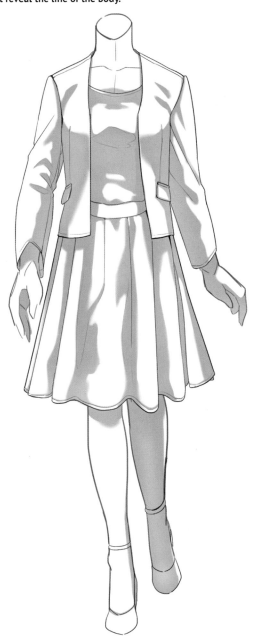

Men's clothing

◉ Men's suits (p. 158)

These are the articles of clothing worn in business situations. The three-piece suit (p. 165) that includes a vest (p. 38) worn beneath the jacket is a traditional style. A suit sets a more formal or official visual tone than the look created by casual clothes.

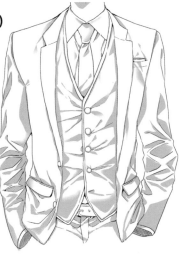

◉ Men's underwear (p. 110)

Of the two main types of men's undergarments, boxer shorts are loose fitting, while briefs are tight and fitted to the body.

Women's clothing

◉ Skirts (p. 60)

Skirts vary greatly in design from those that are full at the hem to types that fit tightly to the body.

◉ Dresses (p. 74) and Party dresses (p. 79)

A dress brings two worlds together: skirts and tops. Among the types of top sections in a dress is the tube top (p. 44), which reveals large sections of the back and chest. It is designed to bring out femininity even more than the skirt.

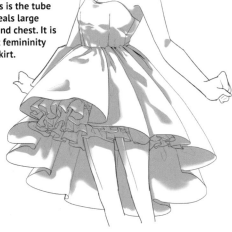

◉ Camisoles (p. 42)

A top made from light material with threadlike straps, the camisole was originally a woman's undergarment. Many have frills, lace or other decorative elements.

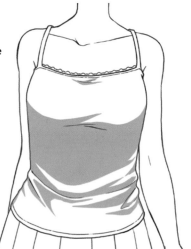

◉ Women's underwear (p. 102)

Included in this category are bras and panties (p. 105). There is a wealth of designs, such as those trimmed with lace and other decorative elements.

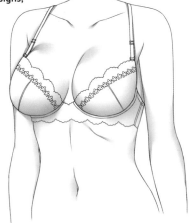

Creases in Clothing

Creases are an important element in clothing, adding depth and contour. Here, we look at typical types of creases and the areas that wrinkle easily.

Types of creases

Pulled creases

A straight crease formed by the fabric being pulled in one direction. These kinds of folds form easily around areas such as the armholes and the sleeves when the arms are raised, under women's breasts and around the waist when the body is twisted.

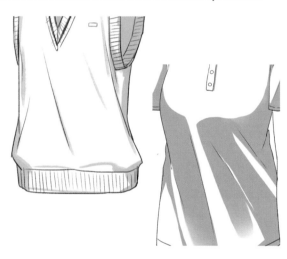

Gathered creases

These are formed when the fabric gathers in one spot. They form easily around the top of sleeves, around the arms and knees when bent and on sleeves that are rolled up.

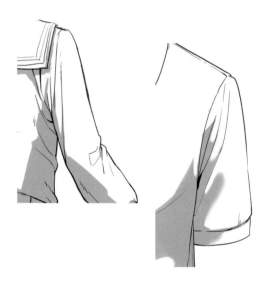

Draped creases

These creases are created when fabric is pulled down by the force of gravity. They form on clothing where the hem and wristbands are drawn in, such as on a sweater, as well as on clothing that has a natural drape to it.

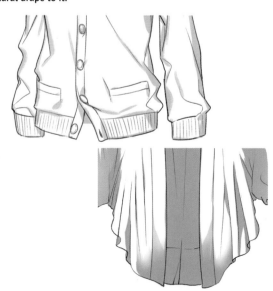

Hollow creases

These are a type of gathered crease that forms when the fabric gathers in one place and part of it forms a hollow. They're typically found in places where the fabric gathers easily, such as around the elbows and knees, in conjunction with gathered creases. Adding shadow in the center gives them dimension.

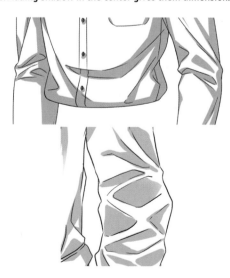

👕 Main places where creases form

🔖 Shoulders

Gathered creases form below the shoulders, toward the armpit in the sleeve and torso sections of the clothing. When the arm is raised or extended, a pulled crease forms from the sleeve toward the shoulder.

🔖 Chests

If wearing a cut-and-sewn top, camisole or other style of top where the hem hangs freely, pulled creases will form under the bust, with the fullest part of the bust as the pivot point.

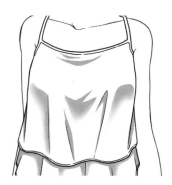

🔖 Waists

Gathered creases form around the narrowing of the waist, with soft draped creases forming that join at both sides of the waist. They form readily on clothes for women with small waists.

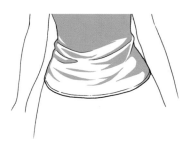

🔖 Elbows

Bending the elbow creates gathered creases and hollow creases along the inner side. On the outer side, the bone pulls the fabric taut so that no wrinkles are formed and a straight line is created.

🔖 Crotches

Gathered creases form at the top of the crotch, radiating out toward the hips. The way the creases form depends greatly on the thickness of the fabric, with relatively thick denim creating large irregular creases.

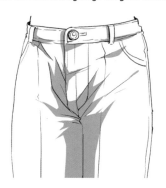

🔖 Knees

On long pants, gathered creases and hollow creases form around the knees on someone standing straight. The fabric gathers to such an extent that it makes the outline around the knees uneven.

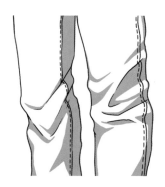

🔖 Cuffs

On items with sleeves that narrow at the wrists, such as shirts and other items with cuffs, the fabric gathers at the top of the cuff to form draped creases. As the fabric is loose, the area around the cuff looks slightly puffy.

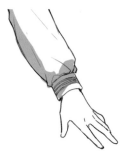

🔖 Hems

The hems of pants touch the tops of the feet, causing the fabric to bunch and form both gathered and hollow creases. As gravity draws the fabric down, large wrinkles form regardless of the thickness of the fabric.

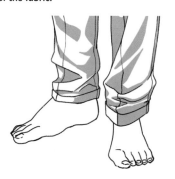

🔖 Buttons

Faint pulled creases form on either side of buttoned-up fabric. The creases are most significant on the side on top (for example, the buttonhole side).

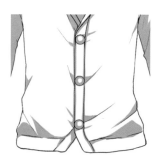

Steps in Drawing Clothing

When drawing clothing, it's important to draw the character's body first in order to create a guide. Let's look at the steps involved, from drawing the body to filling in the shadows.

1 Block-in the body and clothes

Block-in the body of the character you would like to dress. Once the blocking-in is finished, use the joints and particular parts of the neck, shoulders, elbows and hips as markers to block-in the clothing.

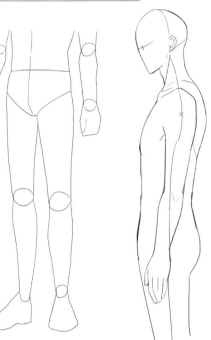

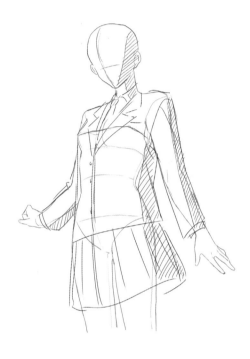

▶ Divide joints, body parts and so on into subsections in the blocked-in figure to make drawing easier.

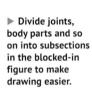

2 Draw a rough sketch, using the blocking-in as a reference

Once the blocking-in is complete, sketch in the clothes and clean things up. Start by drawing the clothes in a rough outline, then work in smaller elements such as collars and belts.

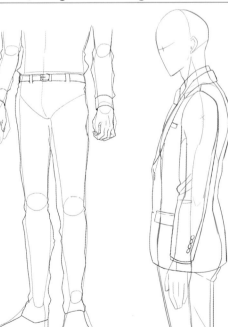

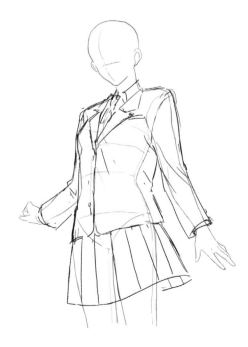

▶ Now is the time to think about some of your details and embellishments, such as the buttons.

③ Clean up lines and add creases and detailed parts

Once the clothes have been cleaned up, add in lines where creases are likely to form and adjust the outline of the clothing accordingly. Draw in pockets, neckties and so on in more detail than in Step 2.

▶ Use clear lines for large or deep creases and faint lines for fine creases to bring out contrast.

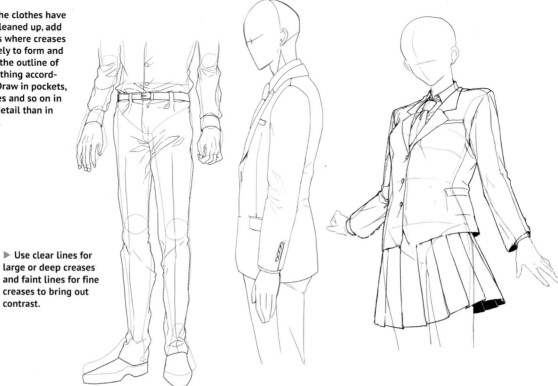

④ Add shadows to complete the sketch

After the line drawing is complete, add shadows to finish the sketch. Decide on the direction from which the light will strike and add shadows to places that will not be lit or that will be hollowed out due to creasing.

▶ If you think of the light as shining downward from the front it will be easier to add shadows.

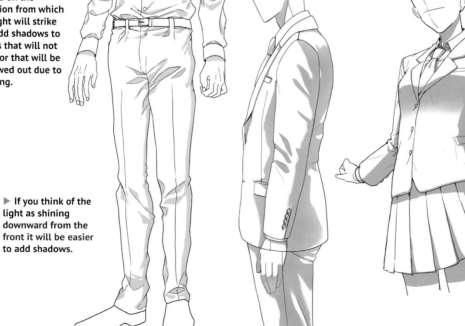

✏️ Drawing shadows

Distinguishing two types of shadow in drawing

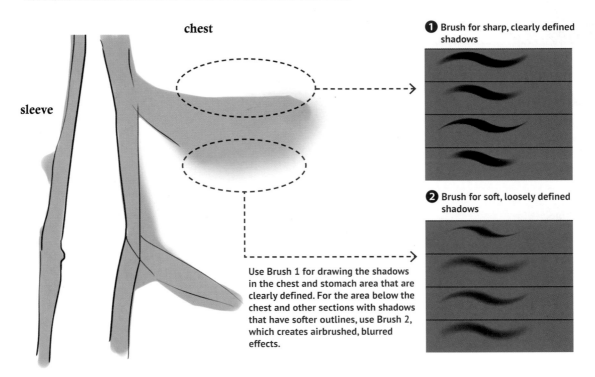

chest

sleeve

❶ Brush for sharp, clearly defined shadows

❷ Brush for soft, loosely defined shadows

Use Brush 1 for drawing the shadows in the chest and stomach area that are clearly defined. For the area below the chest and other sections with shadows that have softer outlines, use Brush 2, which creates airbrushed, blurred effects.

Draw the light to bring out dimension

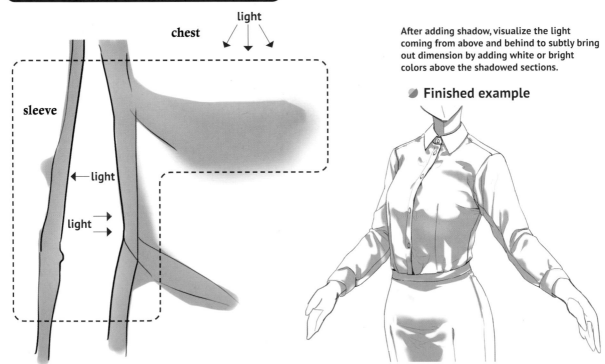

light

chest

sleeve

← light

light →

After adding shadow, visualize the light coming from above and behind to subtly bring out dimension by adding white or bright colors above the shadowed sections.

🔘 Finished example

PART 2
Tops

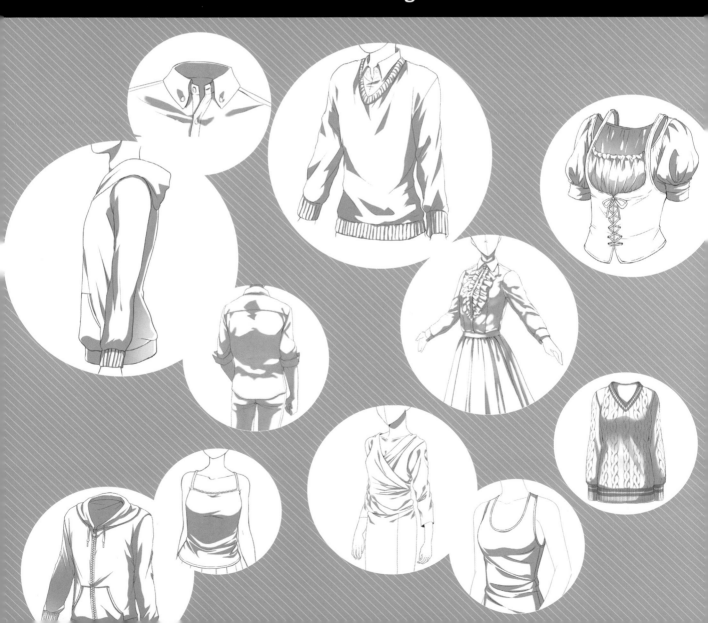

Cut-and-Sewn Shirts

These are casual, mainstream fashion tops that are put on by being pulled over the head. They vary depending on the design in the front, with different closures and depths in the neckline.

Structure of a cut-and-sewn top

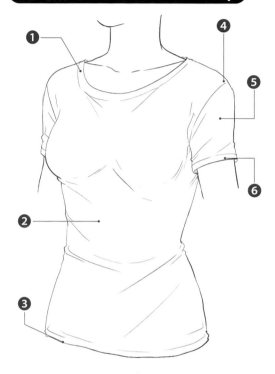

1. neckline
2. front panel
3. hem
4. shoulder seam
5. sleeve
6. sleeve opening
7. back panel

🍪 Round neck

This is the most basic type of cut-and-sewn top. The neckline is rounded, leaving the collarbone clearly visible.

> **TIP** **Cut-and-sewn tops and T-shirts**
>
> The term "cut and sewn" comes from the garment's construction, in which fabric is cut out and sewn together. Starting with T-shirts, most garments can be categorized as cut and sewn. In recent years, the term has come to mean practically the same thing as a T-shirt, but tends to be used mainly to describe T-shirts for women.

Necklines for cut-and-sewn tops

🍪 V-neck

This type has a V-shaped neckline. The décolletage (the area from the neck to chest) is revealed, potentially lending sex appeal to wearers.

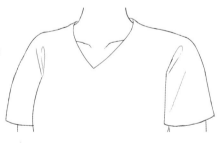

🍪 Crew neck

The neckline is rounded and sits close to the neck. It is one of the original, basic types and creates a casual impression.

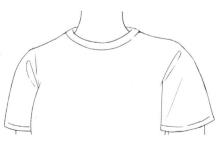

🍪 Henley neck

The neckline is rounded, and there is a placket at the center front with buttons that can be done up or left undone for a more open neckline.

Drawing a cut-and-sewn with a round neck (front and back views)

Front View

1 Draw the outline of the clothing following the lines of the shoulders and torso

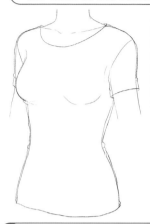

◄ First, block-in the upper body, then follow the lines of the chest and torso to create the outline of the clothing. As most cut-and-sewn tops for women are fitted to the body, make sure the outline is smooth rather than irregular.

2 Add creases to the entire cut-and-sewn

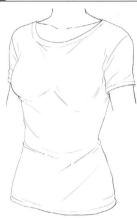

◄ Creases form easily at the chest, in the area around the shoulders and around the hips. Draw gathered creases where the fabric joins around the shoulders, pulled creases where the chest has made the fabric taut and layers of creases where the fabric piles around the waist.

3 Add shadows to finish

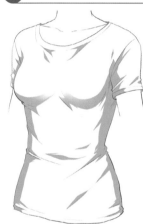

◄ Add shadow where creases have formed, such as under the bust and in the underarm area. Draw the shadow in clearly, following the line of the creases.

TIP Draw creases around the waist

Creases form around the narrow part of the waist where the fabric gathers and puckers out. Drawing in creases around this area creates a cinched-looking waist.

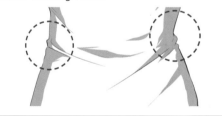

Back View

1 Draw the outline of the clothing following the line of the shoulders and back

▶ In the same way as for the front view, follow the body line of the shoulders, back, stomach and so on to create the clothing outline. Drawing in a clear angle at the narrowing of the waist highlights a rounded silhouette.

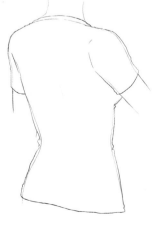

2 Draw creases and add shadows to finish

▶ If the hand is stretched out in front, the sleeve is pulled and creases form from the sleeve opening to the shoulder. Add shadow mainly in the area from the back toward the waist and draw in creases around the waist.

Drawing T-shirts with lettering (front view)

1 Follow the blocking-in of the body to draw the T-shirt and creases

▶ If the sleeve opening is bigger than the girth of the arm, the fabric will look loose. Conversely, fitting the chest area, hips and hem close to the body makes for a more tautly defined physique.

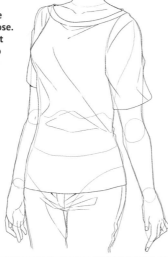

TIP Draw creases around the chest

If a woman is wearing a loose T-shirt, the fabric will form large creases from the chest downward.

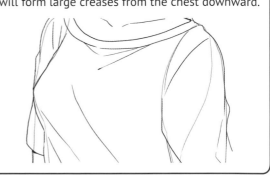

2 Draw the logo onto the chest

▶ Keeping in mind the curves that form due to the shape of the chest, draw the logo onto the chest area of the T-shirt. Shifting the parts of the letters that intersect with the crease lines gives the impression of the clothes being distorted by the creases.

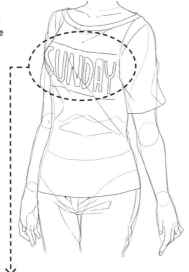

Enlarged view:

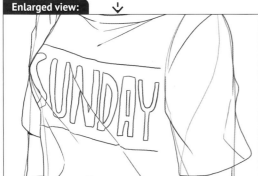

▲ A large pulled crease forms across the chest area.

3 Add shadow to finish

▶ Add shadow in the areas where creases have made the fabric darker and in hollowed-out areas to complete the drawing.

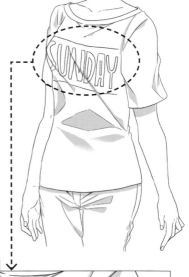

Enlarged view:

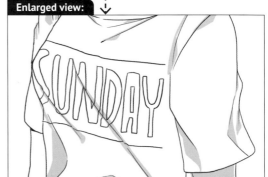

▲ Draw in a fine shadow along the pulled crease line across the chest, and use all-over shadow for areas below draped fabric.

Drawing a long-sleeved cut-and-sewn (front view)

1　Block-in the body and clothing

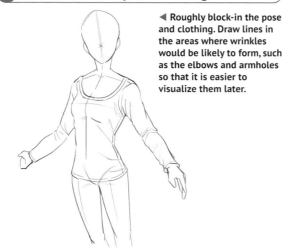

◀ Roughly block-in the pose and clothing. Draw lines in the areas where wrinkles would be likely to form, such as the elbows and armholes so that it is easier to visualize them later.

2　Draw the rough sketch of the body

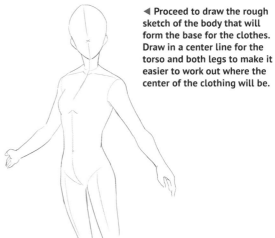

◀ Proceed to draw the rough sketch of the body that will form the base for the clothes. Draw in a center line for the torso and both legs to make it easier to work out where the center of the clothing will be.

3　Follow the line of the upper body to roughly draw in the clothes

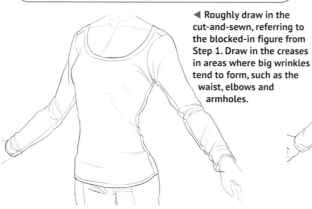

◀ Roughly draw in the cut-and-sewn, referring to the blocked-in figure from Step 1. Draw in the creases in areas where big wrinkles tend to form, such as the waist, elbows and armholes.

4　Complete a line drawing for the rough clothing sketch

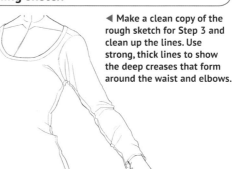

◀ Make a clean copy of the rough sketch for Step 3 and clean up the lines. Use strong, thick lines to show the deep creases that form around the waist and elbows.

5　Draw in the fine wrinkles

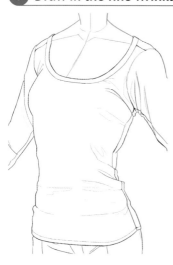

◀ Add in fine wrinkles around the stomach area and so on. Using fine lines to add small wrinkles around the larger creases from Step 4 allows you to create a depth of detail without making the illustration look too cluttered.

6　Completion

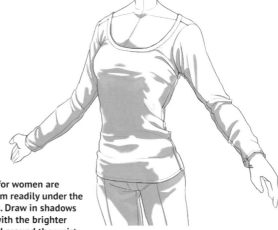

▶ As cut-and-sewn tops for women are close-fitting, shadows form readily under the bust and beneath creases. Draw in shadows to contrast dynamically with the brighter areas above the chest and around the waist.

👕 Examples of cut-and-sewn tops and T-shirts

🔘 Crew neck

The rounded neckline close to the neck, concealing the collarbone, emphasizes a casual look and creates a naturalistic impression. Although its construction is simple, you'll need to clearly mark in the creases from the sleeves and chest to the waist.

This can be worn by men and women, but is best suited for a slim character.

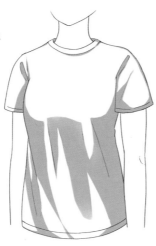

🔘 V-neck

As it has a deep neckline that reveals some of the chest, this type of shirt can lend your character sex appeal. Make sure not to make the V too deep or it can end up being too revealing. This type of garment works well with accessories such as scarves or necklaces.

This type of shirt suits both men and women with slender builds, and is effective even when worn just by itself.

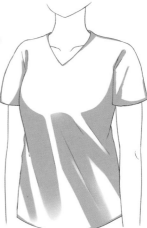

🔘 Henley neck

Having the buttons done up or leaving them open can change a character's appearance, creating a rough impression or bringing out an air of maturity. Apply a rough texture to give the look of waffle-weave fabric with a bumpy surface.

Originally favored by boat and yacht captains, this type of shirt also suits loutish, masculine characters.

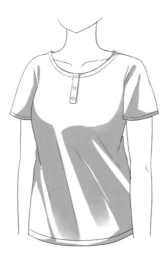

🔘 Boat neck

The neckline is open wide across the front and rounded like the base of a boat. As the collarbone is visible right to the edge, there is more emphasis on the line of the collarbone than in a round-necked version, creating a fresh, elegant impression.

As it creates a softer appearance, it could suit some female characters more than male.

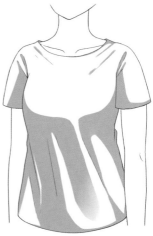

🔘 Front detail

This is a cut-and-sewn top for females that incorporates a draped look in the front panel. Draw in creases in the fabric coming from all four directions and gathering in the center to bring out dimension.

This design suits a character with a mature air.

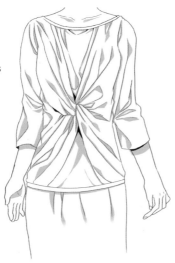

🔘 Wrap style

This design is defined by fabric crossing over in the front panel, as if to wrap the body. It emphasizes the lines of the body while creating dynamism in the clothing.

A look that particularly suits mature and cool female characters, the wrap style also works well with various types of bottoms.

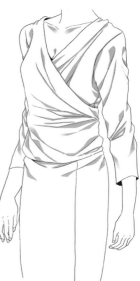

Shirts and Blouses

Collars and a front panel with buttons are the basic features of these tops. There's a lot of variation due to the shapes of the collars and the fabric patterns.

Structure of a shirt

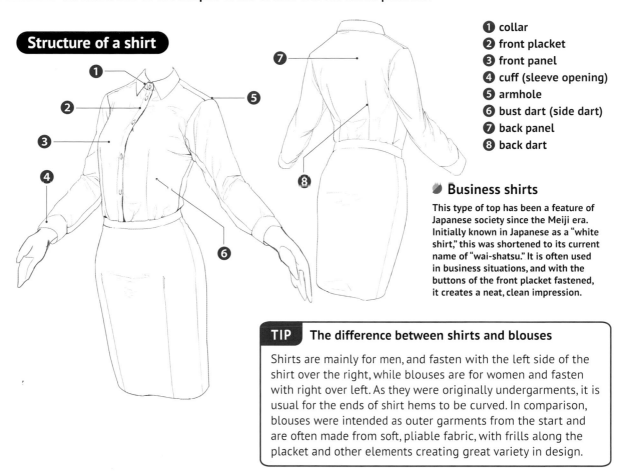

1. collar
2. front placket
3. front panel
4. cuff (sleeve opening)
5. armhole
6. bust dart (side dart)
7. back panel
8. back dart

Business shirts

This type of top has been a feature of Japanese society since the Meiji era. Initially known in Japanese as a "white shirt," this was shortened to its current name of "wai-shatsu." It is often used in business situations, and with the buttons of the front placket fastened, it creates a neat, clean impression.

> **TIP** **The difference between shirts and blouses**
>
> Shirts are mainly for men, and fasten with the left side of the shirt over the right, while blouses are for women and fasten with right over left. As they were originally undergarments, it is usual for the ends of shirt hems to be curved. In comparison, blouses were intended as outer garments from the start and are often made from soft, pliable fabric, with frills along the placket and other elements creating great variety in design.

Examples of neck treatments and fabric patterns

Regular collar

On a regular collar, the neckband is neither high nor low and the tips of the collar create a 75- to 90-degree angle.

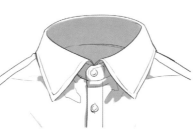

Checks

Lines in different colors and widths intersect to form crosses in this pattern. Various types of checks include tartans, ginghams and argyles.

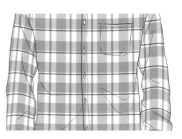

Button-down

The tips of the collar are kept in place by small buttons. This is a very casual type of shirt and it works well with sweaters and down vests.

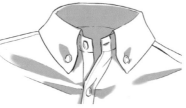

Aloha pattern

Originally from Hawaii, this pattern features tropical motifs such as hibiscus flowers, mostly depicted in a riot of color.

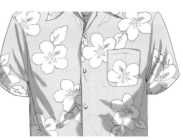

23

✏️ Drawing a business shirt (front view)

① Block-in the shirt and skirt

▶ When a top is the kind that is worn tucked into the lower garment, draw both garments at the same time. Match the waist area of the shirt with that of the skirt.

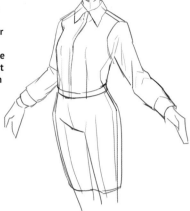

② Use the blocking-in for the body to roughly sketch the shirt

▶ Bring out the character's form by making the outline of the chest and back of the shirt sit close to the line of the body. Match the front placket to the center line of the body and decide on the position of the buttons.

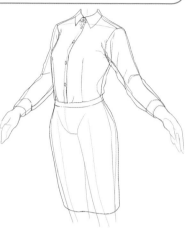

③ Make a neat copy to create a line drawing

▶ Neatly copy the rough sketch from Step 2 to make a line drawing. Vary the thickness of the lines to create dynamism and depth, using a thicker line for the chest protruding forward and a slightly narrower line for the right sleeve in the back.

④ Add in details

▶ Create dimension by increasing details such as creases at the elbow and underarms, shadows around the front placket and creases around the waist area of the shirt where it is tucked into the skirt.

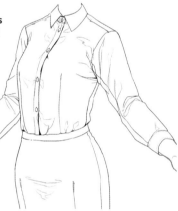

⑤ Completion

▶ Focus the shadows on the area from below the chest to the sides, adding them to the underside of sleeves and other places where creases form hollows.

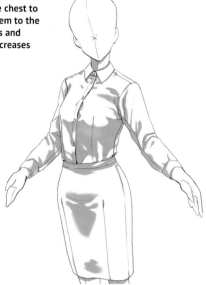

🌰 Example of a back view

▶ A big shadow forms in the hollow between the shoulder blades. The underside of the sleeves is clearly visible in this composition, so make sure there is plenty of shadow there.

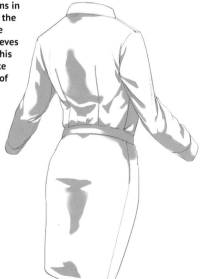

✏️ Drawing a blouse with a frill

① Block-in the blouse and skirt

▶ First, block-in the body, then use the waist position as a reference to block-in the blouse and skirt. Draw in squares along either side of the front placket to form the blocking-in for the frill and decide on its positioning.

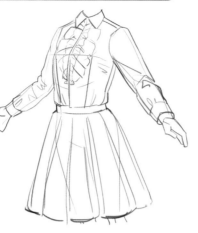

② Follow the line of the chest to capture the flow of the frill

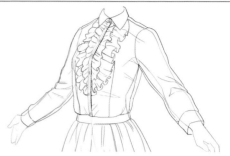

▲ Draw the front placket to align with the center line of the body, using the front placket line as the point from which to roughly sketch the frill extending to the left and right. Use two layers of frill—a narrow frill over a wider one—to bring out volume.

③ Draw the creases in the frill

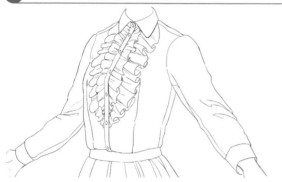

▲ Make the line drawing, adding in the creases in the frill. Keep in mind that the frill is sewn to the front placket and make the front placket the focus as you draw.

④ Add detail to the shadows in the frill, the underarms and so on

▶ Emphasize shadow by darkening the lines between the front placket and the frill, the places where frills layer one on top of the other and so on. Darken the lines under the arms and in the tucks of the skirt in the same way.

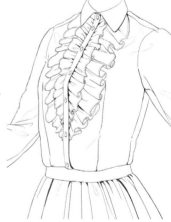

⑤ Completion

▶ Draw shadows under the chest, in the underarm area, along the waistband of the skirt where it meets the shirt and so on. Keep the frill looking fresh and neat by making as much of the surface area as possible white, drawing in shadow only on the underside of material and in hollowed-out areas.

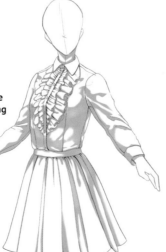

🗨️ Example of a no-frills blouse

▶ When drawing a blouse with no frill, add a bit of shadow under the chest, but not too much, being sure to highlight the lighter areas too.

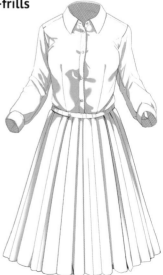

✍ Drawing a disheveled shirt (front view, rear view)

Front View

1 Block-in a male body and shirt

▶ As the sleeves are rolled up, create fabric creases bunched together around the elbows by drawing in randomly distorted lines around both elbows. Use the center line of the body as a reference to draw the left and right sides of the front panel from the collar to the hem.

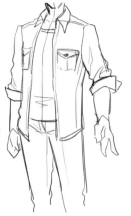

2 Use the blocking-in for the arms and chest as a reference to roughly sketch in the shirt

▶ As the shirt is open at the front and sitting away from the body, draw the chest section slightly distanced from the torso. Draw the rolled-up cuffs to follow the curve of the rounding in the arms.

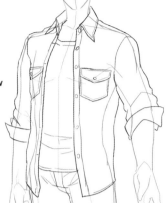

3 Erase the blocking-in and make a clean copy

▶ Focusing on the area around the elbows and the center of the waist, add in creases all over. Also draw in the lines along the side of the shirt that are the seams joining the front and back panels.

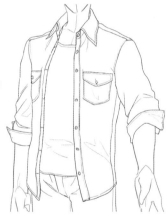

4 Completion

▶ Draw in shadow where the light doesn't hit, such as the inside and underside of the collar, the underside of the sleeves and underarms and the garment worn under the shirt.

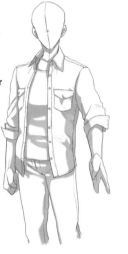

Back View

1 Refer to the blocking-in for the shoulders and back to draw the shirt

▶ Use the line from the shoulders to the arms, the torso line and so on to draw the outline of the shirt. Draw the shirt slightly away from the body around the chest and torso, as there is some slack in the fabric.

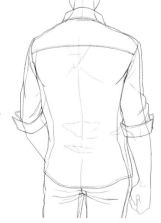

2 Add shadow to complete

▶ The human backbone has an S-shaped curve to it, so to bring out dimension, make the top of the back light and the bottom section dark, with the section from the hips to the buttocks brightening again.

👕 Examples of shirts

🟤 Button-down

This type of shirt has small buttons at the tips of the collar that keep it in place. Many have buttons that are a brighter tone than the shirt to create a subtle accent. Use straight lines to create a firm looking fabric texture.

It creates an active impression, so can be used to interesting, boyish effect on a female character.

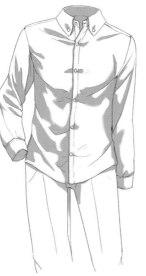

🟤 Polo shirt

This shirt has only two to three buttons at the neck and is pulled over the head to put it on. It's typically made of stretchy material and many examples have ribbed cuffs. Constrict the sleeves slightly where they meet the cuffs for a casual, elegant air.

This shirt suits all kinds of characters and can be used to easily create a sporty look.

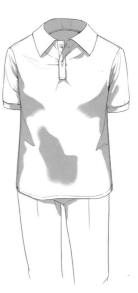

🟤 Flannel shirt

Made from a fabric with a lightly raised nap, these shirts usually have a checked pattern that makes it easy to express a character's individuality. When adding texture, change the angle slightly for each section (front panel, sleeves, collar) to bring out dimension rather than applying it all over.

This type of shirt suits a character with a slim, attractive physique or one wearing tight-fitting pants.

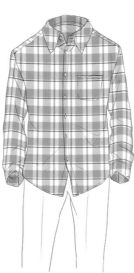

🟤 See-through shirt

Made from sheer material, this kind of shirt is typically worn by women. Beyond the plainer versions, many are decorated with lace and other accents. Create a light look by contrasting the shirt with the skin or an inner layer of clothing.

A variety of expression can be achieved depending on the degree of transparency, from a breezy, clean look to a more racy or suggestive impression.

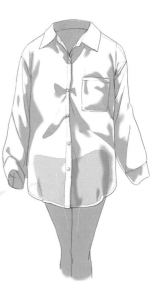

🟤 Banker's shirt

Only the collar and cuffs are white on this type of shirt, with colored or patterned fabric used for the main part of the shirt. This type of shirt makes for a crisp, clean, intelligent image.

As it creates an air of intelligence and flamboyance, it's a strong inclusion when adding an accent to a suited figure.

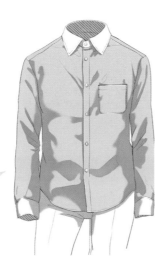

🟤 Hawaiian shirt

While tropical patterns abound, it is said that this kind of shirt has its roots in Japanese traditional dress, which may explain why there are also many dragon and carp motifs on Hawaiian shirts. They are loose-fitting, so draw the outline from the torso to the hem to be nearly a straight line.

Match the shirt pattern to the character, with florals for a cheerful character, martial motifs for a fierce figure and so on.

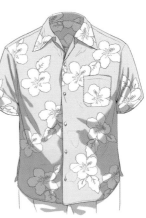

Hoodies

There are various styles of these sweatshirt-style outer layers, most closing with a zipper down the front and often including pockets on the stomach area.

Structure of a hoodie

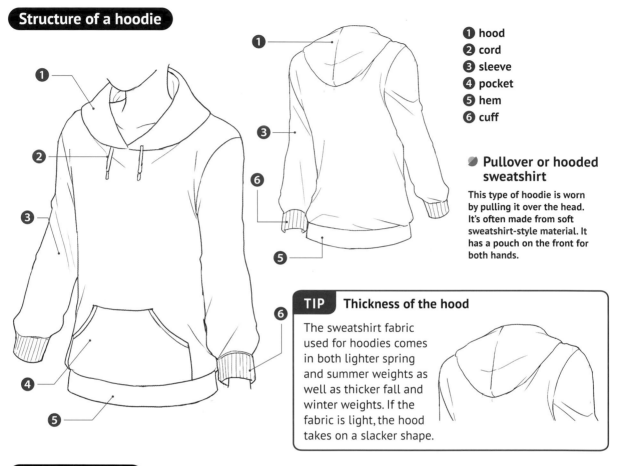

1. hood
2. cord
3. sleeve
4. pocket
5. hem
6. cuff

● Pullover or hooded sweatshirt

This type of hoodie is worn by pulling it over the head. It's often made from soft sweatshirt-style material. It has a pouch on the front for both hands.

> **TIP Thickness of the hood**
>
> The sweatshirt fabric used for hoodies comes in both lighter spring and summer weights as well as thicker fall and winter weights. If the fabric is light, the hood takes on a slacker shape.

Types of hoodies

● Cowl-neck hoodie

This type has a lot of fabric around the neckline so as to completely conceal the neck. Some types have buttons while others have zippers to fasten the neck section.

● Zip-up hoodie

This type has a zipper at the front that allows it to be worn open or fastened. The head of the zipper is usually at around chest height.

● Button-up hoodie

This type fastens with buttons down the front. Most examples fasten higher than the zipper type.

✏️ Drawing a pullover hoodie (front view)

1 Draw the hood around the neck

◄ Block-in the body and draw in the outer and inner lines of the hoodie so that it envelops the area from the chest to around the neck.

2 Draw in the rest of the hoodie, following the lines of the body

◄ Use the blocking-in for the arms and torso as a reference to draw in the outline of the front panel and sleeves. Draw the area near the cuffs a little wider than the actual size of the arms to give the impression of slack fabric.

3 Draw in the cord and pocket

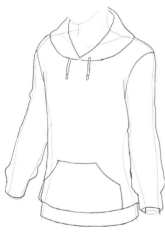

◄ Add in the drawstring that tightens the hood on both sides of the lower section of the hood. Draw the pocket on the stomach area with the bottom part meeting the edge of the ribbing at the hem.

4 Add in creases, cuffs and pocket details

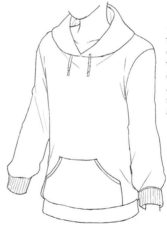

◄ Adding a second line along the entrances of the pocket creates volume. Draw in vertical lines on the cuffs to create the look of ribbing. Add in creases around the shoulders, cuffs and other areas where there are seams.

5 Completion

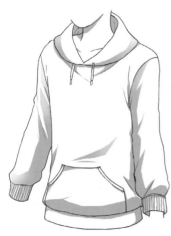

◄ Add in shadow where the hood sits over the top, the undersides of sleeves and around the hem. Adding it around the stomach brings out the effect of the fabric hanging loosely.

🌀 When the hood is on

► On casual hoodies, the hood is not very big, so wearing it pulls the fabric at the chest up and back.

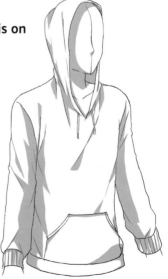

29

✏️ Drawing a pullover hoodie (rear view)

① Follow the lines of the body to draw the hood and top

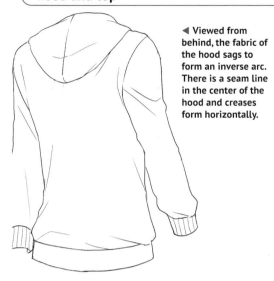

◀ Viewed from behind, the fabric of the hood sags to form an inverse arc. There is a seam line in the center of the hood and creases form horizontally.

② Add shadow to complete

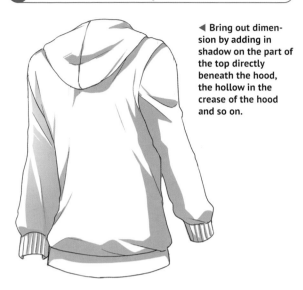

◀ Bring out dimension by adding in shadow on the part of the top directly beneath the hood, the hollow in the crease of the hood and so on.

⬤ Side view

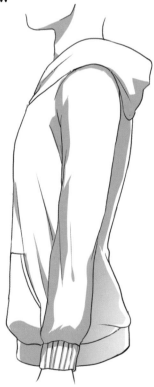

▲ Viewed from the side, the hood extends from the chest and over the shoulders to pile across the back. The fabric is pulled toward the back, so pulled creases form in the chest area.

⬤ When the hood is on (rear view)

▶ The fabric of the hood slackens from the back of the head to the neck, forming creases. They do not form readily at the top of the back, but gather around the shoulders, sides and hem.

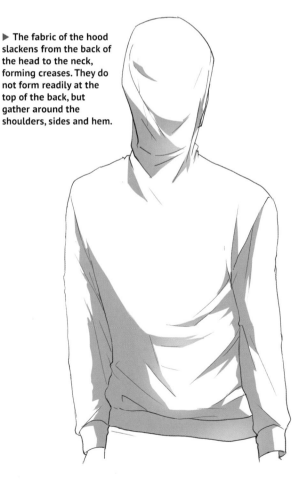

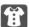 # Examples of hoodies

Zip-up hoodie

The fabric is light and the hood does not have much of a thickness to it. If the hoodie has a zipper with pull tabs at both ends, it is called a double zipper hoodie.

As it has a casual, sporty look, this type suits active characters or those with gruffer personalities.

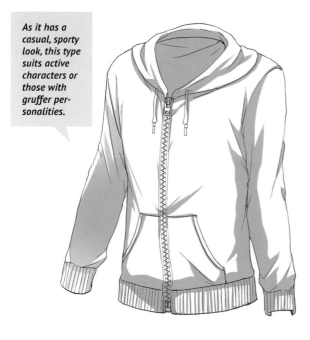

Cowl neck hoodie

The fabric around the neck is thick, so that the necks of some of these hoodies stand like collars. Apart from pullover versions, there are various other types.

The hood covering the neck makes for a masculine look, so this type suits tall, slim male characters.

Button-up hoodie

Twisted cords, large buttons and other decorative elements define this type. When the buttons are fastened all the way up, the fabric does not pull taut but rather forms loose creases.

This type lends your characters a stylish impression.

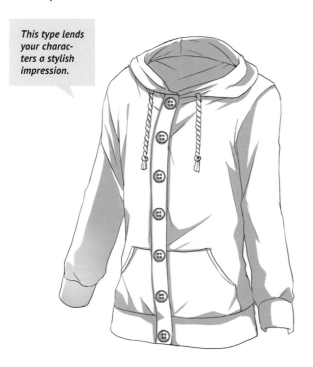

Outdoor hoodie

Intended for outdoor use, functionality such as protection against wind and cold is prioritized in this type, so the hood covers the neck and there are pockets along the bottom. The fabric is thick, so use nearly straight lines to draw it.

This type of garment can evoke the rugged or more active qualities your characters embody.

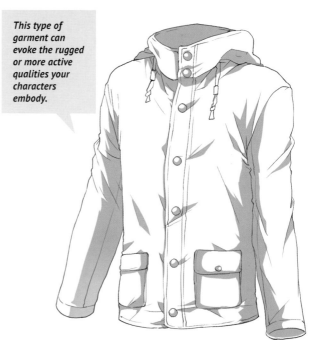

31

Sweaters

Sweaters are usually made from wool or cotton. They come in various patterns depending on how they're knitted and can strike a cozy and casual or slightly dressier tone.

Structure of a sweater

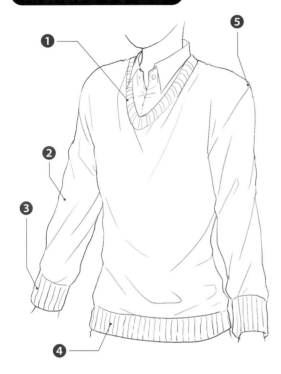

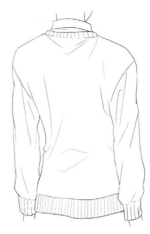

1. collar
2. sleeve
3. cuff
4. hem (waistband)
5. armhole

TIP — Ribbing for the cuffs and waistband

Ribbing is the ridges in knitting. It's made in a way that makes it able to stretch like rubber. Ribbing is characterized by several rows of vertical lines and is often used at the sleeve openings and hems of long-sleeved garments.

Sweater patterns and neck and hem treatments

Aran pattern

This pattern originated from the Aran Islands off the west coast of Ireland. Initially worn by fishermen, the knitted pattern resembles the nets used to catch fish.

Fair Isle pattern

This pattern originated in Fair Isle, Scotland. It incorporates straight, geometric shapes such as triangles and squares to form a pattern.

Mock neck

Unlike with a turtleneck, the fabric at the top of the collar stands up around the neck rather than folding downward.

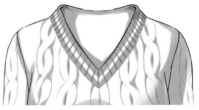

V-neck

The neckline forms a V shape. As the collarbone and neck are visible, it highlights the neck area.

✎ Drawing a knitted sweater (front view, rear view)

Front View

1 Follow the line of the body to draw the outline of the clothing

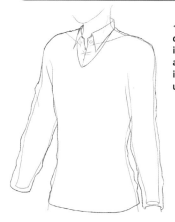

◄ Gravity pulls the fabric down, so make the outline irregular around the sleeves and waist. Draw the neckline, including the shirt collar underneath.

2 Draw in the lines of the neckline, cuffs and hem

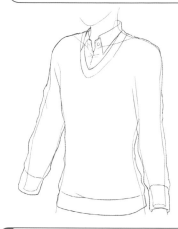

◄ Inside the neckline, cuff and hem outlines, draw lines to separate the fabric from the ribbing sections.

3 Add in vertical lines to form the ribbing

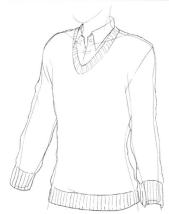

◄ Bring out dimension by adding in vertical lines at regular intervals to form ribbing in the neckline, cuffs and waistband sections.

4 Draw in wrinkles to complete

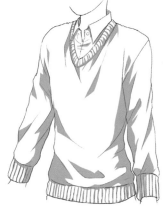

◄ Wrinkles form mainly around the neckline, in the sleeves and around the waist. Add in shadow in the ribbing sections too.

Rear View

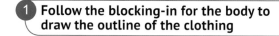

1 Follow the blocking-in for the body to draw the outline of the clothing

▶ As for the front view, take care to draw the fabric sagging around the ends of the sleeves and waist. Make the neckline stand up slightly where the ribbing will go.

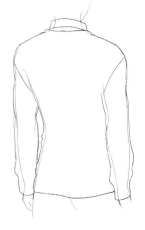

2 Add in ribbing and creases to complete

▶ Around the neckline, under the shoulder seams, across the waist and around the cuffs are the main points where wrinkles form. Too much shadow in the ribbing sections makes for a heavy look, so take care.

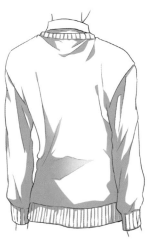

👕 Examples of sweaters

🍂 Aran sweater

The Aran sweater features various patterns, all of which have meaning, such as honeycomb (diligence, labor), diamond (wealth and success), cable (safety and a good harvest) and basket (large fish).

The soft texture makes this type of sweater suit a character with a quiet, calm nature.

❶ honeycomb

❷ cable

❸ diamond

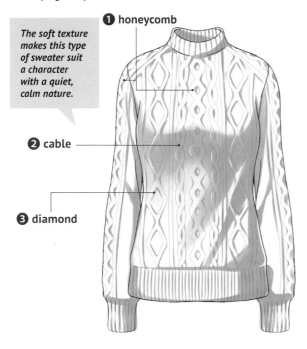

🍂 Tilden sweater

Vertical cables are knitted into this type of sweater, while the neckline, cuffs and waistband have horizontal lines knitted in. It has a V-neck.

Pants go especially well with this type of sweater, which suits male and female characters with slim builds.

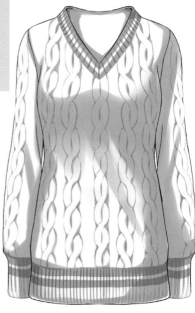

🍂 Bulky sweater

This type of sweater is made from thick yarn, which results in a loose knit. Draw loose helixes for the cables on both sides, with equidistant wavy lines in the center to form the honeycomb pattern.

A high neck and large pattern pairs especially well with female characters also wearing skirts.

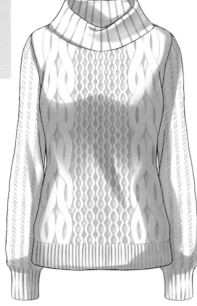

🍂 Fair Isle sweater

This type of sweater is characterized by horizontal rows of different geometrical patterns. At a glance, it looks difficult, but each row of motifs is a repetition of simple symbols.

The classic impression this type of sweater lends your characters makes it especially suitable for layering effects under jackets and vests.

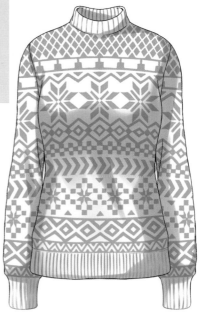

Cardigans

An open-front sweater, cardigans generally have a V-neck and fasten with buttons at the front. Does your character wear it half-buttoned, fully fastened or casually flapping in the wind?

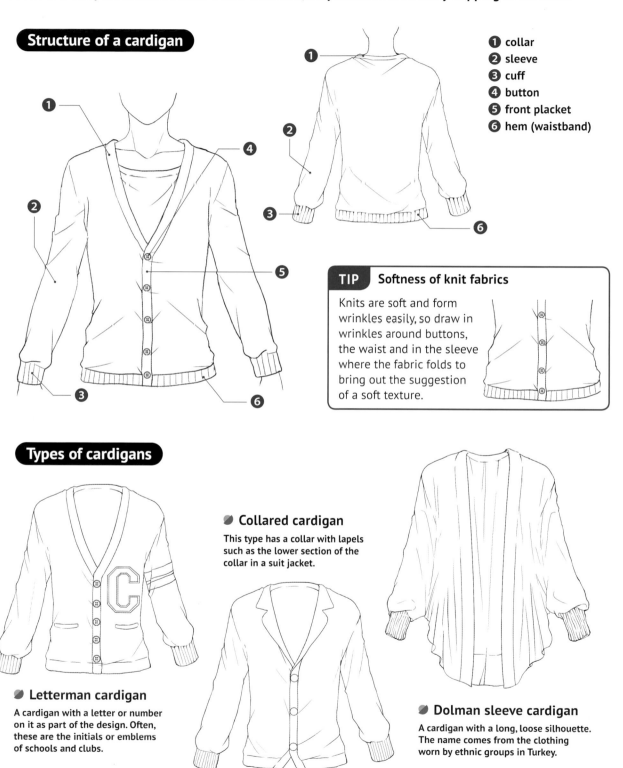

Structure of a cardigan

1. collar
2. sleeve
3. cuff
4. button
5. front placket
6. hem (waistband)

TIP Softness of knit fabrics

Knits are soft and form wrinkles easily, so draw in wrinkles around buttons, the waist and in the sleeve where the fabric folds to bring out the suggestion of a soft texture.

Types of cardigans

Collared cardigan

This type has a collar with lapels such as the lower section of the collar in a suit jacket.

Letterman cardigan

A cardigan with a letter or number on it as part of the design. Often, these are the initials or emblems of schools and clubs.

Dolman sleeve cardigan

A cardigan with a long, loose silhouette. The name comes from the clothing worn by ethnic groups in Turkey.

Drawing a cardigan for men (front view)

1 Draw the outline and the line for the collar

▶ Make the neckline into a V shape and draw the lines for the clothing underneath. Use the bottom of the V as a guide for where to place the top button.

2 Draw a line from the bottom of the V down

▶ Draw a line from the bottom of the V-neck to the hem, curving it slightly at the top to create the impression of the side of the cardigan on the viewer's right lapping over the other side.

3 Draw in lines to indicate the width of the collar and placket

▶ Draw lines that follow those drawn in Steps 1 and 2 at an equal distance to show the width of the collar and front placket.

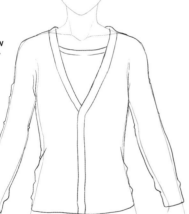

4 Add cuffs, waistband, wrinkles and buttons

▶ Draw in buttons an equal distance from one another along the front placket and add wrinkles on either side. Place the bottom button only at a slightly shorter distance from the one above it. Draw vertical lines in the cuffs and hem to indicate ribbing. Finally, add creases around the armholes and waist.

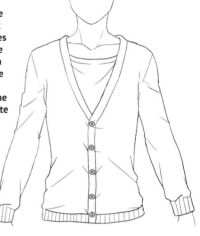

5 Completion

▶ Add shadow below each crease and in the underside of the sleeves. The fabric fits close to the body around the waistband, so little shadow is needed.

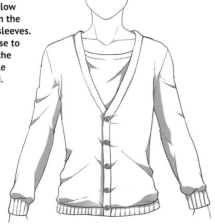

Example of the rear view

▶ Creases form easily around the neck, armholes and back of the waist. The back of the waist is different from the front in that the fabric is attached to the waistband with more ease, so large wrinkles form.

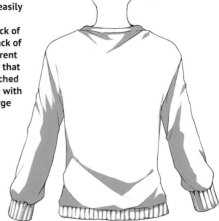

👕 Examples of cardigans

🍃 Letterman cardigan

A large letter or number is in a prominent position as part of the design of this cardigan, which also has pockets. It is usual for the cuffs to be ribbed. Many have lines in only one of the sleeves.

🍃 Collared cardigan

Many of this type have notched, diamond-shaped lapels. Apart from drawing in the buttons and ribbed cuffs, draw the wrinkles in the sleeves and around the waist to express the soft texture of the fabric, typical of a cardigan.

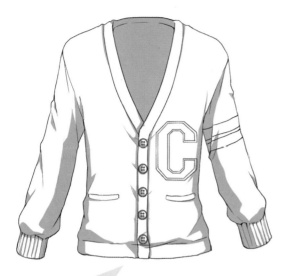

With its extremely casual air, it suits a cheerful student.

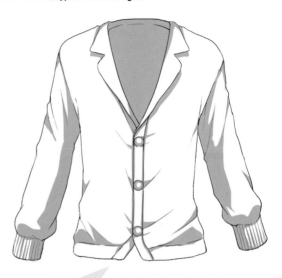

Similar in form to a jacket, but brought in around the waist, this type suits a character with a good physique.

🍃 Topper cardigan

This type of cardigan is about hip length and worn unfastened. From the top, it spreads out in a loose A-line shape, so draw the hem to appear as if it is fluttering.

🍃 Dolman sleeve cardigan

This type is characterized by its large armholes and sleeves that taper toward the openings. Draw in vertical creases near the hemline to express the look of folds in the soft fabric.

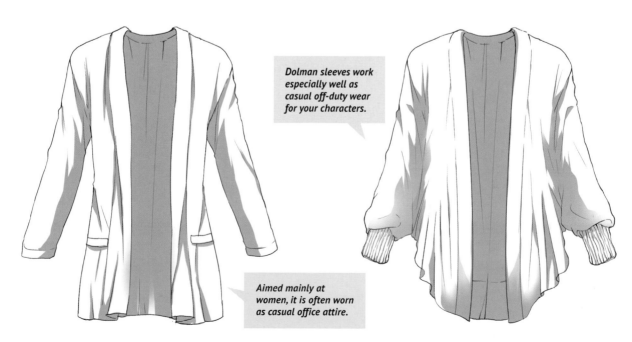

Dolman sleeves work especially well as casual off-duty wear for your characters.

Aimed mainly at women, it is often worn as casual office attire.

Vests

Vests once fastened in the front and were worn only as formalwear. Today, they're casual wear, available in a range of fabrics and designs.

Structure of a vest

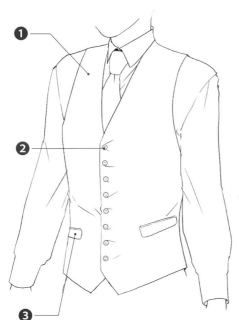

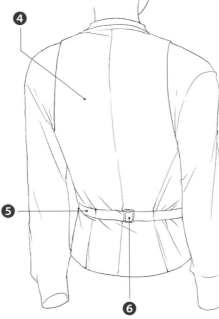

❶ front panel
❷ button
❸ pocket
❹ back panel
❺ back belt
❻ buckle

🥖 Waistcoat

This is a kind of top worn mainly by men over a shirt in formal settings. The belt at the back of the waist can be altered to slightly change the size to fit the body.

Types of inner garments worn beneath vests

🥖 Shirts

This kind of top has a collar and buttons at the front. It suits all kinds of vests and creates a relaxed impression.

Plain, white shirts are particularly versatile, but a colored or patterned shirt worn with a monotone vest is also attractive.

🥖 Cut and sewn

This type of shirt has no collar and is put on by being pulled over the head. Teamed with a vest that is open at the front, it creates a casual air.

A cut-and-sewn shirt has a freshness to it that works well in spring and summer.

🥖 Puff-sleeved blouse

A vest for women that ties with cords at the front like a bodice works well with sleeves that have been gathered for a puffy effect.

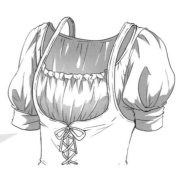

This design creates a flowy effect combined with its emphasis on the chest area.

✒ Drawing a waistcoat (front view, rear view)

Front View

1 Draw the outline of the shirt and vest

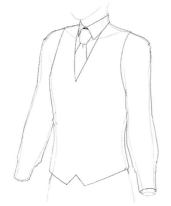

◀ Follow the block-ing-in for the body to draw the shirt beneath the vest, then draw the outline of the vest. Drawing in a collar and tie at the neck results in a more formal waistcoat.

2 Draw the front panel and buttons

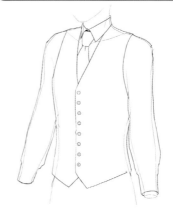

◀ Draw a vertical line at about the center of the vest and add a row of buttons to indicate that the fabric is on top of the fabric on the other side.

3 Add in creases and pockets

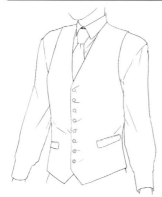

◀ Draw in the pockets, wrinkles in the shirt sleeves and other fine details in general.

4 Completion

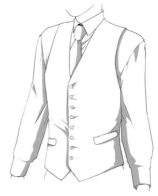

◀ Draw in shadow in the underside of the sleeve and along the side and other places that light doesn't reach. Adding in a thin line of shadow beneath the top layer of the vest will bring out dimension.

Rear View

1 Draw the outline for the shirt and vest

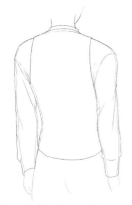

▲ Follow the blocking-in for the back to draw the shirt, then draw the outline of the vest over the top. Make sure the vest is not too wide at the shoulders.

2 Draw the back belt and creases

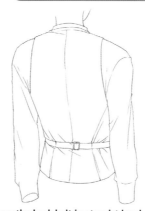

▲ Draw the back belt in at waist level. Adding in a few wrinkles directed toward the belt creates the appearance of the fabric being gathered as the waist is cinched.

3 Completion

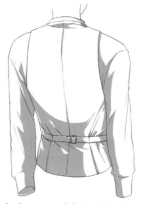

▲ Add shadow around the back belt and in the undersides of the sleeves. Rather than applying shadow along the entire length of the belt, add in areas of brightness to bring out dimension.

👕 Examples of vests

🔘 Down vest

Varying depending on the type of fabric used for the outer surface and the amount of padding used, these vests can be used for outerwear or worn as an inner layer. Drawn to look voluminous, they appear more casual, while thinner vests make for a sleek, put-together appearance.

A shiny surface creates a mature look that suits a wild or more sensuous character.

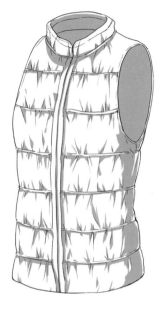

🔘 Knitted vest

A knitted vest can be patterned or plain, with various neckline treatments also affecting the impression they make. Draw in ribbing around the neckline and the hem to bring out the look of a texture with softness and warmth to it.

As this type of vest has a gentle air, it suits a student, but also works as a casual addition to an adult or older character.

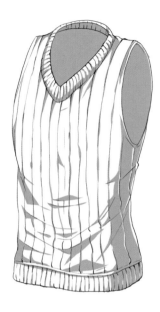

🔘 Lapeled vest

Like a suit jacket, this type of vest has lapels in the front panel. Typically made from suiting fabric, tweed and other twilled fabrics, it has a mature, elegant and calm air to it. The design of the lapels changes the look of the vest.

As it's a classic garment, it suits old men but also works on youthful characters to create a trendy air.

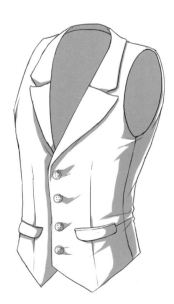

🔘 Bodice

This type of vest, for women, functions similarly to a corset as it has cords or hooks that hold the front panels firmly together. As the waistline is emphasized, pay attention to how the chest merges with the waist area.

Known as a dirndl and worn as part of folk dress in southern Germany, this kind of top is suited to fairy-tale costumes or as the top section of one-piece dresses.

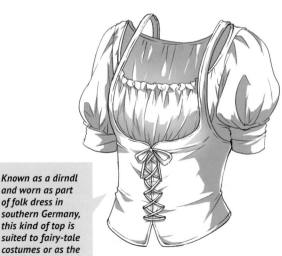

Tank Tops

Made from thin fabric, this sleeveless type of shirt generally has a low neckline, with some versions for women having bra cups built in.

Structure of a tank top

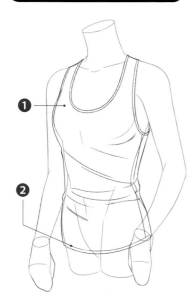

①

②

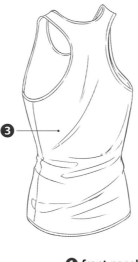

③

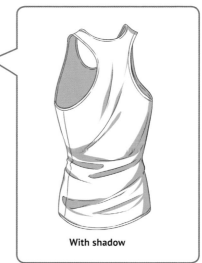

With shadow

① front panel
② hem
③ back panel

✎ Drawing a tank top (front view)

1 Follow the blocking-in for the body to draw the area around the neckline

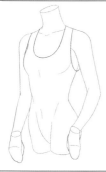

◀ Draw a deep U shape on the chest and armholes from the tops of the shoulders to under the arms.

2 Draw the outline for the waist area and hem

◀ This type of top fits close to the body, so match it to the line of the torso and hip when drawing the outline from the hip to hem.

3 Draw in wrinkles from the bust down

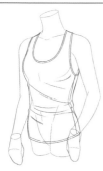

◀ If the tank top has bra cups built in, don't draw wrinkles. Draw creases from the bust down.

4 Completion

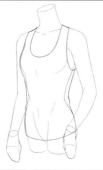

◀ Add shadow under the bust and along the sides, in the hollows of the creases and so on to complete. For the shadow in the bust area, covering a large area with shadow gives the look of a large bust, while less shadow creates a smaller appearance.

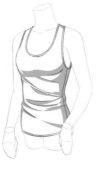

Camisoles

Made from thin, soft fabric, these are sleeveless tops for women. With thin shoulder straps holding them up, they reveal the area around the shoulders.

Structure of a camisole

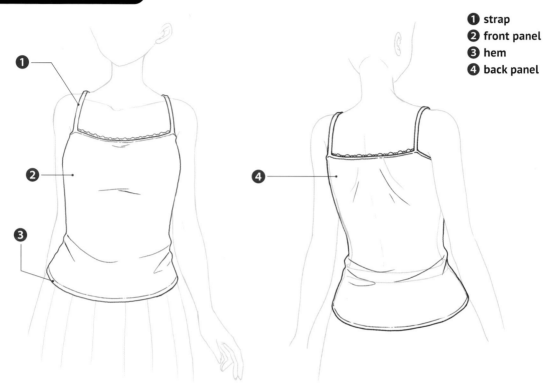

1 strap
2 front panel
3 hem
4 back panel

Examples of types of camisoles

🌸 Frilled lace camisole

This type of camisole is decorated with layers of frills. It has an air of breezy coolness to it.

Often made from sheer or silky fabrics, it's suited for wearing with laidback outfits.

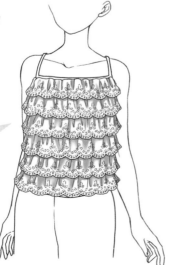

🌸 Chiffon camisole

Made from light, sheer fabrics, this type of camisole often has tiered hemlines and evokes a soft, gentle feeling.

As it flares out toward the hem, this type balances well with tight-fitting pants and skirts.

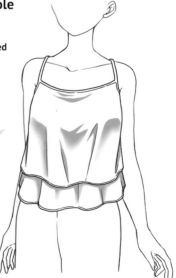

✎ Drawing a camisole

1 Draw the shoulder straps

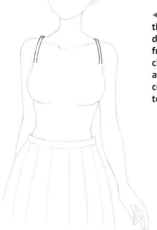

◀ Use the blocking-in for the body as a reference to draw the shoulder straps from the shoulders to the chest. Position them to sit at the edges of the collarbone and go to the top of the chest.

2 Draw the outline of the camisole

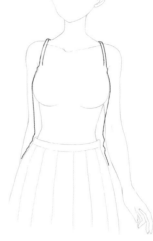

◀ Draw the outline of the camisole from the bases of the straps, following the line of the chest. Visualize the fabric draping from the chest as you draw the lines from the chest to the hem.

3 Draw in the neckline and hem

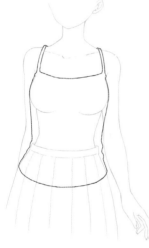

◀ Join the bases of the straps to form the neckline and the lines at the sides of the body to form the hemline. Use an inverse arch-shaped line for both.

4 Draw the creases in the camisole

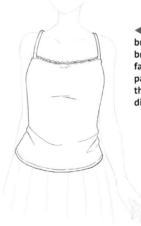

◀ Draw creases in under the bust and around the waist to bring out the look of the fabric texture. Add a line parallel to the hem and to the neckline to bring out dimension.

5 Completion

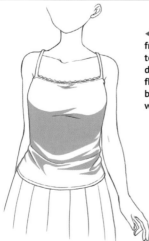

◀ Create a broad shadow from beneath the bust down to the waist. From the waist down to the pelvis, the hem flares out and light hits it, so brighten areas apart from where there are creases.

🔘 Example of a rear view

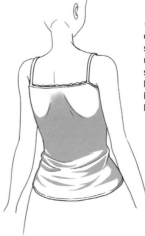

◀ The fabric used for a camisole is thin, so the shoulder blades and other undulations of the body stand out. Draw shadow between the shoulder blades in an unbroken band down to the waist.

Tube Tops

This type of top for women has no sleeves and no shoulder straps. As it is kept in place in the upper part of the chest by strong stretch fabric, it tends to reveal the shape of the body.

Structure of a tube top

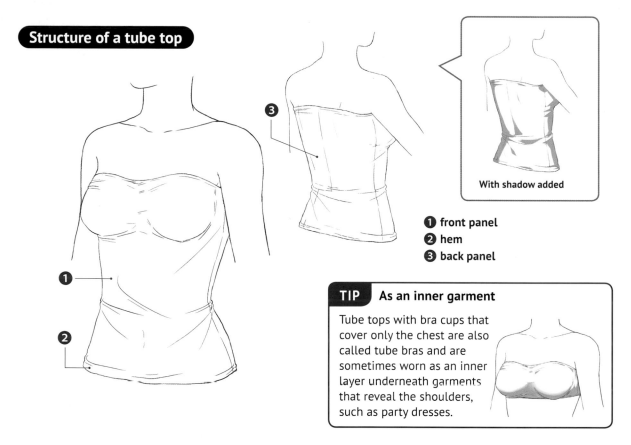

With shadow added

❶ front panel
❷ hem
❸ back panel

TIP **As an inner garment**

Tube tops with bra cups that cover only the chest are also called tube bras and are sometimes worn as an inner layer underneath garments that reveal the shoulders, such as party dresses.

✎ Drawing a tube top (front view)

1 Follow the blocking-in for the body to draw the outline of the garment

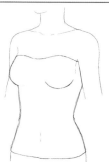

▲ As it sits close to the body, the blocking-in for the body can be used as is to form the outline of the garment. Join the sides at the top of the chest and the hemline to create its shape.

2 Draw the creases and seam lines

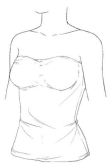

▲ Draw creases in around the chest and waist to bring out the look of the fabric fitting close to the body.

3 Completion

▲ Draw shadows in, focusing on the areas along the sides, under the arms and beneath the chest. Be aware of using rounded, curved lines when adding shadow around the chest.

PART 3

Outerwear

Jackets

Coats

Blousons

Jackets

A general term for upper-body wear that reaches to the hips, jackets usually have sleeves and are open at the front. Here, we cover casual jackets.

Structure of a jacket

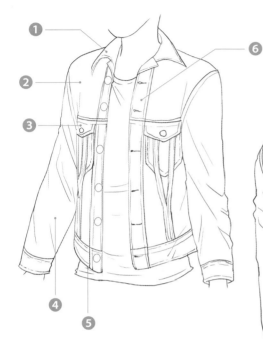

1. collar
2. front panel
3. pocket
4. sleeve
5. hem
6. front placket
7. back panel
8. yoke
9. seams

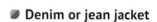

🔹 Denim or jean jacket

The hem sits slightly above the hips so it is suitable for wearing with longer inner layers.

Types of front openings on jackets

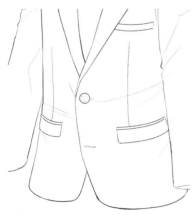

🔹 Buttons

This type fastens with buttons at the front. Generally there is one row of buttons (single-breasted) but there are also double-breasted types with two rows.

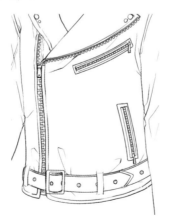

🔹 Zippers

This type has a zipper to fasten it down the front. Most have the zipper at the center, but some have front plackets that layer one over the other, with the zipper on the right side.

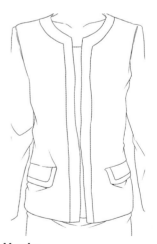

🔹 Hooks

Hooks attached to the back of the front placket are used to fasten this type of jacket. This design is often used on women's jackets, and they are often worn unfastened to reveal the top underneath.

Part 3 Outerwear | Jackets

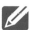 Drawing a denim jacket (front view)

1 Use the blocking-in for the upper body as a reference to draw in the outline of the garment

▲ Block-in the upper body, then draw the sleeves, following the line from the shoulders along the arms. Draw in the collar around the neck and the front panel of the jacket from the base of the neck to the hem to create the outline.

2 Draw in the front placket, hem and sleeve opening to show their width

▲ Draw in the inner lines of the front placket, hem and sleeve opening, then draw another line parallel to them to indicate their widths.

3 Draw in the chest pocket and other design elements of the garment

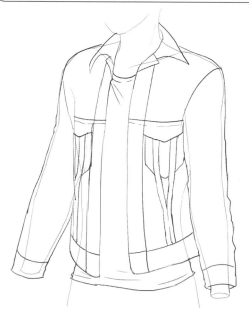

▲ Draw the pockets and flaps on both sides of the chest. Draw in a Y-shaped decorative element from the flaps to the hemline to add to the jacket design.

4 Completion

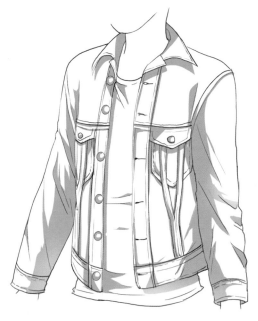

▲ Draw buttons and buttonholes along the front plackets. Add lines along the sides of those drawn in Steps 2 and 3 to create the look of stitching lines and bring out dimension. Create shadow, focusing on the undersides of the sleeves, around the buttons and around the waistband.

✏️ Drawing a denim jacket (rear view)

① Follow the line of the body to draw the outline of the garment

◀ Block-in the rear view of the body and follow the line from the shoulders along the arms to draw the outline of the garment. Make a mountain-shaped line at the neck for the collar and follow the line of the back and torso to draw the body of the jacket.

② Draw the seam lines

◀ Draw lines at the sleeve openings and inner hem to indicate the cuffs and waistband, then add in the lines for the armholes and a horizontal line that joins left and right across the back to form the yoke section. Add in lines on the left and right sides of the yoke down to the hem to indicate seam lines.

③ Bring out dimension by adding stitching lines

◀ Add another line alongside the ones drawn for the armholes, back yoke and seams to create the look of a line of stitching and bring out dimension.

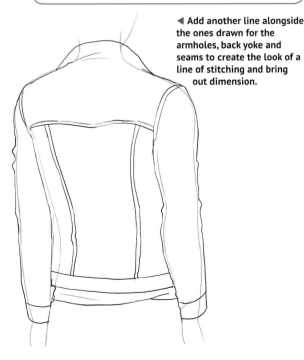

④ Completion

◀ Add in creases and shadow beneath the collar, down the back and along the sleeves. Shadows form in the hollows of creases, in the undersides of sleeves, along the edges of the stitching lines in the yoke and dart sections and around the waist.

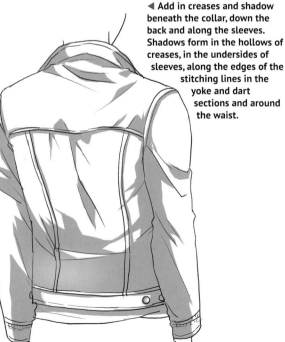

👕 Examples of jackets

🟤 Tailored jacket

The distinctive neck treatment of a collar with lapels is key. This type resembles a suit jacket but it is for casual wear, so make sure the shoulders are not too angular.

> Pair this type of jacket with shirts or cardigans and plain, dark pants for a smart, casual look

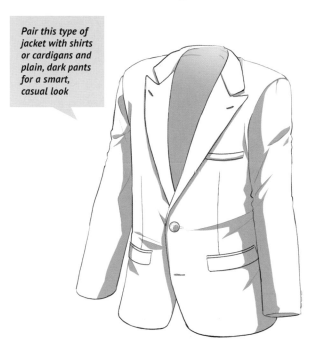

🟤 Military jacket

This is quite a long jacket. Wrinkles form easily in the sleeves and body section. Refer to Page 53 to draw the fur around the hood.

> The jacket itself has a rugged air, but it suits women as well as men. It works especially well with jeans and chino pants.

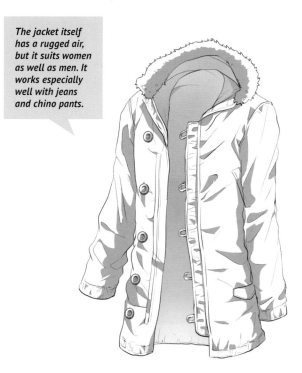

🟤 Motorcycle jacket

Key to this type of jacket are the multiple zippers, not only down the front but also along the chest, near the waistband and near the sleeve openings. Make sure to clearly draw the metal parts in the belt around the waist, the belt loops and so on.

> As it is tight around the hips, this type of jacket suits a slim, tall character. The front can also be worn open with a long-sleeved cut-and-sewn shirt underneath.

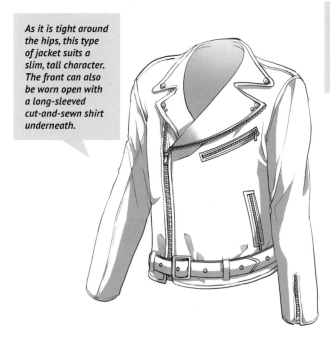

🟤 Collarless jacket

A collarless jacket for women, this type has long sleeves and is worn open at the front. Draw a rounded neckline with the front plackets spread apart to reveal the garment beneath it.

> With its calm air, this type of jacket works well with a relatively plain skirt.

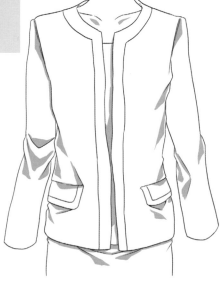

Coats

A coat does much more than keep out the cold. The collar, the presence or absence of a hood, the front placket and the design of the body section all help to heat up the design and flair.

Structure of a coat

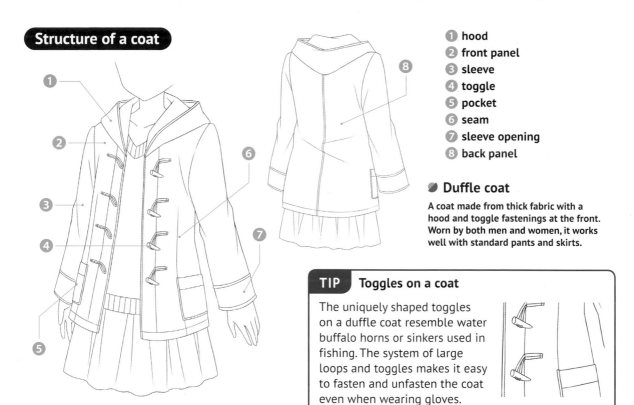

1 hood
2 front panel
3 sleeve
4 toggle
5 pocket
6 seam
7 sleeve opening
8 back panel

Duffle coat

A coat made from thick fabric with a hood and toggle fastenings at the front. Worn by both men and women, it works well with standard pants and skirts.

TIP | **Toggles on a coat**

The uniquely shaped toggles on a duffle coat resemble water buffalo horns or sinkers used in fishing. The system of large loops and toggles makes it easy to fasten and unfasten the coat even when wearing gloves.

Types of neck treatments on coats

Wide collar

The wide collar can be turned up to keep out wind and rain. Coats typical of this type include the pea coat and trench coat.

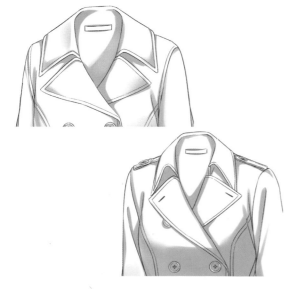

Faux fur trim

Faux fur is attached in various ways, such as around the edge of the hood, around the collar or as the actual collar. This treatment is often used for puffy coats and mod coats.

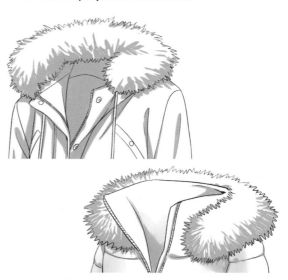

Drawing a duffle coat (front view)

Duffle coat

① Block-in the body and the clothing worn beneath the coat

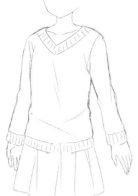

◄ First, block-in the body and the clothing worn under the coat. The clothing will be seen from the front opening of the coat, so draw in the wrinkles.

② Draw the hood around the neck

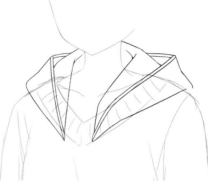

◄ Draw the line of the hood from around the neck to the shoulder seams. Sketch in two lines around the edge of the hood opening to indicate the thickness of the fabric. Draw the fabric at the back of the neck to appear piled up.

③ Draw the front panels and sleeves of the coat

◄ Draw lines from the shoulder seams and ends of the collar down to the wrists and hem to create the outline of the duffle coat. Add lines around the sleeve openings to indicate the thickness of the fabric and in the body of the coat to indicate the seams.

④ Completion

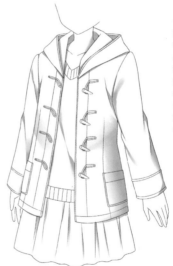

◄ Draw the toggles along the front placket and wrinkles in both elbows. Add shadow, focusing on the inside of the hood, along the sides of the body and along the sleeves to complete. Add shadow to the clothing worn underneath too.

Toggles

① Draw the horn-shaped toggles

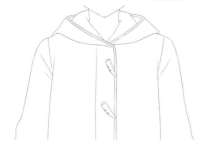

▲ Draw the duffle coat's front placket as if the coat were done up, then follow the line of the front placket to add the horn-shaped toggles.

② Draw the loops for the toggles

▲ Draw the loops that join the toggles to the coat next to each toggle. Key to this is drawing the loops on a slightly downward diagonal angle.

③ Draw the loops on the other side to complete

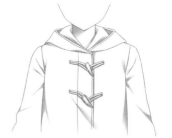

▲ Draw the toggle fastening loops on the opposite side from the toggles to complete the drawing. Add shadow to the tips of the toggles, the overlapping front plackets, around the hood and so on.

① **Block-in the body and the clothes to be worn underneath the coat**

▶ Block-in the back of the body and the clothes to be worn underneath the coat. The three areas of the body that will assist in drawing the coat are the shoulders, back and hips.

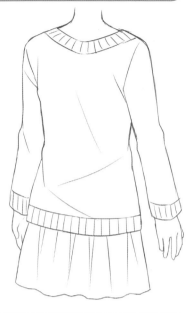

② **Draw the hood around the neck**

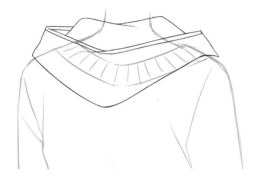

▲ Draw the section of the hood that covers the neck and shoulders. Make the outer section of the hood fall in a loose V shape between the shoulders.

③ **Draw the back panel of the coat and sleeves**

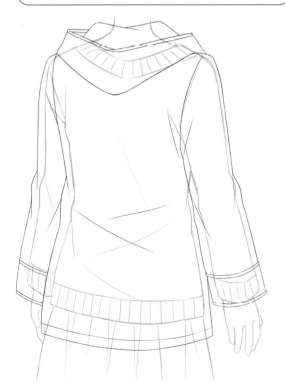

▲ Using the position of the shoulder seams as a reference, draw the outline of the sleeves and back. Lighten the blocking-in for the clothing worn underneath and draw in the coat so that it envelops the whole body.

④ **Completion**

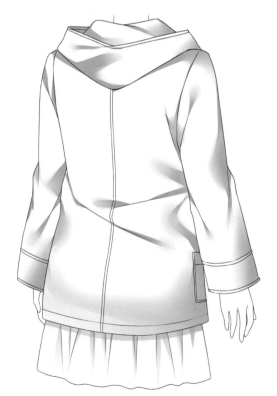

▲ Draw the underside of the hood and the creases in the back and add shadow around the sleeve openings and hem to complete the drawing. Add light shadow to the top part of the skirt where the coat is sitting over it.

✏️ Drawing faux fur on a coat

Coats with stand collars

1 Draw the coat without faux fur

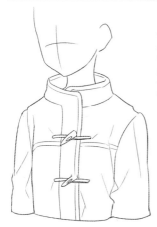

◀ Draw the fur around the collar or along the edge of the hood, but before you do this, block-in the character wearing the coat without fur.

2 Block-in a tube shape around the neck

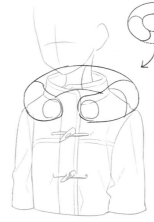

◀ At the front only, cover the section around the collar by blocking-in the shape of a donut with a part missing. This forms the base for drawing the fur.

3 Follow the blocking-in to draw the flow of the faux fur

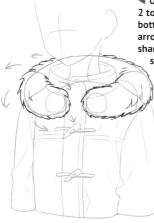

◀ Use the blocking-in from Step 2 to draw fur flowing from top to bottom in the direction of the arrows. Make the ends of the fur sharp at random distances to show how the fur lies.

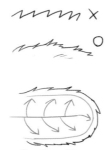

direction of fur

4 Completion

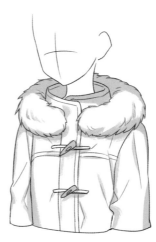

◀ Erase the blocking-in for the fur section and add a few light lines in around the inner part of the fur to indicate how the fur lies. Add shadow, focusing on the area around the collar, the back of the neck and the underside of the fur.

Hooded coat

🖊 Example of front view

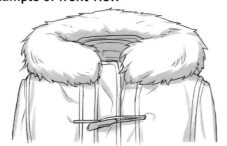

▲ In order to express the thickness of the fur, increase the volume vertically to create the look of dimension. Draw the fur so that it starts to flow in separate directions at around the back of the neck.

🖊 Example of rear view

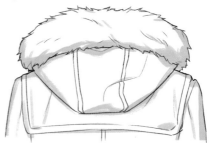

▲ When drawing fur on the hood, follow the line of the edge of the hood and draw the fur flowing in an arch shape. As for the front view, draw the fur to flow in separate directions working out from the center.

🧥 Examples of coats

🔘 Peacoat

This type of coat is characterized by its wide collar, buttons at both left and right and its short length. In order to differentiate it from a jacket, make the hemline wider and bring out the look of thicker fabric.

Suits a wide range of male characters, from teens to old men. It works well with pants, in particular, slim-fitting styles such as skinny jeans.

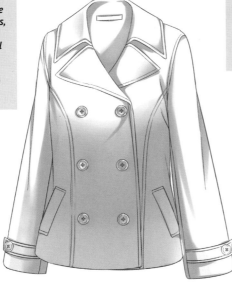

🔘 Trench coat

Originally used by the military and retaining the name, this type of coat has straps called epaulettes on the shoulders. It has two rows of buttons, and the collar crosses over the chest when these are fastened.

As it creates a neat silhouette, this versatile coat suits all types of characters.

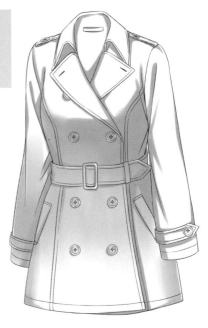

🔘 Shearling coat

Made from sheepskin, this type of coat is defined by its fluffy texture. Make sure to draw in the texture of the wool on the inside of the coat and around the sleeve openings.

The relaxed air of this coat makes it especially suitable for a sweet female character or a mature woman.

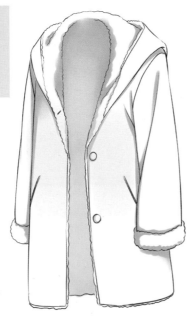

🔘 Convertible collar coat

The collar on this kind of coat is doubled over at the back so that it stands up. It is characterized by its lack of decoration and loose silhouette. Apart from a middle-length style that reaches just below the crotch, there is also a longer length that has a hem reaching to just below the knees.

The simple, classic style of this coat means it is often used as business wear.

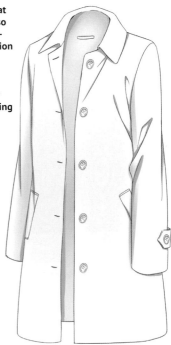

🍂 Mod coat

Made of thick fabric in comparison with other coats, and with fur around the hood adding to the bulky silhouette, this type of coat requires care when drawing so that it doesn't turn out too big. A cord around the neck draws in the hood, while the cord in the body section draws in the waist.

This coat can make the upper body seem large, so get the balance right by drawing it on a slim character, teaming it with skinny jeans or other slim-fitting pants.

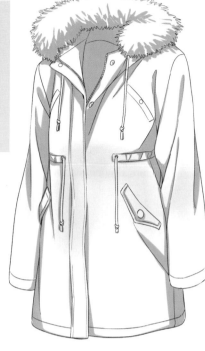

🍂 Chester coat

This type of coat is quite long, with the hem reaching to about the knees. Like a suit jacket, the collar is divided into upper and lower sections, making it resemble a long tailored jacket. It also comes in a double-breasted type.

On a man, this coat makes for a refined, sophisticated look, while on a woman, it creates a relaxed air.

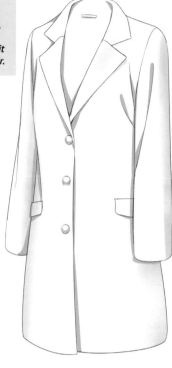

🍂 Puffy coat

Also called a down coat, this type is filled with down and quilted to keep out the cold. It has the appearance of rounded segments stacked one on top of the other. Many have fur around the collar.

This type of coat makes the upper half of the body larger, so is easy to pair with pants on either men or women. If worn open, it works well with sweaters and other knitted tops.

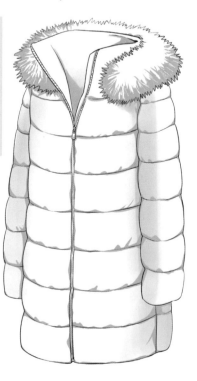

🍂 Cocoon coat

The rounded form of this coat envelops the body like a cocoon. It is a design that is mainly for women, and has soft curved lines from the chest to the hem.

The simple, extremely casual design of this coat makes it easy to pair with dresses or tight patterned pants.

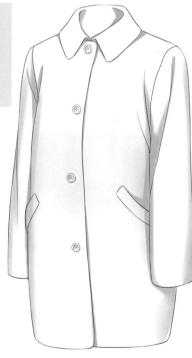

Blousons

Elastic or cords gather the hem and cuffs of the blouson or blouse jacket. This coat is defined by its slightly short length, which has the bottom hem hanging around the hips.

Structure of a blouson

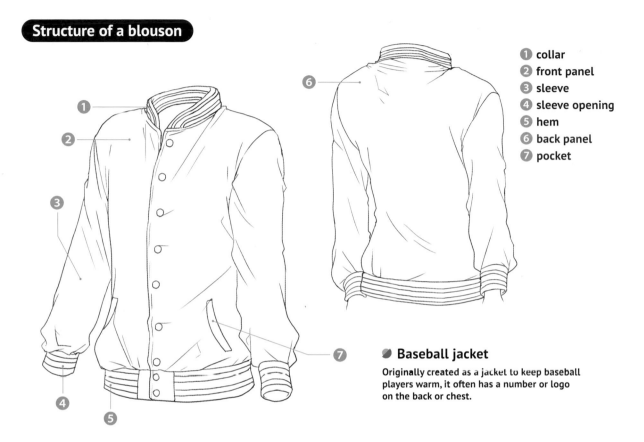

1. collar
2. front panel
3. sleeve
4. sleeve opening
5. hem
6. back panel
7. pocket

🍂 Baseball jacket

Originally created as a jacket to keep baseball players warm, it often has a number or logo on the back or chest.

The shape of the collar, sleeve openings and hemline on blousons

🍂 Collar

Elastic or cord runs through the collar to keep it close to the neck. Some have fleecy fabric lining the inside.

🍂 Sleeve opening, hem

In the same way as with the collar, elastic, cord or ribbing (p. 32) is used to keep the wrist and waistbands close to the body to keep out the cold.

✏️ Drawing a baseball jacket (front view)

1 Draw the front panel and sleeves to follow the body

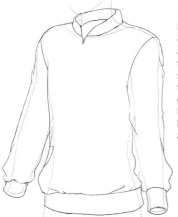

◀ Block-in the upper body and draw the outline of the sleeves and front panel by following the line of the shoulders, arms and torso. Draw the cuffs gathered firmly and the hem sitting close to the body at the same width as the blocked-in hips.

2 Draw the front opening

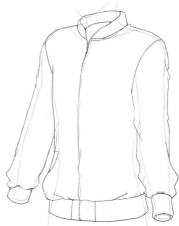

◀ Draw the front opening by making a line down the center of the jacket from below the collar to the hem, following the curve of the chest. Draw a line in the center of the waistband and one on either side.

3 Draw in horizontal lines on the collar, cuffs and waistband

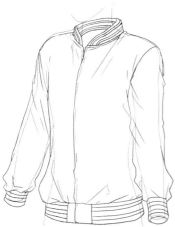

◀ Draw two thick horizontal lines on the collar, cuffs and waistband. Draw creases at the base of the collar, around the cuffs and armholes and around the waistband to heighten the texture of the jacket.

4 Draw the buttons and pockets

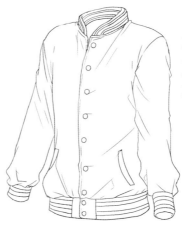

◀ Draw in snap fasteners along the front placket from the base of the collar down to the waistband. Add pockets on both sides and draw in creases near the pockets.

5 Completion

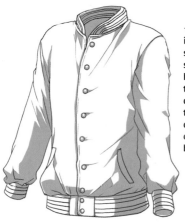

◀ Obvious shadows form in the undersides of the sleeves, sides of the stomach and around the hem. Pay close attention to how shadows form in detailed areas to draw them in along the long creases round the base of the collar, around the buttons and so on.

🔘 Example of rear view

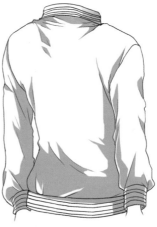

◀ Shadows form in much the same places as for the front view, focusing on the underside of the sleeves and around the hem. Don't forget the fine shadows around the underside of the collar, armholes and so on.

👕 Examples of blousons

🥟 Blouse jacket (front view)

If there is a pattern on both the left and right of the jacket, they are often mirror images, while more complex motifs such as dragons are positioned to flow freely. Recent versions are not limited to Japanese motifs, but include patterns such as hearts, characters and so on.

In recent times, these jackets have come to be associated with criminals and ruffians in Japan. It works well as an outer garment teamed with casual tops and bottoms

🥟 Blouse jacket (rear view)

A large embroidered motif runs across the entire back. However, as the jacket has raglan sleeves (where the top of the sleeve is joined to the base of the collar) make sure the embroidery doesn't overlap onto the sleeve.

As it is a short jacket with the hem just above the hips, a hip-covering long top worn with it flatters the figure.

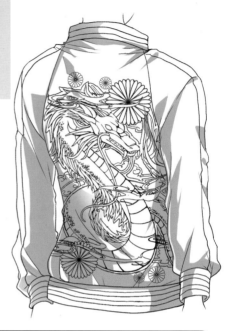

🥟 Laborer's jacket

Draw the outline of the garment using the same process as the baseball jacket, with small wavy lines to indicate the outline of the fleecy fabric used in the collar. Draw two lines for the seams of the sleeves and cuffs, around the pockets and along the edge of the front placket to render the effect of sturdy fabric.

With its rugged air, this type of jacket especially suits a manual worker or tradesperson.

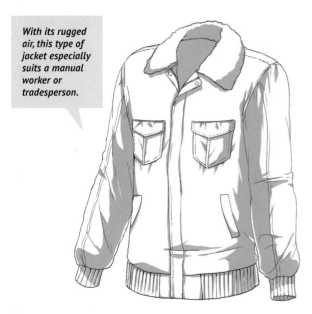

| TIP | Motifs on a Japanese souvenir jacket |

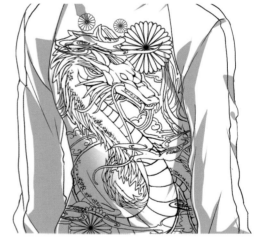

The Japanese name and motifs for this type of jacket ("Suka-jan") are said to derive from "Yokosuka jumper." After World War II, American soldiers stationed at the Yokosuka American military base ordered jackets with Asian motifs such as tigers and dragons embroidered on them, and they continued to be sold as souvenirs and grow in popularity.

Skirts, Pants and Shorts

Skirts

Pants

Shorts

Skirts

A garment for females that covers the area from the hips down but is not divided at the crotch. It varies greatly depending on the length of the hem, the shape and whether it has pleats or not.

Construction of a skirt

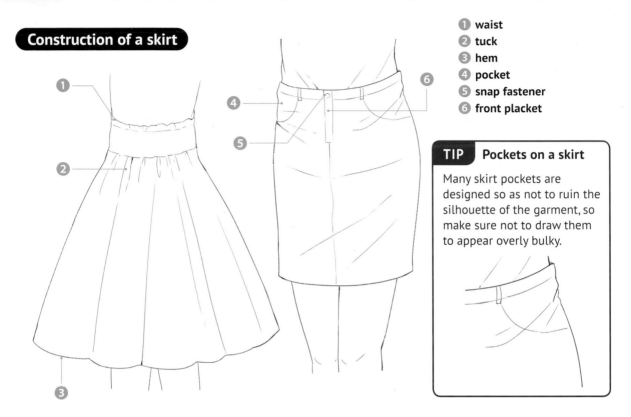

1. waist
2. tuck
3. hem
4. pocket
5. snap fastener
6. front placket

TIP — Pockets on a skirt

Many skirt pockets are designed so as not to ruin the silhouette of the garment, so make sure not to draw them to appear overly bulky.

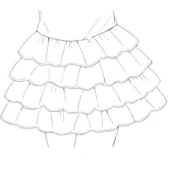

Skirt shapes and types

🍃 Flared

The hem flares out, starting from the hips and getting much wider toward the feet.

🍃 Tight

Fitted exactly to the line of the legs from the hips down. As it follows the line of the body around the hips, there is considerable roundness in that area.

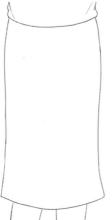

🍃 Pleated

There are many types of pleats, with fine or wide ones and different kinds of folds creating a wealth of variety.

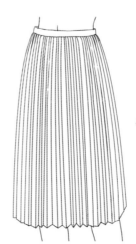

🍃 Tiered

This type is made of tiers of fabric. Its airy hemline means it easily evokes an air of adorability, and it is often used in performers' costumes.

🖊 Drawing a pleated skirt (front view)

1 Block-in the body

▲ Block-in the body. The hips, joints of the legs and center line of the body will be used as the foundation lines for the pleated skirt.

2 Draw the outline of the skirt with the position of the hips as the foundation

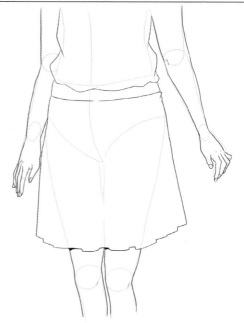

▲ Begin to draw the outline starting from the hips, with the skirt starting to flare out on both sides at about the height of the hip joints. Keep in mind that the hem is pleated and draw it in using an irregular line.

3 Draw in vertical lines for the pleats

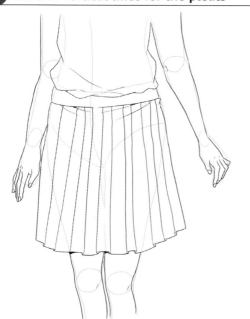

▲ Extend vertical lines up from the irregular line of the hem to suggest the pleats. The skirt flares out at the hem, so the key is to make the vertical lines slightly diagonal from about the middle of the hips.

4 Completion

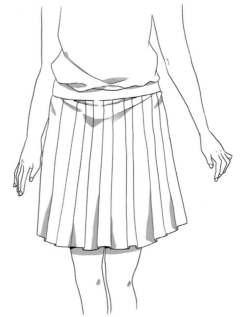

▲ Add in shadow to emphasize the outer and inner sections of the pleats. Create a loose V shape in the middle of the hips where the hipbones are pulling the skirt to either side and there is a hollow in the center.

👕 Various types of pleats

🥥 One-way pleats

Pleats are all folded in the same direction in this type, which are also known as side pleats. Due to its construction, the shadow of each pleat is the same shape.

▶ Often used in the skirts of school uniforms, these pleats create the impression of movement and lend an active feel.

🥥 Box pleats

Pleats are folded in, resembling the shape of a box. Each pleat is quite wide, and the hemline is like a line repeating alternating convex and concave shapes.

▶ The large pleats have an air of sweetness and work well for evoking a classy look in clothing such as private school uniforms.

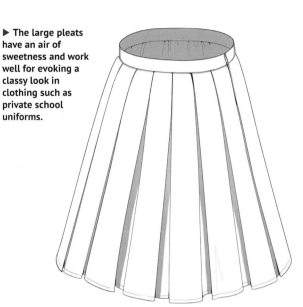

🥥 Accordion pleats

Just like the bellows of an accordion, the fabric has narrow pleats made up of mountain and valley folds. Even finer pleats are known as crystal pleats.

▶ This type evokes a gentle, graceful image, so can be used to lend elegance to a character.

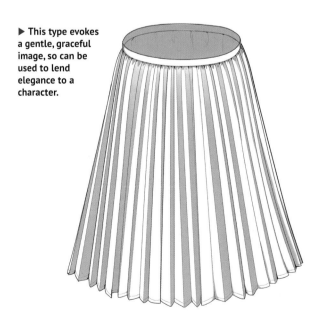

🥥 Inverted pleats

As the name suggests, these pleats are reversed. They are actually box pleats with the outer side of the pleat on the inside. Most have one pleat each at right and left, or just one in the center.

▶ This type of pleat makes for a classic impression and is easy to use as casual wear on characters with gentle dispositions.

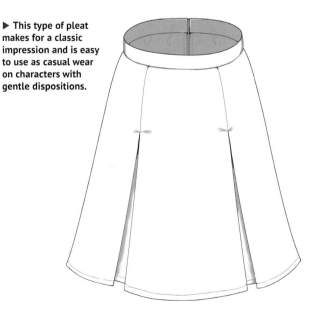

👕 Examples of skirts

👕 Flared skirt

The general term for skirts that flare out gently from the hips down to the hem. Their structure hides the line of the legs and makes it difficult to tell where they are, so make sure to block-in the body so that the legs don't get too long.

The flared hemline highlights femininity, making this skirt suitable as casual wear for all kinds of characters.

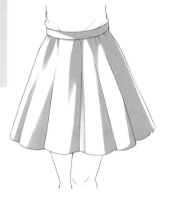

👕 Tight skirt

Fitted exactly to the body, this skirt emphasizes curves. Set the hem above the knees for a look that is classy but sexy at the same time.

As it makes for a formal impression and reveals the line of the body, it suits a mature woman.

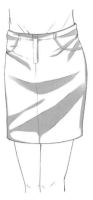

👕 Tiered skirt

Featuring layers of frilled fabric, at a length above the knees lends it a younger look, while longer versions with hems below the knees have an elegant air.

At a length above the knees, it gives an active impression, so it's an easy choice when creating a costume for a bright, cheerful performer-type character.

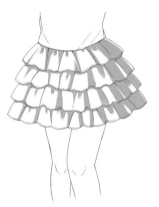

👕 Chiffon skirt

A skirt made from sheer, light, soft fabric. To draw it, sketch in the shape of the flared skirt as the underskirt, then use fine, faint, soft lines to bring out the look of the sheer fabric layered over it.

The breezy, transparent feel heightens the impression of lightness and gentleness.

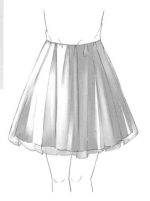

👕 Peplum skirt

This skirt combines the tight skirt with a decorative piece of flared fabric around the hips (the peplum). When drawing the peplum, work as if drawing a frill to give it the appearance of fluttering.

As it has a classic, relaxed air, it suits a sophisticated or gorgeous character.

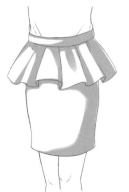

👕 Gored skirt

Several long panels are sewn together to create this type of skirt. As the vertical lines are not pleats but seam lines in the fabric, the key to drawing this type of skirt is to clearly join the lines from the hem to the hips.

The lines are clear and create the impression of precision, so this type of skirt suits a stylish, cool character.

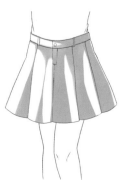

Drawing a long pleated skirt (front view)

1 Draw the outline of the skirt, starting at the hips

▶ Follow the line of the body from the hips to the feet to draw the outline of the skirt. Long lengths of fabric are drawn down by gravity, so make sure the hem doesn't flare out too much. Use the navel as a guide for easily determining the height of the hips.

2 Draw the waistband and pleats at the hemline

▶ Match the narrow waistband to the position of the navel. Draw the area in the front section of the hemline so the inward- and outward-facing pleats are clearly visible.

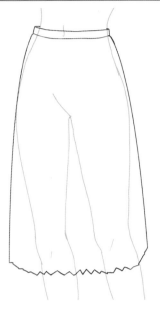

3 Draw in pleats

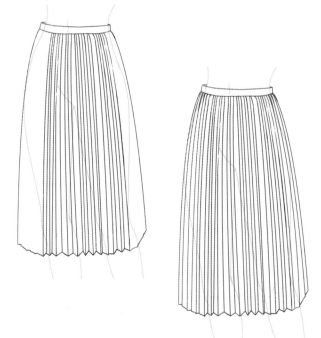

▲ Draw lines up from the front-facing section of the hemline where the pleats are clearly depicted facing inward and outward. Make sure the lines of the pleats get closer together the nearer they get to the waistband.

4 Completion

▶ Add shadow so the bright and dark sides of the pleats alternate, thereby creating dimension. For the dark side of the pleats, apply shadow all over, but use light gradation for the area around the hips.

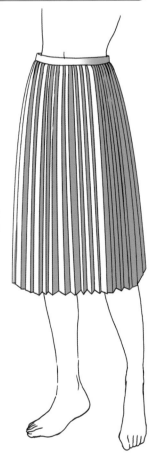

👕 Examples of long skirts

🍂 Fishtail skirt

The hem length differs on the front and back of this kind of skirt. The back is longer and has a fishtail shape. The front has loose pleats from the center out to the hem on each side.

The legs are visible, and there is an airy maturity to this style, making it suit a bright, cheerful character.

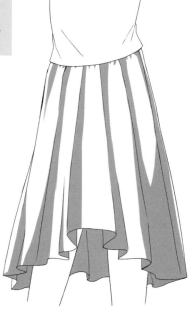

🍂 Narrow skirt

Its slim, form-fitting silhouette means this cylindrical skirt is also known as the pencil skirt. Draw in the same way as for a tight skirt, but make it longer, following the line of the body from the hips down. A narrow, tapered hem makes it even sexier.

Vertical lines are emphasized, so it is a handy device for highlighting a stylish character's charms.

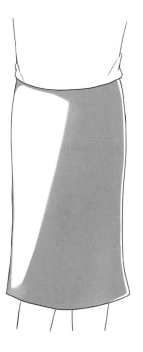

🍂 Sarong skirt

A cylindrical skirt that appears to be wrapped around the body. Its structure is simple, with the line from the hips down close to being straight. The fabric laps over itself, so be aware that the hemline is not a simple inverse-arc shape.

As it evokes a natural, gentle air, this type of skirt suits a mature, calm character.

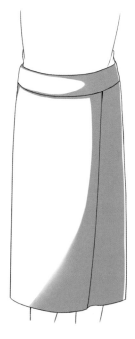

🍂 Pa'u skirt

Worn for dancing the hula, this type of skirt has fine gathers in the fabric around the hips. The wrinkles formed by the densely bunched gathering are best expressed using small dots for shadow rather than lines.

Team it with a sleeveless top or tube top to highlight a playful air.

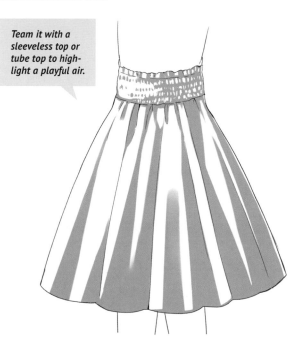

Pants

Pants present an array of designs: what fabric to choose, what cut looks best. Belt loops or an elastic waist? With such range and variety, pants are the perfect garment to practice drawing.

Structure of pants

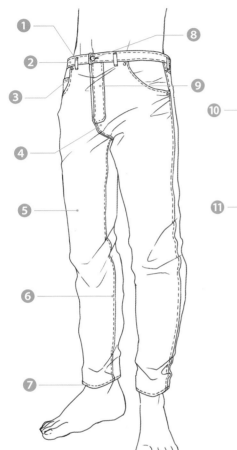

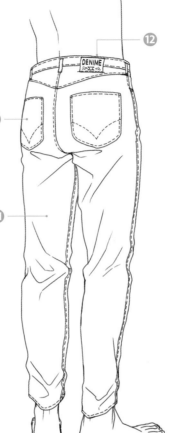

1. belt loop
2. waistband
3. coin pocket
4. rise
5. front panel
6. stitch
7. hem
8. front button
9. fly
10. hip pocket
11. back panel
12. patch

TIP — Denim stitching

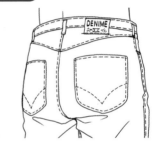

When it comes to denim, the stitching is an important element. Some jeans have motifs on the back pockets, while others have stitching that contrasts with the fabric in color and thickness to create definition.

Types of pants

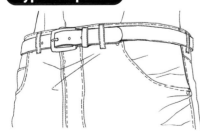

Jeans

As the denim they're made from tends to be firm, the outline is irregular rather than smooth and creases form readily in the crotch area and knees.

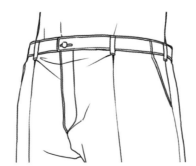

Chinos

These pants are made from chino cloth. Many have tucks (folds in the fabric) around the waist, and as there is ease in the fabric, it doesn't wrinkle easily.

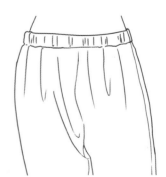

Sarouel pants

These have a long, loose rise and are tapered from the knees down, so there is some shape to them. They have their roots in traditional Islamic dress.

✎ Drawing jeans (front view)

1 Draw the outline, following the line of the legs

◄ Draw the outline of the pants from the hips to the ankles. Denim fabric is sturdy, so add bumps along the outline.

2 Draw belt loops and wrinkles over the entire garment

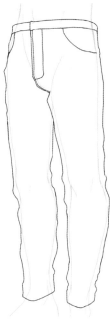 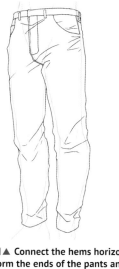

◄▲ Connect the hems horizontally to form the ends of the pants and draw the lines for the waist, front fastening and pockets. Add the wrinkles from the belt loops, around the rise, below the knees and at the hems to adjust the shape of the pants.

3 Add stitching to make the denim look more realistic

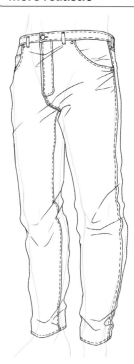

◄ Draw stitching at joins in the fabric such as around the waist and front fastening, along the outer and inner legs and so on to enhance the look of the denim texture.

4 Completion

► Add shadow around the crotch, knees and back panel. Wrinkles form most readily in the area from the hips to crotch, so make this the focus of your shadowing.

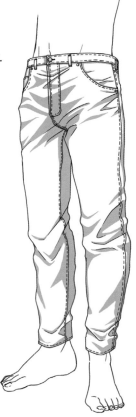

67

Drawing jeans (rear view, belt section)

Rear View

1 Follow the blocking-in for the legs to draw the pants

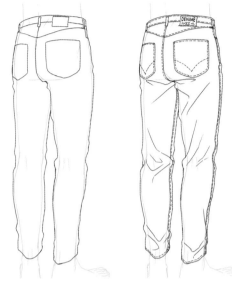

▲ As with the front view, draw an irregular outline from the hips to the ankles and add the back pockets and patch. Draw wrinkles in the inseams, at the back of the knees and along the hems. Last, add lines of stitching.

2 Add shadow to the creases to complete

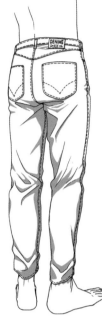

◄ Add shadow, focusing on the inseams, the back of the knees and hems. The fabric in the seat of the pants doesn't gather to the same extent as it does in front, so shadows hardly form at all.

Belt (Front View)

1 Draw lines to match the height of the belt loops

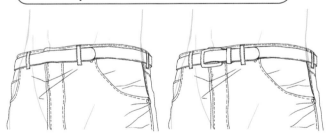

▲ Draw parallel lines through the top and bottom of the belt loops, using a curved line for the end of the belt. Draw in the buckle at the center.

2 Draw the belt holes and clasp to complete

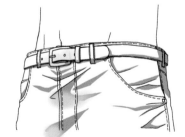

▲ Draw holes in the belt and add shadow overall to complete. A narrow belt isn't of much use when worn with denim jeans, so keep this in mind at the stage of drawing the belt loops.

Belt (Rear View)

1 Draw the belt, paying attention to the curve of the lower back

◄ There is no buckle at the back so the belt can be rendered simply by drawing parallel lines to match the tops and bottoms of the belt loops.

2 Add shadow around the belt to complete

◄ As there is thickness to the belt, shadows form on the underside. Don't just apply shadow to the underside though; add in shadow for the creases as well to bring out dimension in the pants.

👕 Examples of pants

🫘 Cargo pants

These pants have large pockets above the knees on both sides. Many are in earth tones, and some have drawstrings around the hems. Keep the loose fit in mind and express the contrast created by the wrinkles to enhance the look of these pants.

Choosing the appropriate width for the character's physique means these can be worn by any type of character.

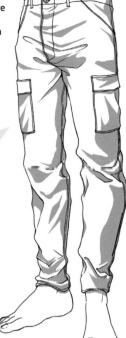

🫘 Chino pants

Made from a sturdy cotton fabric, these pants have their roots in military attire, which is why they are usually beige or another plain color. Adding a center crease down the middle of both legs lends them a look of class, while without the crease, they appear more casual.

Due to their simplicity, they suit everyone and can also be worn as casual officewear.

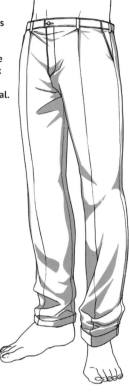

Skinny jeans are not for every character you draw, as they reveal every curve and contour.

🫘 Skinny jeans

The fabric hugs the body closely in these extremely tight jeans. Be aware of the defining characteristics—the silhouette that tapers toward the ankles and the wrinkles that form readily around the knees and hems—as you draw.

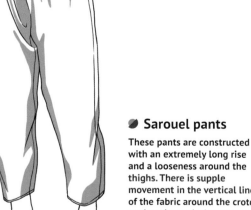

These are similar to yoga pants, the loose draping fabric creating a casual look.

🫘 Sarouel pants

These pants are constructed with an extremely long rise and a looseness around the thighs. There is supple movement in the vertical lines of the fabric around the crotch, so draw in vertical creases to lend the pants a soft look.

Shorts

Longer shorts, like the cargo version, tend to be worn by men, while more cropped or tighter styles are typically preferred by women.

Structure of long and short shorts

🫘 **(left) Long shorts**

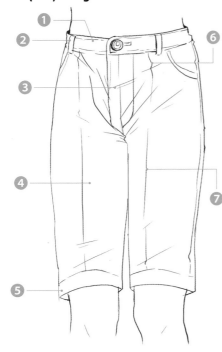

🫘 **(right) Short shorts**

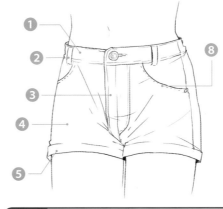

1. waist
2. belt loop
3. fly
4. front panel
5. turn-up
6. tuck
7. center crease
8. stitching

TIP **Creasing around the crotch**

As pants are manufactured so that the legs are slightly astride, when the wearer is standing straight, the fabric from both legs gathers in the center, with the excess forming wrinkles in the rise. The way creases form is largely influenced by the type of fabric, with denim tending to be particularly prone to creasing.

Types of long and short shorts

🫘 **Culottes**

The wide, flared hems of this type make them resemble a skirt. Many have decorative elements such as ribbons and pleating.

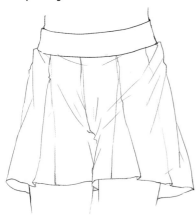

🫘 **Hot pants**

With hardly any hem allowance, both legs are boldly on display. They are mainly for women, and work well for expressing vigor and sexiness.

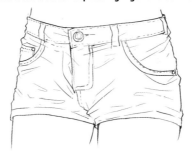

🫘 **Long shorts**

Made from light fabric, they do not cling to the skin and therefore feel cool. They come in various lengths from above the knee to below the knee.

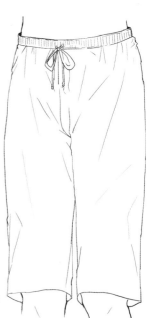

Drawing shorts (front view)

Long Shorts

1 Draw lines to envelop the legs from the hips to above the knees

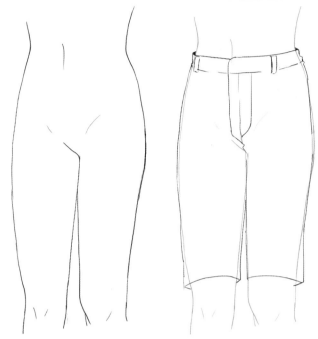

▲▶ Follow the line of the body from below the navel to above the knees to draw the outline so that it closely envelops the legs. Add the fly and belt loops around the hips.

2 Draw wrinkles and tucks to complete

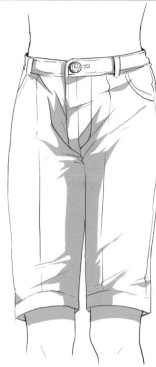

▲ Draw in the pockets, buttons and tucks and add creases around the crotch and at the hems. Add shadow on the inside of the thighs and on the legs beneath the hems to complete the drawing.

Short Shorts

1 Draw lines to envelop the legs from the hips to the thighs

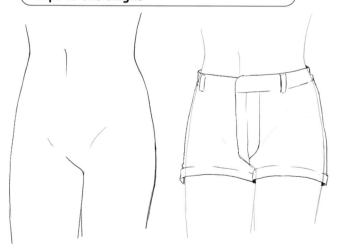

▲▶ Block-in the upper and lower body and draw the waist in line with the navel and the turn-ups of the hems at crotch height. At the sides, draw the seam lines that join the front and back pieces.

2 Add stitching and shadow to complete

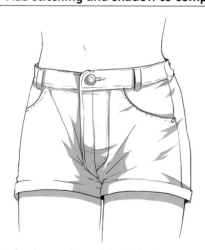

▲ Keeping the roundness of the thighs in mind, add creases around the crotch. Draw details such as buttons and pockets and add stitching to complete the drawing. Add shadow around the crotch and beneath the turn-ups.

Examples of shorts

● Culottes

Drawing the outline is nearly the same as for that of a skirt. The hem is divided in two, so capture how the fabric overlaps around the tops of the legs and add in shadow to convey the feel of pants.

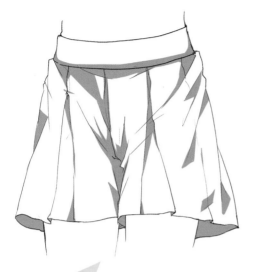

Culottes evoke a sweetness and an active air, so are well-suited to an innocent character or a young girl.

● Hot pants

As for shorts, the waist is at the same height as the navel. Draw the turn-ups at the tops of the legs. If the fabric is denim, make sure to draw plenty of creases and shadow around the crotch.

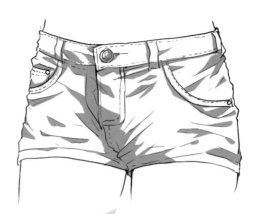

These particularly suit brash teenage girls and active personalities, and can be paired with tights to suit an even wider range of characters.

● Long shorts

Draw in vertical lines along the waistband similar to ribbing to indicate wrinkles in the elastic. As the fabric in the pants is loose, wrinkles don't tend to form in the crotch, but draw several large vertical creases from the waist toward the hems.

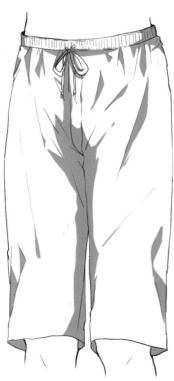

These evoke a light, gentle air, so suit not only middle-aged men but also other younger, more energetic male characters.

| TIP | Things to note about the length of long shorts |

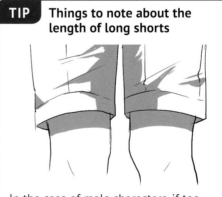

In the case of male characters, if too much skin is revealed above the knees, it can make them look childish. For female characters, knee lengths are fine, but on male characters, making the hems cover the knees allows for the expression of both masculinity and maturity.

PART 5

Ensembles and Outfits

Dresses Denim Overalls

Party Dresses Kimonos

Coveralls Yukatas

Ensembles

Dresses

Dresses accommodate the widest range of fashion, flair and expression. There are so many design choices to make in terms of the cut, fabric and shape of the skirt, sleeves and collar.

Structure of a dress

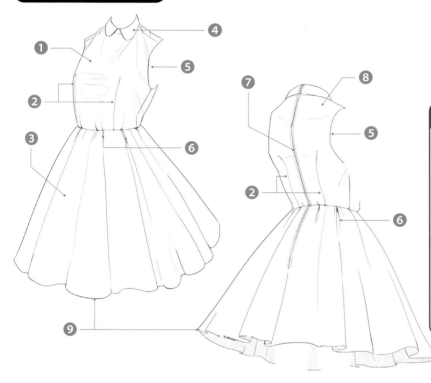

1. front panel
2. dart
3. skirt
4. collar
5. armhole
6. tuck
7. zipper
8. back panel
9. hem

TIP — Collared dress

Dresses have all kinds of treatments around the neckline. Those with a collar create a feminine, sweet impression.

Types of dress

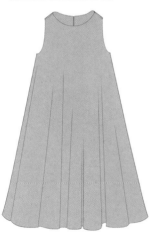

A-line

Resembling a capital letter A, this type of dress is cut close to the body around the shoulders but flares out toward the hem.

Pencil

This type of dress has a skirt that is tightly fitted from the thighs down to the knees.

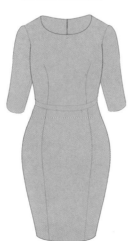

Flared

Gathered at the waist, the skirt section of this dress flares out toward the hem.

Apron

The top part of this dress resembles an apron in form. It is loosely fitting from the hips down.

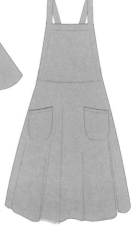

✏️ Drawing a flared dress (front view)

① Block-in the dress and the figure

◀ Block-in the face and body and draw the center line. Be aware of this line as you roughly block-in the dress.

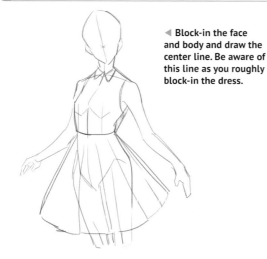

② Follow the line of the body to draw the dress

◀ Create dimension by drawing seam lines beneath the top of the bust. Draw the seam joining the top and skirt section to sit slightly higher than the waist.

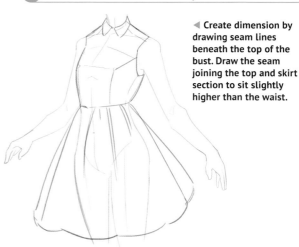

③ Create the line drawing for the top

▶ Drawing the seam that joins the front and back sections brings out dimension.

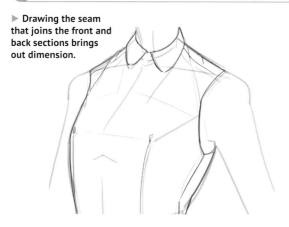

④ Create the line drawing for the skirt

◀ Draw the skirt as if drawing a frill. Make the width of the frill wide to create the look of soft material spreading out.

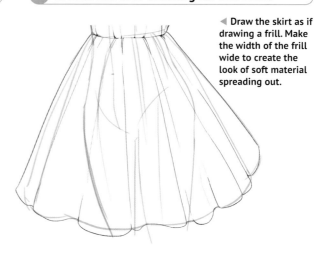

⑤ Draw in where the top and skirt join, the skirt section and so on

▶ Draw tucks in the upper part of the skirt, with the lines reaching to the hem.

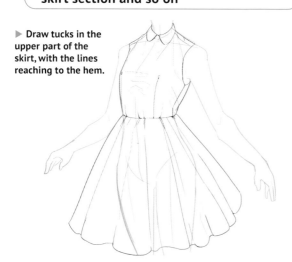

⑥ Completion

◀ Erase the blocking-in lines for the body and check that things don't look out of place where the legs become visible.

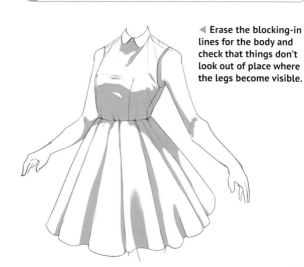

Drawing a flared dress (rear view)

1 Block-in the dress and figure

▶ Block-in the body and draw the center line. Use the back and the center of the buttocks as references for blocking-in the dress.

2 Follow the line of the body to roughly sketch the dress

◀ The material in the back of the skirt may be higher than in the front depending on the roundness of the buttocks.

3 Create the line drawing for the top

◀ Follow the center line down the back to draw the zipper. Draw darts in the back directed toward where the skirt joins the top.

4 Create the line drawing for the skirt

◀ Use the center line of the buttocks as a reference to draw the zipper to halfway down the skirt.

5 Draw in the join of the top and skirt

◀ Add creases where the top and skirt meet and draw tucks around the skirt.

6 Completion

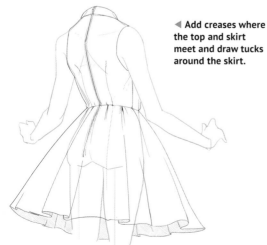

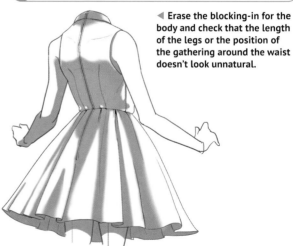

◀ Erase the blocking-in for the body and check that the length of the legs or the position of the gathering around the waist doesn't look unnatural.

👕 Examples of dresses

📎 A-line

Many of these types of dress have no seam joining top and skirt. As the waist position comes up higher than the hips and is not pulled in, there are not really any large shadows.

Types where the waist is not pulled in heighten the air of immaturity, making these dresses suitable for young women.

📎 Pencil

The slim, fitted waist defines this type, which varies in sleeve length from having no sleeves at all to having long sleeves. Follow the line of the body to draw it.

The line of the lower body is prominent so it suits a character with a slim figure or works well on a mature woman.

📎 Maxi skirt

The pleats that form in the hem and reach up to the highest points of the chest define this type. The waist is pulled in, so shadows form beneath the bust.

This creates a laidback impression, so it can be used for a wide range of characters such as laid-back characters and mature types.

📎 Lace

This type of dress is made from lace often with floral motifs. Continuous, regular repetition of the same pattern recalls the look of lace.

Femininity and beauty are highlighted in this type of dress, so it suits well-bred or flashy characters alike.

Drawing lace

Floral patterned lace

1 Create a geometric motif

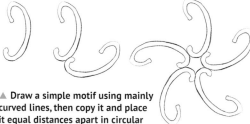

▲ Draw a simple motif using mainly curved lines, then copy it and place it equal distances apart in circular fashion to form a floral motif.

2 Place the motifs at equal distances from one another

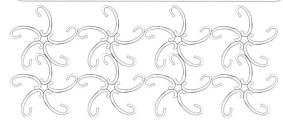

▲ Create a geometric pattern by lining the motifs up next to one another at equal distances.

3 Create a flower motif

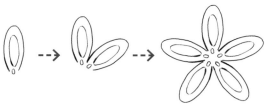

◀▲ Combine oval shapes to create a flower motif in the same way as in Step 1. Create other differently shaped flower petals too.

4 Scatter the flower motifs across the geometric pattern

▶ Place the flower motifs from Step 3 randomly over the geometric pattern from Step 2 to form the lace fabric.

Hand-drawn lace patterns

1 Create a diagram-like pattern

▲ Combine straight lines and circles to form a diagram-like pattern as the base for a lace pattern.

2 Draw a dense collection of lines to form a hand-drawn pattern

▲ Draw several curved lines freehand, placing them closely together to form a motif.

3 Scatter the motifs across the diagram-like pattern

▲ Place motifs such as those from Step 2 at uniform distances over patterns such as that from Step 1 to form the appearance of a lace pattern.

Party Dresses

Party dresses are for formal occasions. Many designs reveal the arms, chest area and back, so they may be worn with a layered garment, such as a bolero, that covers the shoulders.

Structure of a party dress

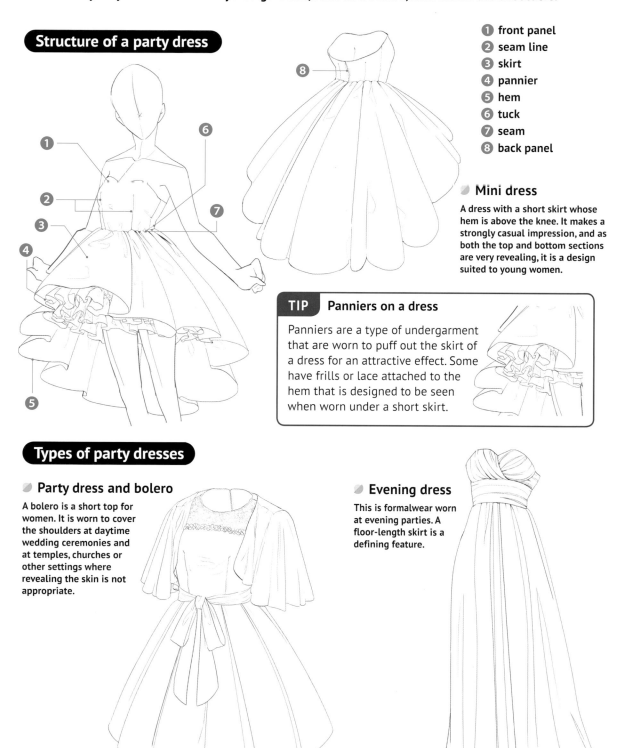

1 front panel
2 seam line
3 skirt
4 pannier
5 hem
6 tuck
7 seam
8 back panel

Mini dress

A dress with a short skirt whose hem is above the knee. It makes a strongly casual impression, and as both the top and bottom sections are very revealing, it is a design suited to young women.

TIP **Panniers on a dress**

Panniers are a type of undergarment that are worn to puff out the skirt of a dress for an attractive effect. Some have frills or lace attached to the hem that is designed to be seen when worn under a short skirt.

Types of party dresses

Party dress and bolero

A bolero is a short top for women. It is worn to cover the shoulders at daytime wedding ceremonies and at temples, churches or other settings where revealing the skin is not appropriate.

Evening dress

This is formalwear worn at evening parties. A floor-length skirt is a defining feature.

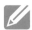 # Drawing a mini dress (front view)

1 Block-in the figure and dress

▶ Roughly block-in the figure and use the position of the chest and hips as a reference to sketch in the mini dress. Draw in the pannier frills that puff out the skirt underneath too.

2 Make a rough copy of the outline of the top and skirt

▶ Make a rough copy of the top section to fit exactly over the lines of the body. Start the high waist of the skirt at around the same point as the figure's elbow.

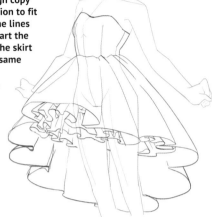

3 Draw the outline of the dress

▶ Make a clean copy of the dress and clean up the shape. Draw the hem of the skirt clearly so that it won't lose its impact even after the frills of the pannier are added in.

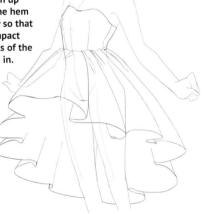

4 Draw in the frills and seam sections

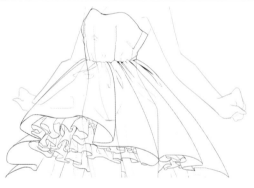

▲ Draw the frills of the pannier and the seam that joins the top and skirt. Make the tucks in the skirt section darker to bring out more volume in the skirt.

5 Completion

▶ Add shadow to the lower part of the top and inside the skirt to complete. The frills are all under the skirt so are all dark, but depth can be created by adding highlights to the sections at the very edge near the skirt.

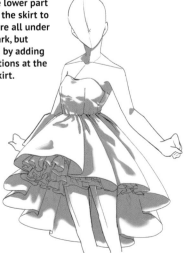

Example of a rear view

▶ Add a band of shadow across the back and along the pleats of the skirt. Bring out dimension in the skirt by adding line and shadow to indicate the layers of the puffed-out hemline.

✏️ Drawing frill patterns

Follow these steps for drawing frills

◀ First, in order to set the height of the frill, block in two parallel lines. The finished frill will extend slightly beyond these lines.

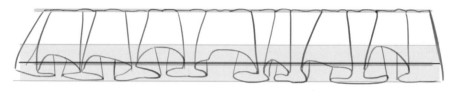

◀ With an omega symbol in mind, roughly draw in the frills so the lower line passes through the center of the omega symbol. It's fine to alter the shape of the frills, but make sure they don't extend beyond the section marked in blue.

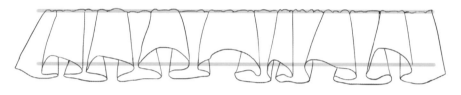

◀ Clean up the rough sketch to make the line drawing. Draw in the section at the top that joins the lace to the garment, using a bumpy line. Make the edges of the folds stand out clearly for a dynamic look.

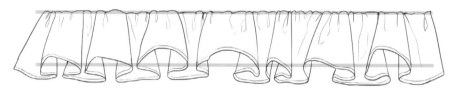

◀ Draw creases in the frills. Starting from where the lace joins the garment, draw teardrop shapes to indicate wrinkles.

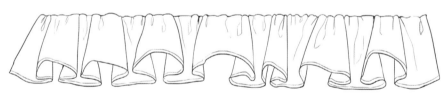

◀ Erase the rough lines to complete. Apart from drawing the wrinkles, increase the amount of detail such as the double lines along the edge of the frill to express depth and softness.

A curved frill collar

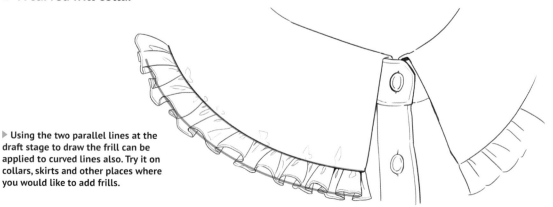

▶ Using the two parallel lines at the draft stage to draw the frill can be applied to curved lines also. Try it on collars, skirts and other places where you would like to add frills.

🔖 Examples of party dresses

🔘 Tiered dress and tailored bolero

This combination features an adorable dress with a tiered hem and a bolero that recalls the shape of a formal jacket. For the hem, aim to draw at least three tiers. The bolero has long sleeves and a wide collar.

Both sweet and formal, this outfit could be used for a female character participating in a wedding.

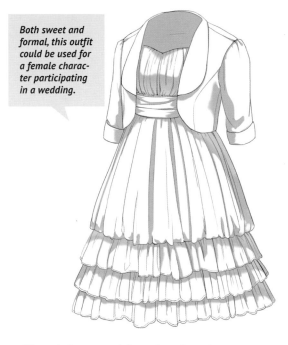

🔘 Flared dress and butterfly bolero

This outfit comprises a feminine dress with a wide hem and a butterfly bolero that flutters to recall its namesake. Sheer fabrics are often used for butterfly boleros, so lightly draw in the shoulders and arms to bring out the look of transparency.

This creates the impression of class, and suits a female character such as a young woman who has just reached adulthood.

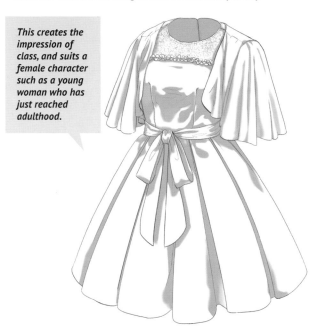

🔘 Flared dress and faux fur shawl

In contrast to the bolero, the arms do not pass through a shawl, but rather it wraps around the shoulders. Don't make the fur section stand up too much as it looks more appealing if it has a rounded, fleecy appearance.

This is a combination that suits a woman with a youthful facial structure. On its own, the fur shawl can also suit a brash female character as an overgarment.

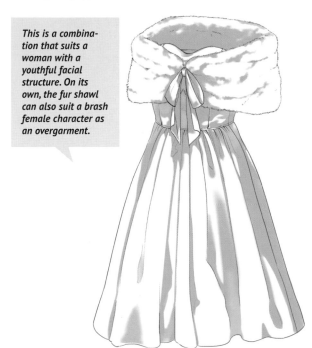

🔘 Tight dress and lace shawl

This outfit teams a tight dress that reveals the line of the body with lace that shows the skin. It's an elegant look, but the line of the body is obvious, so make sure to sketch in the body accurately first.

Both sexy and elegant, this combination works to draw out the full appeal of a mature character.

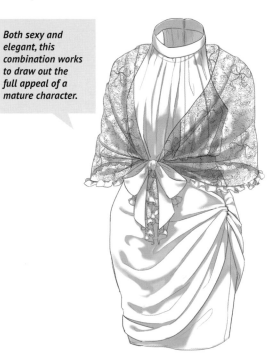

Coveralls

Top and bottom combine to form one piece of clothing. Originally attire for laborers and farmworkers, overalls have now been adopted as everyday street fashion.

Structure of overalls

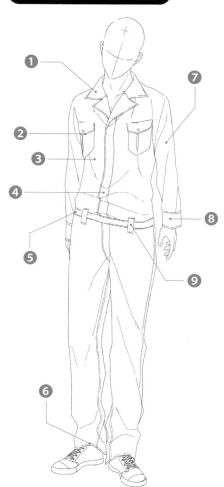

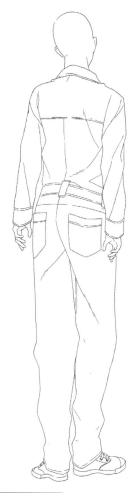

1. collar
2. pocket
3. front panel
4. front placket
5. waist
6. hem
7. sleeve
8. sleeve opening
9. belt loop
10. yoke

TIP **The back yoke**

The yoke is a separate piece of fabric that is usually attached in the shoulder area. It's sometimes in a different color or a different fabric for the purpose of design, and as it joins the left and right sides, there is a line of stitching running across it horizontally.

Types of coveralls and how they're worn

Tied on the hips

Rather than wearing the top section, it is taken off and the sleeves are tied around the hips. This creates a look similar to regular bottoms and jackets or other outer garments can be worn also.

Open at the front

The top section is left undone to reveal the inner garment underneath. The open collar increases the casual feel, giving the impression of a wild personality.

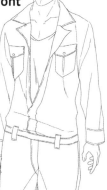

Short sleeves

Designed for summer wear, there are also sleeveless versions.

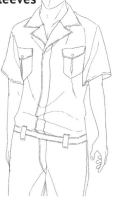

83

Drawing coveralls (front view)

1 Block-in the figure

▶ Block-in the entire figure, including the feet. The waist will serve as a guide for where the upper and lower parts of the clothing join.

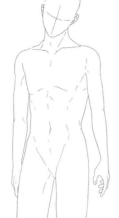

2 Draw in the top section from around the chest

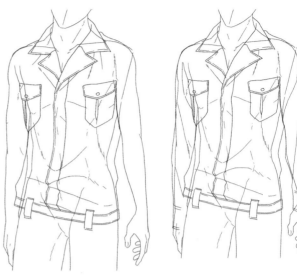

▲ Draw the outline of the top section of the clothing from the shoulders to the hips, adding in the collar, pockets and wrinkles in the stomach area. Next, draw the sleeves to cover the arms from the armholes to the wrists, adding diagonal wrinkles and secondary lines to indicate the cuff sections.

3 Draw in pants to match the blocking-in for the legs

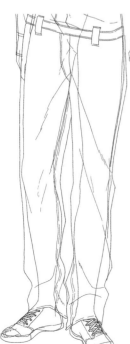

◀ Use the blocking-in for the legs to draw the outline of the pants, drawing in the flow of creases from the rise to the hems. Draw the top edge of the pants to join with the line of the waist.

▶ Add in shadow where large creases form under the arms, around the rise and in the sleeves and hems to complete the drawing.

4 Completion

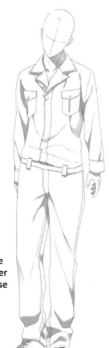

Example of a rear view

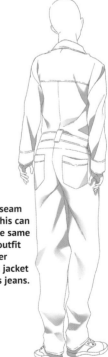

▶ Apart from the seam line at the waist, this can be drawn using the same process as for an outfit that teams an outer garment such as a jacket with pants such as jeans.

👕 Examples of coveralls

👕 Open at the front

The front opens down to the position of the hips, making the chest slightly visible. Draw a low neckline on the garment worn under the coveralls, revealing the collarbone and top of the chest to create sex appeal.

> *A plain shirt worn underneath the coveralls strongly suggests a laborer, while a patterned shirt or hoodie creates a casual look.*

👕 Short sleeves

Use the same process as for drawing a short-sleeved shirt, creating the look of loose sleeve openings and slack fabric around the stomach area. Leaving the front open makes for a fresh look, but if it is open too far down it comes across as slovenly, so draw it to reveal just a little of the neck.

> *Rolling up the hems of the bottoms to reveal the feet creates a breezy look. Teamed with a peaked cap, the casual feel is emphasized still further.*

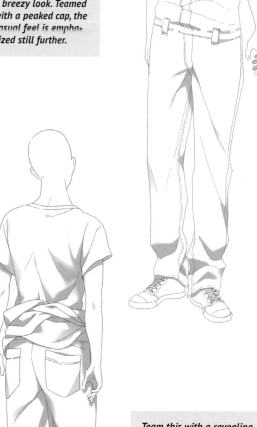

> *Pair this with a T-shirt for a refreshing laid-back look for men or women.*

👕 Tied around the waist (front view)

This look is defined by the twist of material at the front of the stomach that is created by tying the sleeves together. When it comes to sleeve length, dangling sleeves reaching to the inseam create a strong effect for women, while for men, tying the sleeves so they reach to around the rise makes for a cleaner look.

> *Team this with a revealing top that fits close to the body, such as a tube top, for a striking silhouette.*

👕 Tied around the waist (rear view)

The fabric of the top section tied at hip level characterizes this look. The clothing worn underneath bunches up with the fabric wrapped around the waist, forming wrinkles.

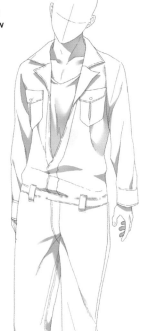

85

Ensembles

A single garment for women that combines tops and bottoms to still appear separate. The bottom section may be pants or a skirt.

Structure of an ensemble

1. front panel (top)
2. seam
3. front panel (bottom)
4. hem
5. zipper

TIP — The seam joining top to bottom

This is the section where the top and bottom parts of the garment are joined together. If it is clearly visible, it looks gawky, so it is designed to allow the fabric from the top section to drape down over it or for other fabric to conceal it.

Examples and types of ensembles

Wide type

Roomy all over, with the hems spreading out like a skirt, this type is made from fabric that has an undulating movement to it.

Strongly feminine, it works well teamed with handbags, necklaces and other feminine accessories.

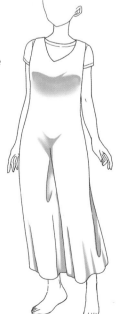

Camisole type

The shoulder and chest areas of this type resemble a camisole. Worn by itself, it is very revealing around the shoulders and chest, so it is usually worn with a garment such as a cut and sewn.

As it evokes femininity, it can be worn alone or with a cut and sewn or sweater underneath to create a complete look.

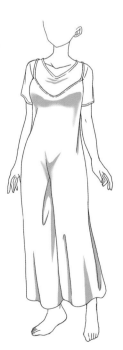

Drawing an ensemble (front view, rear view)

Front View

1 Draw the outline of the top and pants

▶ Block-in the entire body, then use the line of the shoulders, hips and legs to draw in the outline of the top and pants. Also draw the line in the center of the pants that divides right from left.

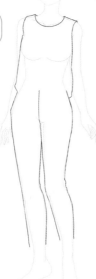

2 Draw the ends of the pants and the seam that joins top to bottom

▶ Draw the line for the seam that joins top to bottom and the fabric draped over the top to clearly define the top and bottom sections. Also draw the opening of the pockets at around the hip position.

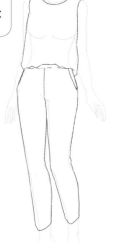

3 Draw in tucks in the pants and wrinkles in the garment

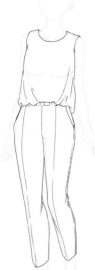

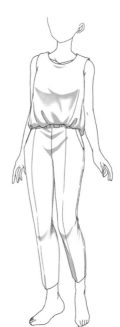

4 Completion

◀ Draw in shadow under the bust, around the seam that joins the top to the bottoms, in the rise and below the knees. The fabric around the crotch has some ease and doesn't form wrinkles readily, so keep shadowing to a minimum.

Back View

1 Draw the outline of the clothing and add wrinkles

▶ Use the same process in Steps 1, 2 and 3 for drawing the front view to draw the outline and wrinkles in the clothing. The wrinkles in the top form in a shape similar to the shoulder blades. Draw a zipper in the center of the top and add wrinkles in the pants around the buttocks and the backs of the knees.

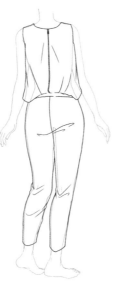

2 Add shadow to the top and pants to complete

▶ Add shadow in a band along the back, under the buttocks and at the backs of the knees. Create dimension in the figure by adding light shadow at the top of the pants to meet up with the shadow on the back.

Denim Overalls

Originally worn by miners and laborers, the top part of a pair of denim overalls is constructed from a bib, or piece covering the chest and held in place with shoulder straps.

Structure of denim overalls

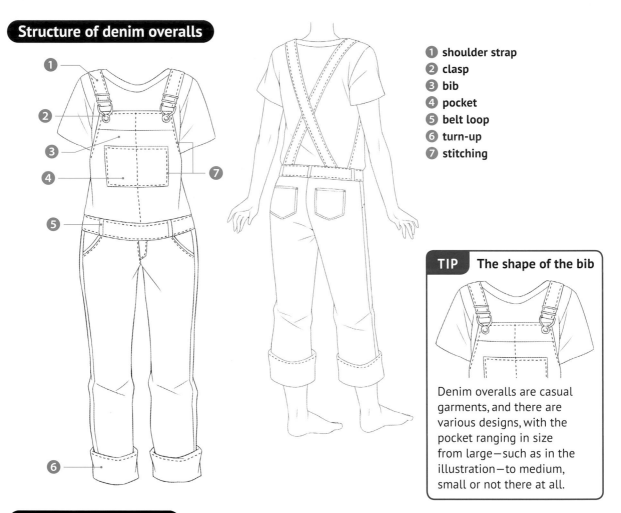

1. shoulder strap
2. clasp
3. bib
4. pocket
5. belt loop
6. turn-up
7. stitching

TIP The shape of the bib

Denim overalls are casual garments, and there are various designs, with the pocket ranging in size from large—such as in the illustration—to medium, small or not there at all.

Styling denim overalls

The look of an outfit featuring denim overalls depends largely on what is worn underneath, with short sleeves creating a childish impression while bare shoulders make for a mature, laidback look.

Both straps over the shoulders

Worn as the garment is intended, both shoulder straps come over the center of the shoulders. On women it makes for a casual, neat impression.

This way of dressing down the garment creates a carefree, breezy impression. Teaming it with a patterned or logo-print shirt makes for an even more casual look.

One strap only

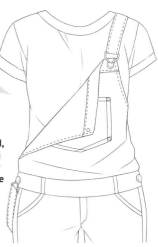

One shoulder strap is removed, with the key to this look being the bib section that turns over at the front. Males may remove both straps, leaving the bib section hanging loose in a trendy style.

 # Drawing denim overalls (front view)

1 Draw the body and the shirt to be worn underneath

▶ Block-in the shirt to be worn under the denim overalls and the entire body. When drawing them, the important points of the body are the shoulders, hips and position of the knees.

2 Draw the pants section

▶ Follow the line of the body from the hips to below the knees to draw the outline of the pants, the line of the waistband, creases at the knees and the turn-ups at the hems.

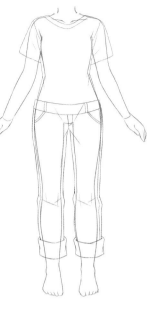

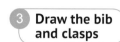

3 Draw the bib and clasps

◀ Draw the bib from the top of the chest to the hips and add the line of the pocket. Draw the straps on both shoulders and the clasps between the strap and bib sections.

4 Draw the stitching on the denim

◀ Bring out the texture of the denim by drawing stitching on the shoulder straps, bib, pocket and pants section. Add a vertical line of stitching in the center of the bib too.

5 Draw the outline of the garment and add wrinkles

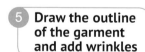

▶ Draw wrinkles in the stomach part of the bib and at the knees. Last, add shadow at the sides of the T-shirt, around the hip section of the bib and on the inner thighs, knees and hems to complete the drawing.

Example of a rear view

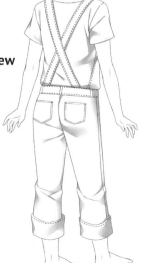

▶ Draw the shoulder straps to cross in an X shape to reach hip level on the pants section of the denim overalls. Draw in shadow on the side of the T-shirt, knees and hems as for the front view, also adding it under the buttocks.

Drawing denim overalls with one strap down (front view)

1 Draw the cut-and-sewn layer to be worn underneath the denim overalls

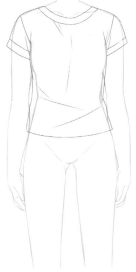

▲ Block-in the entire figure and draw the cut and sewn onto the upper body. As the bib will hang to one side and reveal the cut and sewn, draw in the wrinkles at the top of the chest and around the hips.

2 Draw the pants section onto the lower body

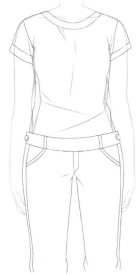

▲ Use the position of the hips as a marker for drawing in the pants on the lower body, following the same process as on Page 89. Draw the belt loops around the hips, the pockets and the seam lines on the sides that join the front and back panels.

3 Draw the folded-over bib

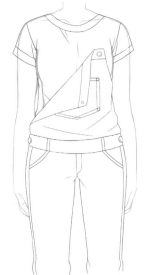

▲ Draw the button that clips into the clasp on the left side of the chest (the side on which the strap is fastened). Next to that, draw the bib so that it hangs down in front.

4 Draw the shoulder strap and clasp

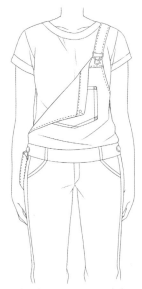

▲ Draw the shoulder strap and clasp on the left shoulder and add stitching to the strap and bib. Draw the strap from the right shoulder hanging down, starting from the position of the button on the right hip.

5 Completion

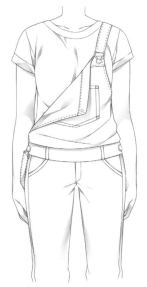

▲ Draw wrinkles onto the cut and sewn and bib and add shadow at the elbows and so on to complete the illustration. Add fine, dark shadow to the folded-over section of the bib to convey the look of wrinkles in the fold.

Example of a rear view

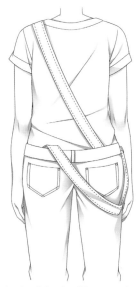

▲ As the right shoulder strap that has been removed from the bib is attached to the button at the hips, the key point to drawing it is to show it hanging from the hips.

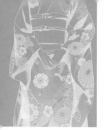

Kimonos

Starting with the long-sleeved furisode, there are various types of kimonos and traditional Japanese robes featuring different shapes and fabric patterns.

Structure of a kimono

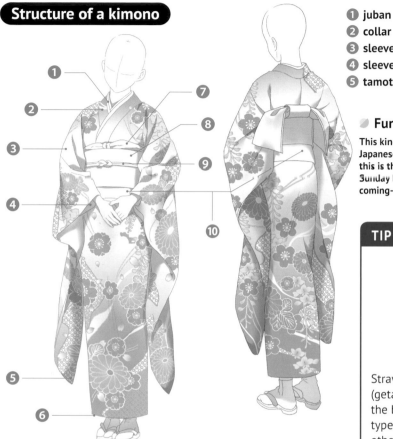

1. juban (undershirt)
2. collar
3. sleeve
4. sleeve opening
5. tamoto (sleeve bag)
6. hem
7. obi-age (bustle)
8. obi (sash)
9. obi-jime (obi clasp)
10. ohashori (surplus fabric fold)

◢ Furisode

This kind of kimono has long sleeve bags. Of all the Japanese traditional dress worn by unmarried women, this is the most formal ceremonial style. Akin to Sunday best, it is worn mainly by young women for coming-of-age ceremonies, at weddings and so on.

> **TIP** **Footwear to match kimonos**
>
>
>
> Straw sandals (zori) and wooden clogs (geta) are worn with socks divided at the big toe (tabi). Zori come in various types, some with low, flat soles, and others with built-up platforms.

Tying an obi

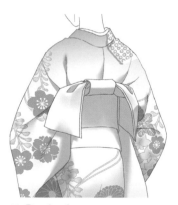

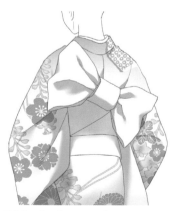

◢ Fat sparrow knot

This method of tying an obi results in "wings" at right and left and a drum-shaped knot at the center, calling to mind a sparrow leaving its nest. The drum-shaped knot is a way of tying the obi so that it is puffed out like the barrel of a drum.

◢ Bunko knot

The ends of the sash spread out airily before trailing down in this style of knot. It creates a sweet, modest and neat impression, and as it is a simple means of fastening the obi, it is also frequently used with yukatas.

◢ Vertical arrow knot

This way of tying the obi resembles a butterfly knot on a diagonal angle. It is usual for the end of the sash to be pointing toward the top left. Its flamboyant air leads it to be used frequently at celebrations such as the coming-of-age ceremony.

 # Drawing a furisode (front view)

1 Block-in the entire figure

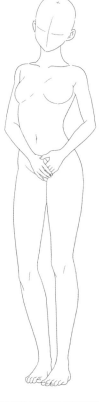

▶ Block-in the entire figure down to the feet. The base of the neck, chest, hips, wrists and ankles are the main points of reference for drawing the furisode.

2 Draw the obi and collar

▶▼ Draw the lines for the obi-age, obi and ohashori between the chest and hips. These garments create a thickness so draw the obi to sit a distance away from the body. From around the neck down to the chest, draw the furisode's collar and the collar of the juban (underwear worn beneath the furisode) along with the armholes and the line of the chest.

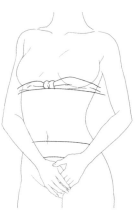

3 Draw the sleeves and the lower part of the kimono

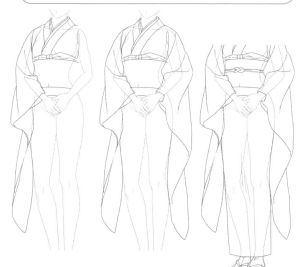

▲ Draw one sleeve at a time from the shoulder down along the arm. Draw the outer edge of the sleeves one arm width out from the arms. Draw the sleeve bags to trail down to the ground in wavy, undulating lines. Last, draw the lower part of the kimono from the ohashori down to the ankles.

4 Completion

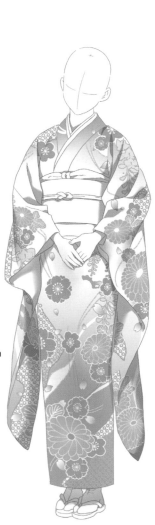

▶ Shadows form mainly beneath the obi, in the creases of the sleeves, the trailing sections of the sleeves and around the ankles. Apply a floral pattern and texture to the furisode to complete the drawing.

✏️ Drawing a furisode (rear view)

① Block-in the entire figure

▶ The key point to drawing the kimono from behind is the line from the hips to the buttocks. Use smooth, curved lines from the back to the hips and buttocks when blocking-in the rear view of the figure.

② Draw the obi onto the back

◀ Draw in the lines for the obi and ohashori at hip position. Above this, draw the drum-shaped knot of the obi and the wing sections to its left and right. Fan the wings out like that of a butterfly and draw two wrinkles from the edge of the knot into each wing.

③ Draw the back body section, sleeves and lower section of the kimono

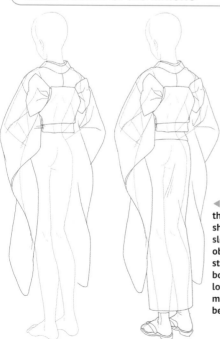

◀ Draw the collar around the neck and the outline of the sleeves from the shoulders to the elbows. The join of the sleeves to the body is hidden under the obi, so draw the insides of the sleeves starting from beneath the wings of the bow. Use a soft, supple line to draw the lower part of the kimono, keeping in mind the roundness of the buttocks beneath the ohashori.

④ Completion

▶ Add shadow on the underside of the obi, the inner edges of the sleeves and around the ankles and apply the texture for the floral pattern to the furisode overall. Don't simply apply the floral pattern the same way all over, but increase the motifs toward the hem for visual balance.

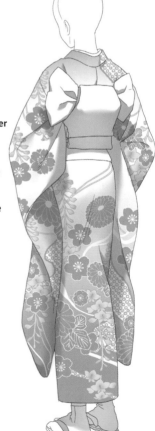

 # Drawing a hakama/formal Japanese skirt (front view)

1 Block-in the entire figure

▶ A hakama is a skirt worn over the kimono, covering it from the hips down. It is often worn with a furisode or its shorter-sleeved variant, the kofurisode, at graduation ceremonies. Women wear it to fasten below the chest, so choose a pose that allows the shape of the chest or hips to work as a reference when drawing.

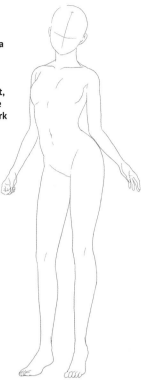

2 Draw the front section of the kimono and the sash of the hakama

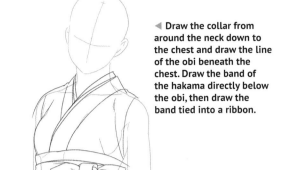

◀ Draw the collar from around the neck down to the chest and draw the line of the obi beneath the chest. Draw the band of the hakama directly below the obi, then draw the band tied into a ribbon.

3 Draw the kimono sleeves and the hakama

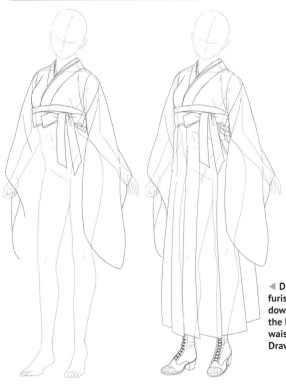

◀ Draw the sleeves of the furisode from both shoulders down to the wrists. Next, draw the long pleats from the waistband down to the ankles. Draw in boots for a retro effect.

4 Completion

▶ Add shadow to the inner edges of the sleeves, the hakama pleats and the feet and apply floral texture to the furisode. Apply gradation to the hakama so that the color darkens toward the hem.

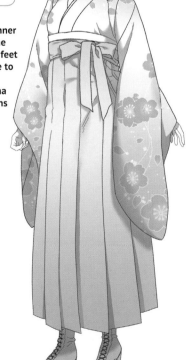

Yukatas

A traditional Japanese garment that can be worn after bathing or for sleepwear. These days it's worn at summer festivals and other events as simple but traditional form of dress.

Structure of a yukata

1 collar
2 obi
3 sleeve
4 ohashori
5 hem
6 sleeve opening
7 obi bow

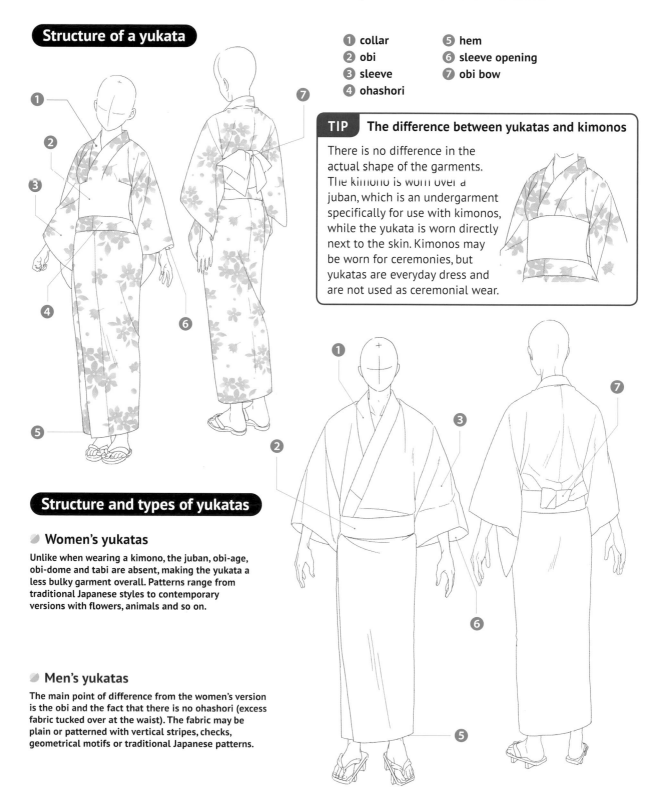

TIP **The difference between yukatas and kimonos**

There is no difference in the actual shape of the garments. The kimono is worn over a juban, which is an undergarment specifically for use with kimonos, while the yukata is worn directly next to the skin. Kimonos may be worn for ceremonies, but yukatas are everyday dress and are not used as ceremonial wear.

Structure and types of yukatas

Women's yukatas

Unlike when wearing a kimono, the juban, obi-age, obi-dome and tabi are absent, making the yukata a less bulky garment overall. Patterns range from traditional Japanese styles to contemporary versions with flowers, animals and so on.

Men's yukatas

The main point of difference from the women's version is the obi and the fact that there is no ohashori (excess fabric tucked over at the waist). The fabric may be plain or patterned with vertical stripes, checks, geometrical motifs or traditional Japanese patterns.

Drawing a woman's yukata (front view)

① Block-in the entire figure

▶ Block-in the entire figure. For a women's yukata, the chest, hips, wrists and ankles are points of reference.

② Draw the collar, front section, obi and sleeves

▶ ▲ Draw the lines for the obi below the chest and at the top of the hips and draw the collar in around the neck and down to the chest. Draw the outline for the sleeves from the shoulders down to the wrists and add in the wrinkles from the sleeve openings up to under the arms.

③ Draw the lower body part of the front panel

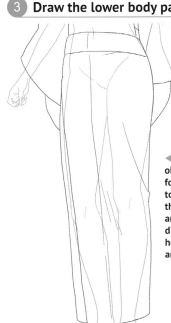

◀ Draw the line for the ohashori below the obi and follow the line of the legs to draw the lower part of the yukata down to the ankles. Add in several diagonal wrinkles at knee height to create dimension around the legs.

④ Completion

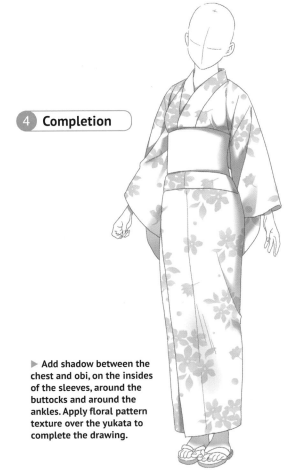

▶ Add shadow between the chest and obi, on the insides of the sleeves, around the buttocks and around the ankles. Apply floral pattern texture over the yukata to complete the drawing.

Drawing a man's yukata (front view)

1 Block-in the entire figure

▶ Block-in the entire figure including the feet. For a man's yukata, the shoulders, hips, wrists and ankles are points of reference.

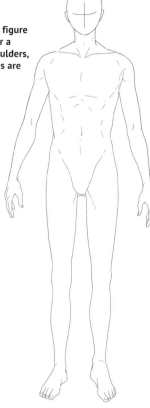

2 Draw the collar, front panel, obi and sleeves

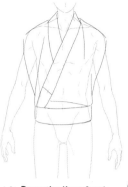

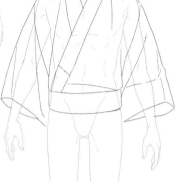

▲▶ Draw the lines for the obi between the chest and crotch and the lines for the collar from around the neck and extending down toward the obi. For the armholes, draw bold lines down to the hips and draw the sleeves wide and roomy enough to fit in three arm widths.

3 Draw the lower body part of the front panel

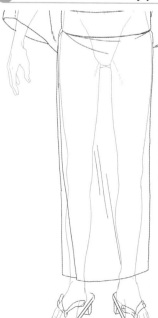

◀ Draw lines from the obi down to the ankles for the lower part of the yukata. From the right hip down to the hem, draw a line to show where the fabric laps over the front. Add several wrinkles in the center to evoke the soft texture of the yukata.

4 Completion

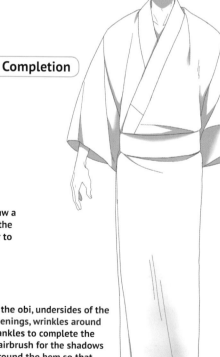

▶ Add shadow to the obi, undersides of the sleeves, sleeve openings, wrinkles around the hem and the ankles to complete the drawing. Use the airbrush for the shadows on the wrinkles around the hem so that they don't turn out too dark.

 # Drawing a man or woman's yukata (rear view)

1 Block-in the entire female figure

◄ As for drawing the kimono, when drawing the female figure from behind use smooth curves to block-in the line of the back, hips and buttocks.

2 Draw the bow in the obi, the ohashori and sleeves

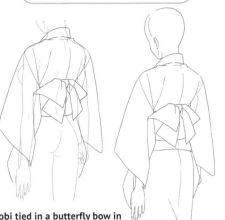

▶ ▲ Position the obi tied in a butterfly bow in the space between the hips and shoulder blades. Draw the outline of the collar around the neck, follow the line from the shoulders down the arms to draw the outline of the upper-body section and draw the line for the sleeves from the armholes down to the wrists. For the section from the hips down, add the line for the ohashori below the obi and draw in the lower part of the yukata, following the line of the legs from the buttocks down.

3 Completion

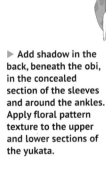

▶ Add shadow in the back, beneath the obi, in the concealed section of the sleeves and around the ankles. Apply floral pattern texture to the upper and lower sections of the yukata.

1 Block-in the entire male figure

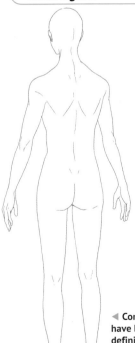

◄ Compared with women, men have broader shoulders as a defining feature. Block-in the entire figure to give the appearance of a broad back.

2 Draw the bow of the obi, the back section and sleeves

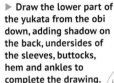

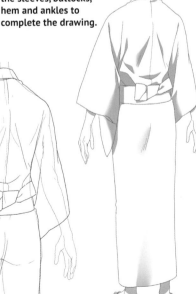

▶ ▲ Draw the bow of the obi at hip height. It is usual to tie obi on male yukatas using a "mouth of a shell" knot. As for drawing a female figure, draw the collar around the neck, the outline of the upper body from the shoulders to the wrists and the line expressing the roomy sleeves from the armholes down.

3 Completion

▶ Draw the lower part of the yukata from the obi down, adding shadow on the back, undersides of the sleeves, buttocks, hem and ankles to complete the drawing.

Underwear and Underlayers

Tights and Leggings Negligees

Women's Underwear Men's Underwear

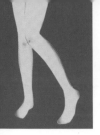

Tights and Leggings

These garments cover the area from the hips down and are mainly for women. Tights cover the toes, while short leggings go to above the knees.

Structure of tights and leggings

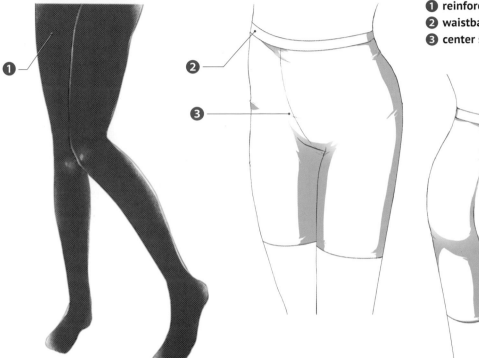

1 reinforced thigh
2 waistband
3 center seam

Types of tights and leggings

Leggings

This type can be any length from below the knees to the ankles. They are mainly worn to provide an extra layer of clothing.

Leggings work with all kinds of shoes from heels and pumps to sandals.

As stirrup pants make the legs appear slimmer, they can lend an even lighter, airier look to a female character.

Short pants and pumps or sandals highlight a character's legs.

Leggings are versatile and complement various outfits, making them suitable for characters ranging from laidback to active types. Change things up by pairing them with different styles of footwear.

Stirrup pants

These leggings cover the foot area, but only around the arch, leaving the front of the foot and toes and the heel exposed.

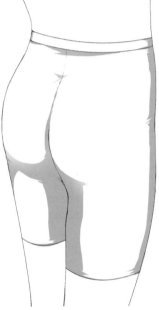

✎ Drawing different thread thicknesses (denier) in tights

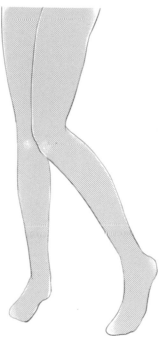

● 20 Denier

Items below 30 Denier are classified as stockings. They are extremely sheer overall, especially in areas where bone protrudes or fleshy areas.

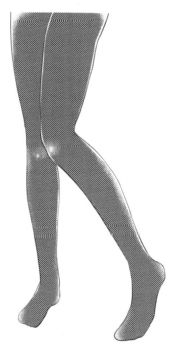

● 40 Denier

These appear quite sheer. Key to capturing this look is that fleshy areas appear a whitish color on the surface.

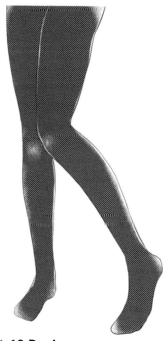

● 60 Denier

There is only a hint of sheerness to these. As they appear to firm up the legs, they create an attractive silhouette, making for a neat, trim look.

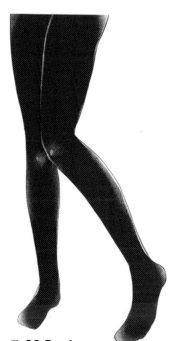

● 80 Denier

As these are nearly opaque, only a faint sheerness on the kneecaps is visible, depending on the pose and composition of the drawing.

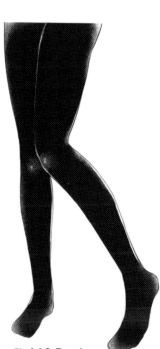

● 110 Denier

There is hardly any sheerness to these. Worn mainly to protect against the cold, they create a slightly unrefined silhouette.

TIP | **Where tights tend to be sheer**

The fabric of the tights is stretched and becomes thinner at the tips of the knees and toes, heels and around the calves. Making the points white where the fabric has thinned out gives the effect of skin showing through.

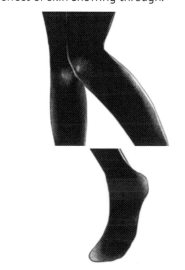

Women's Underwear (Bras)

Beyond their functional roles, with their various styles and embellishments, bras can strike a range of fashion notes for your female characters.

Structure of a bra

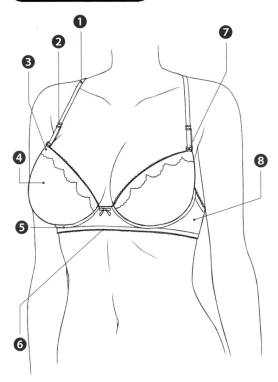

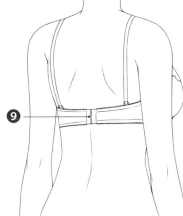

1. strap
2. adjustor
3. embellishment
4. cup
5. underwire
6. under band
7. hook (for the strap)
8. side band
9. hook and eye (for the back)

TIP Showing the back

The shoulder blades are crucial for bringing out dimension in the back when a character is wearing a bra. Block in the center line of the body at the rough sketch stage so that it's easy to draw the shoulder blades and bra hooks in the right position.

Bra types and decorations

¾-cup bra

The cup of this type has ¼ cut away on a diagonal angle. It pushes the breasts together and up, making for an attractive cleavage.

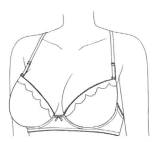

Half-cup (demi-cup) bra

This type is cut horizontally halfway down the cups. Many have removable straps and create a rounded bust.

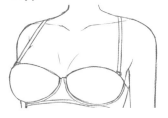

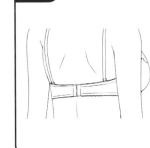

Lace decoration

Cups of this type are trimmed with lace in a small floral pattern. Make the edges of the cups and the underband look like they are trimmed with petals for a sweet effect.

Frill decoration

The edges of the cups and the underband are frilled on this type. On the cup sections, add faint wrinkles like those in light fabric for an attractive look.

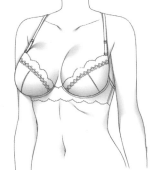

✍ Drawing a ¾-cup bra (front view)

1 Block-in the body and chest

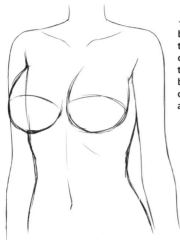

◀ Start by drawing the body without the chest, then block in the chest over the top. Visualize the roundness of the breasts to block-in lines over the top of the bust and clean up the shape.

2 Draw the bra cups and wire

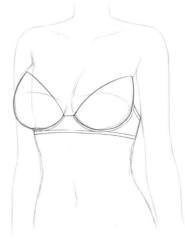

◀ Follow the line of the chest, drawing in ¾ cups and the underwire and underband that support them.

3 Add in decoration and straps

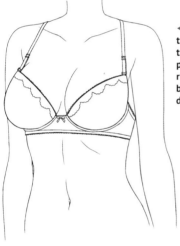

◀ Follow the line of the body to draw in the straps, adjustors, patterns on the cups, ribbon on the under band and other decorations.

4 Completion

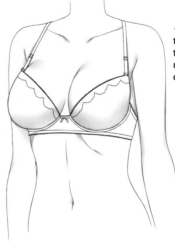

◀ Add graduated shadow to the chest, undersides of the cups, underarms, ribcage and collarbone to complete the drawing.

◗ Example of rear view

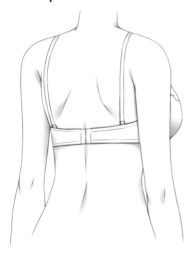

TIP Bust size and cup shape

Half-cups give the bust an attractive appearance, but large breasts spill out over the top. Of the various cup types, ¾ cups are popular, but characters with large breasts look best in full cups.

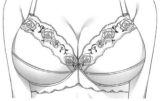

Examples of bras

½-cup

Firm cups and wire work to lift the bust from below. As considerable flesh is exposed, it's easy to highlight the swelling of the breasts.

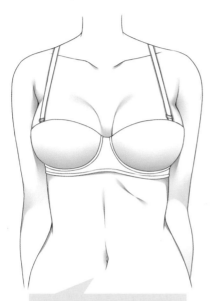

This type works well with tops with low necklines where the chest is visible, such as V-necks.

Full cup

This type covers nearly the entire bust. It's not intended to boost the bust size, but rather to enhance the breasts' natural roundness.

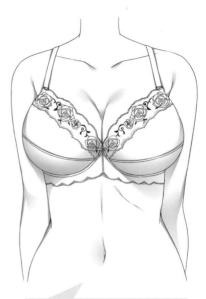

With this type of bra, even large-breasted characters can be given an attractive body line.

Front-fastening type

The hook is at the front on this type of bra. As it brings the flesh from the sides and back to the center of the bust, it creates a prominent cleavage.

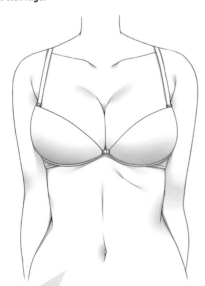

As this type boosts the bust size, it can be used to render cleavage and fullness on even small-chested characters.

Sports bra

This type minimizes breast movement and bounce during exercise. Similar to a tank top in form, it fits close to the body and keeps the bust in position even when moving.

On a slender, in-shape female character, this type highlights health and fitness.

Women's Underwear

While panties and other forms of women's underwear all share a similar structure, differences in embellishment and fabric type make for a wealth of variety.

Structure of panties

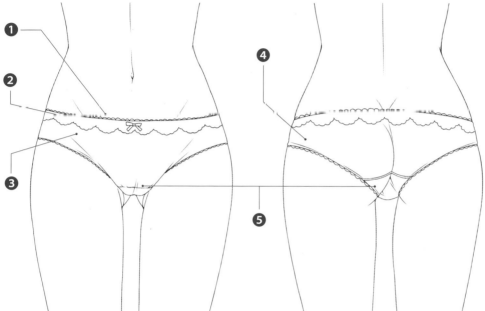

1 waist
2 decoration
3 front (front panel)
4 back (back panel)
5 crotch

Examples of panty motifs

Floral embroidery

This adorable design has small flowers embroidered across the front. There are also floral motifs decorating the waist.

As this design is not too strongly individual, it can be used for a wide range of female characters from about ten to twenty years old.

Ribbon frill

These feminine panties have a small ribbon decoration on the front and frills along the waist. There are smaller frills around the legs.

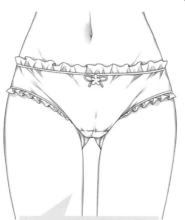

As they create an extremely girlish impression, these would suit a character in her teens or a fashion-conscious character.

Front frill

Detailed in design, this type has seams in the front with a frill in the center and embellishment along the seams.

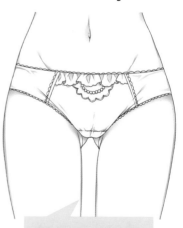

This type would look fine even on an older laid-back female character.

Drawing panties (front view)

1 Draw in the rough shape of the panties

▶ Block-in the lower body and use the position of the waist and legs as a guide for drawing in the outline of the panties.

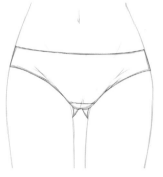

2 Draw embellishments

▶ Follow the line of the waist to draw ribbons, lace or other decoration on the front. Draw creases in around the crotch.

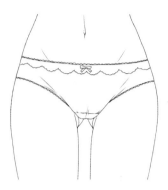

3 Completion

▶ Add shadow to the part of the buttocks visible from the front. Last, add shadow to the decoration and creases to complete the drawing.

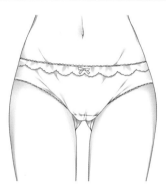

Example of a rear view

▶ The buttocks are a fleshy part of the body so the fabric of the panties sags between the buttocks, readily forming wrinkles.

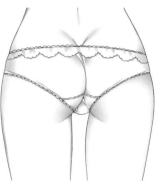

Examples of panties

Low-rise panties

These were designed so they would not be visible when worn with low-rise bottoms. They reveal the line of the groin.

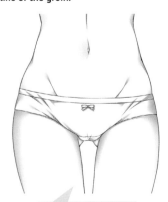

Often worn with low-rise jeans, for a peekaboo effect.

Boxer shorts

Similar to men's boxer briefs in form, these have a low rise.

These create a neat and trim impression and suit sporty clothing.

Thong

This type is cut to reveal both buttock cheeks. As there is not much fabric, it is sandwiched between the buttocks.

The thong is worn when wearing tight pants or other garments that fit closely to the body.

Negligees

This underlayer for women is similar to a dress in shape. It has an airy silhouette and a short hemline and is often highly decorative.

Structure of a negligee

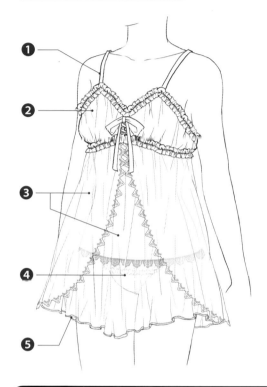

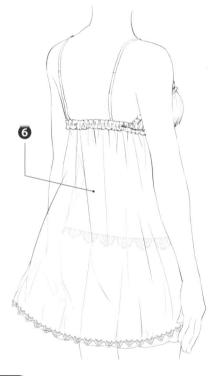

❶ strap
❷ bust cup
❸ front (front panel)
❹ panties
❺ hem
❻ back (back panel)

Parts where wrinkles form in a negligee

🔘 Fabric around the stomach

The lace fabric in the front forms vertical wrinkles from the underband of the bust down to the hem.

Negligees are often part of a set that includes panties.

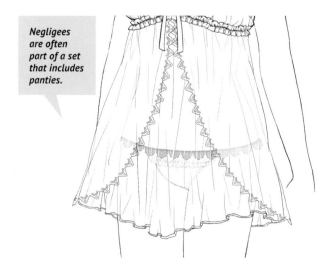

🔘 Decorative frill

As the fabric in the decorative frill around the bust is bunched closely together, many fine wrinkles form.

Wrinkles extend from the seam line in the center out to the edge.

🔘 Fabric in the bust

Soft fabrics such as silk are used in the bust cup section, meaning wrinkles form easily.

Wrinkles form vertically from where the frills are attached above and below.

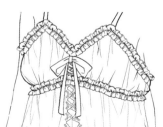

 # Drawing a negligee (front view, rear view)

1 Draw the outline of the garment, pivoting out from the line of the chest

▶ Follow the form of the chest to draw the bust cup sections. Draw an A-line silhouette from beneath the bust cups to cover the stomach area and form the front panel.

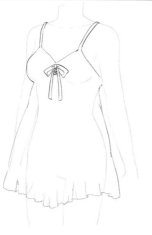

2 Draw the frills around the bust

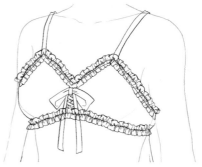

▲ Draw a line around the bust cups and use it as a guide to fill in frills above and below.

3 Draw lace on the front

▶ From just below the ribbon decoration on the chest, draw lines extending to the left and right of the hem and add lace along the lines.

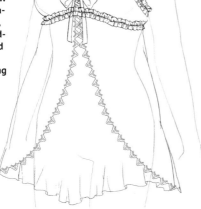

4 Add wrinkles in the bust cups and down the front

▶ Make the lines for the wrinkles faint in the front section to bring out the look of sheer fabric. Use darker lines in the fabric on the bust cups so the fabric does not look sheer.

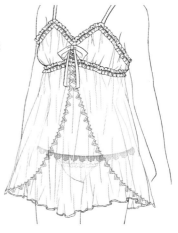

5 Completion

▶ Add shadow in the frills, bust cups and the fabric at the front to complete the drawing.

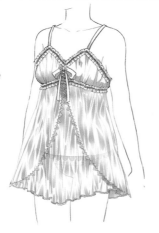

TIP Differentiating shadows

Use plenty of gradation in the front section to form whitish, shining areas, creating the look of softly sheer texture. In the bust section, add dimensional shadow to contrast with the front section.

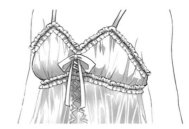

1 **Use the line of the back to draw the outline of the garment**

▲ Draw the upper edge of the garment back at the height of the bust underband. From the upper edge down, draw the outline in an A-line shape.

2 **Add in embellishments and creases**

▲ Draw frills along the underband and add vertical wrinkles in the fabric at the back.

3 **Add shadow to complete**

▲ Add shadow in the bust cup area, the bottom of the straps, in the frills and in the fabric at the back to complete the drawing.

✎ Key points of organdy fabric

◗ Overall

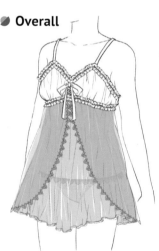

▲ When adding color to organdy, separate each layer and decrease the opacity to easily bring out the sheer look of the fabric.

▲ Applying texture such as the one above is another method.

◗ Around the stomach

This area is not sheer.

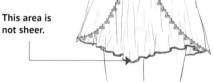

second layer

first layer

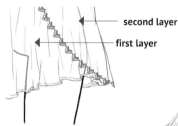

▲ Make the line of the body fainter the more layers of fabric are covering it.

◗ Chest area

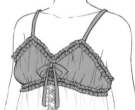

◀ The fabric is not sheer around the chest area so make the lines in the drawing slightly thicker.

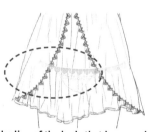

▲ For the line of the body that is concealed by clothing, rather than erasing it, decrease the opacity or use a fainter color to bring out the sheer look. Otherwise, erase the lines of the body that are covered by wrinkles in the fabric.

◀ Use gradation for some of the shadow to increase the appearance of transparency.

◗ Embellishment

▲ For the frill, use thicker lines than for lace, as this fabric is regular, not sheer.

▲ The fabric is sheer, so use fine lines in the drawing.

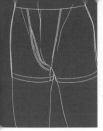

Men's Underwear

These undergarments cover the lower part of the male body. Divided by shape, there are three main types, with boxer briefs and trunks being the most commonly worn among adult males.

Structure of boxer briefs

1 waist
2 front (front panel)
3 front opening
4 back (back panel)

Types of men's underwear

🌰 Briefs

There is no inseam, and the underwear fits closely to the body. Some are patterned, but their clean appearance makes the white version the standard.

🌰 Boxer briefs

These have a short inseam and are made from sturdy stretch fabric. Many have logos on the elastic waistband.

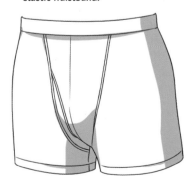

🌰 Trunks

This type has a short inseam but rather than fitting close to the body, they are loose and roomy. All-over colors and bright prints are the norm.

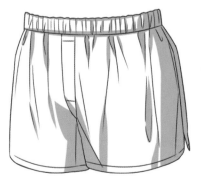

✐ Drawing boxer briefs (front view)

① Block-in the lower body and draw the outline of the briefs

◀ Block-in the lower body and draw the outline of the briefs around the line of the hips and the inner parts of the thighs. These undergarments fit snugly on the body, so follow the roundness of the body when drawing them.

② Draw the line of the elastic waistband

◀ Slightly below the outline of the waist, draw the line to indicate the elastic waistband.

③ Draw the fabric in the front opening

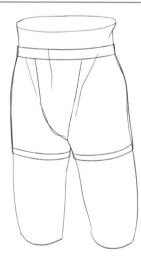

◀ At the center front, draw in the line of the front opening. Add in an extra line along the hem of each leg to indicate the elastic.

④ Create double lines for the seams and to bring out dimension

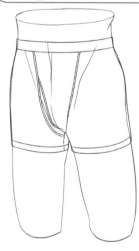

◀ Use double lines for the front seams to create the look of sturdy, reinforced stitching. Add two diagonal lines in the center to complete the front opening.

⑤ Completion

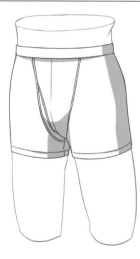

◀ Add shadow on the inseam, inside the thighs and down the back. Use light shadow beneath the elastic waistband to bring out dimension.

● Example of rear view

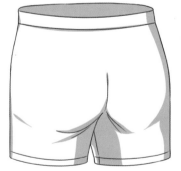

◀ Most men's buttocks are not as large as women's, so make sure that the line from the hips down the legs does not curve out. Shadows form on the inner sides of the thighs and beneath the buttocks.

✏️ Drawing trunks (front view)

1 Refer to the blocking-in to draw the loose fabric

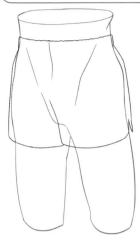

◀ The fabric in trunks hangs loosely, so create a slight gap between the line of the body and the trunks to indicate this. The line at the waist is not straight, but irregular due to the bunching of the fabric, so make sure to draw this. There are joins in the fabric at the bottoms of the side sections.

2 Draw the lines for the elastic waistband and front opening

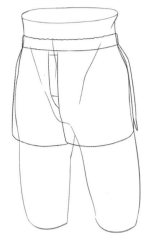

◀ Slightly below the line for the waist, draw in a line to indicate the elastic waistband. Draw the opening for the front in the center of the trunks.

3 Draw creases on the stretched elastic waistband

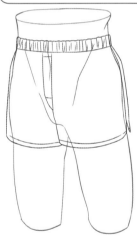

◀ Add lots of vertical lines close together around the elastic waistband to show how the fabric has gathered to form wrinkles. Make two lines around the hems to bring out dimension in the fabric.

4 Add wrinkles in the fabric at the front

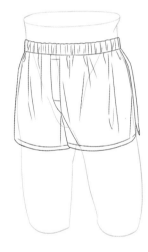

◀ Draw random vertical lines across the front to indicate wrinkles. The fabric tends to form hollows close to the elastic waistband, so draw several lots of two close lines that together form one set of wrinkles.

5 Completion

◀ Add shadow to the creases in the inseam, back section and so on. Adding shadow in the center of the two close lines from Step 4 enhances the look of the hollows in the fabric.

🌑 Example of a rear view

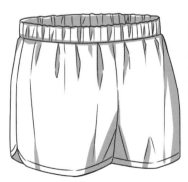

◀ Add shadow in the hollows of the fabric in the same way as for the front. Bring out dimension by adding shadow in the elastic waistband too.

Shoes and Bags

Shoes

Handbags

Shoulder Bags

Travel Bags

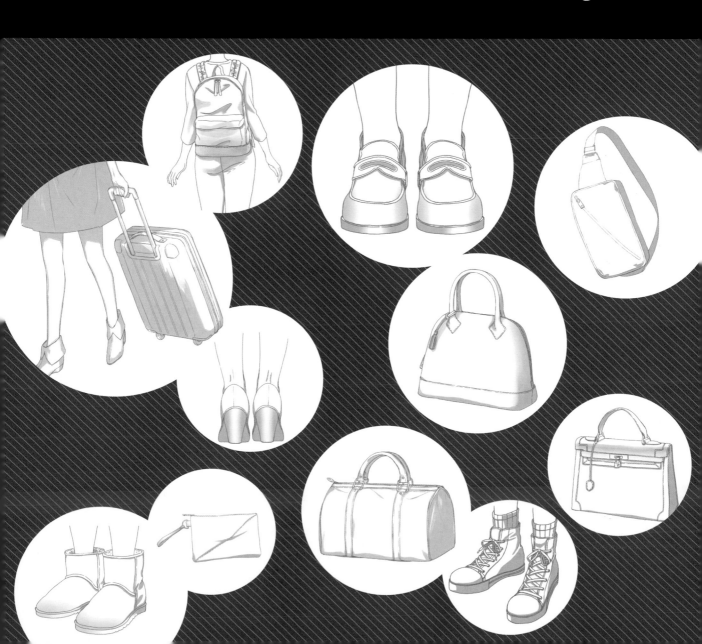

Shoes

For some, an outfit is not complete until it's finished off with the right pair of shoes. But which style is right, with so many options? Pumps, boots or sneakers? You choose!

Structure of shoes

1 opening
2 tongue
3 shoelace
4 eyelet
5 upper
6 toe
7 sole (outsole)
8 heel

Types of shoes

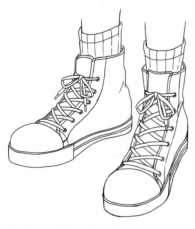

Casual fashion footwear

This type is worn for going out during free time. Casual sneakers are a typical choice but there is no clear-cut rule, so any shoe is fine.

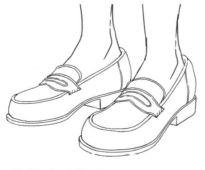

Student footwear

These shoes are worn when commuting to school and within school grounds. It is usual to wear loafers and other outdoor shoes when commuting and change to soft-soled shoes, sneakers and so on for indoor use when at school.

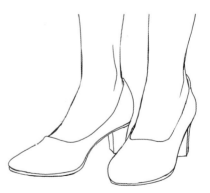

Business footwear

These are for wear at work and tend to be more formal, with leather shoes for men and pumps for women being common.

Drawing loafers (front view)

1 Use the blocking-in for the feet as a reference to draw the upper part of the shoes

▶ Draw the outline of the openings and the upper section of the shoes to start. Position the saddle section a bit above the join of the big toe.

2 Draw a line from the tips of the toes to the heels

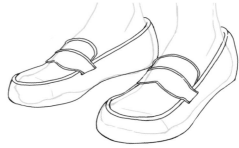

▲ Shoes are made to envelop the feet, so draw the outline slightly beyond the blocking-in of the feet to cover the whole of the feet, from the tips of the toes to the heels. Add another line around the opening and the uppers to indicate thickness.

3 Draw the soles and heels

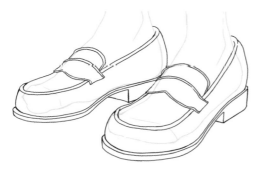

▲ Draw a line along the soles to indicate the thickness of the soles and add heels.

4 Completion

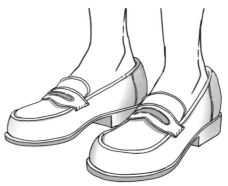

▲ Add shadow in the back of the shoe and the heels, the front edges of the shoes and on the soles. Draw the decorative section and shadow on the saddles to bring out dimension.

◢ View from front

▶ The fronts of the feet are in the foreground so the front sections of the shoes and the soles are larger. Darken the heel section with shadow to bring out depth from front to back.

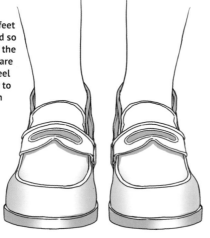

◢ View from behind

▶ Only the section covering the back of the foot and the heel section is visible. Enhance the overall look by adding in the finishing around the opening and the seam line in the back.

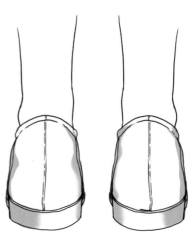

 # Drawing high-top sneakers (front view)

1 Use the blocking-in for the feet as a reference to draw around the feet

▶ Draw a line to cover the feet from the tips of the toes to the ankles. Leave a fair gap around the ankles and at the tips of the toes. Round out and raise the line around the tips of the toes.

2 Draw in the lines for the uppers and the soles

▶ In the centers of the feet, draw the lines to form the sections from the uppers to the tongues. Draw curved lines at the ends of the feet to form the rounded cup sections. Add in lines on the bottoms of the feet to form the thick soles.

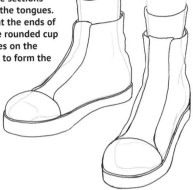

3 Add eyelets and creases

▶ Add details such as the eyelets that will hold the shoelaces, the creases around the ankles, horizontal lines along the outsides of the soles, the socks and so on, cleaning up the drawing as you go.

4 Completion

▶ Draw the shoelaces in so they cross over alternately and add shadow. Bring out dimension by adding shadow to the creases around the ankles, the heels, the undersides of the laces and the soles.

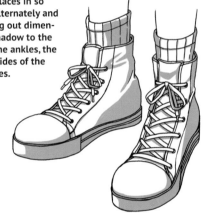

◉ View from front

▶ It may appear complicated, but without the laces, the sneakers have as simple an appearance as in Step 3. Draw in the fabric around the ankles, the parts at the ends of the feet and the soles, finishing by drawing in the laces.

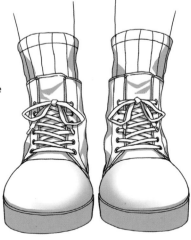

◉ View from behind

▶ Sneakers that cover the ankles are made from soft material so creases form between the ankles and heels. Add shadow to the creases and bases of the shoes to bring out dimension.

✏ **Drawing pumps (front view)**

1 Draw a line from the tips of the toes to the heels

▶ Block-in the feet with the heels raised and draw a line that surrounds the tips of the toes and up around the heels. The opening for the foot is large for pumps, so draw it to start from around the joint of the big toe. Extend the tip of the toe to create an acute angle, working with the image of a rounded triangle in mind.

2 Draw the soles and heels

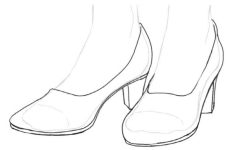

▶ The soles of pumps are not very thick, so draw in the soles as if tracing along the undersides of the feet. Heels are different from loafers in that they are flatter and closer to the ground.

3 Completion

▶ Add shadow to the undersides of the pumps, the heel cups and the heels. The silhouettes of pumps are attractive because of the feet inside them, so add shadow around the anklebone to make the feet and shoes look like a set.

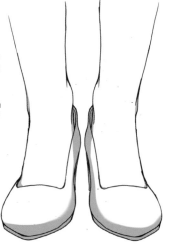

TIP Deciding the angle of the heel

① Decide on the position of the tips of the toes and extend a straight line from the center of the toes along the ground toward the heel.
② Draw a straight line to intersect with the line from 1 in the position in which you want to draw the heel.
③ Draw the heel at line 2 at whatever height you like.

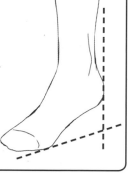

🔘 View from front

▶ As the opening is close to the toes, most of the surface seen is the bare feet. The soles are also thin, so add a narrow band of shadow from the underside of the ends of the shoes to the heels.

🔘 View from behind

▶ From behind, the heels appear large. Add all-over shadow to the soles and use gradation on the heels to show their rounded shape. Draw in the Achilles tendon in the legs for an attractive look.

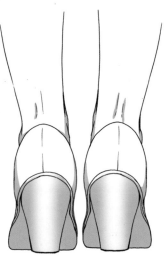

👕 Examples of shoes

🔘 Slip-ons

These shoes have no laces or fastenings and are slid onto the feet. This style is mainly used for sneaker-type footwear. Although they have no laces, there is detail in the creases and hollows that form to match the shape of the tops of the feet.

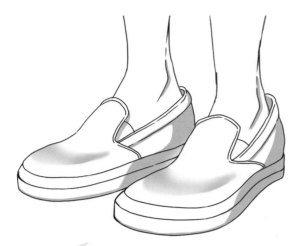

Their simple appearance makes these suitable for both men and women, in particular for relaxed, casual characters.

🔘 Deck shoes

Originally footwear used on the decks of boats, these have a lace running all around the opening to hold the ankle firmly in place. The low-cut opening and the tops of the feet are easily visible.

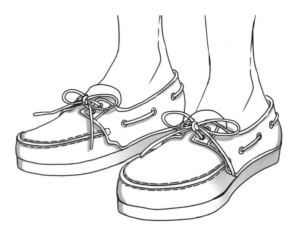

These evoke a strong sense of summer and suit an active, brisk character or one with a youthful personality.

🔘 Mules

These are sandals for women that cover the top of the foot but have no strap around the heel. Many have low heels and thin soles.

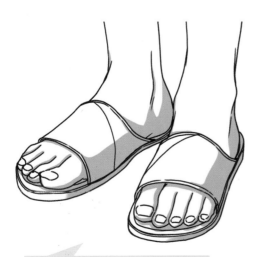

The laid-back feel of these shoes lends them to being worn by characters who tend to wear loose clothing such as voluminous dresses or long skirts.

🔘 High-heeled mules

These are mules with elevated heels. There is a wealth of designs, some with decorative straps across the front of the feet, others with straps around the heel for stability.

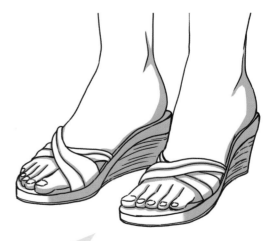

More feminine than mules, these shoes work with any kind of summery apparel regardless of whether it's pants or skirts.

Sheepskin boots

These boots are made of sheepskin or a material that imitates it. The fleecy texture makes for a warm, cute impression. They have large uppers and the openings are also large.

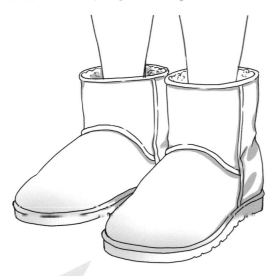

These go well with cute outfits, but are also attractive with slim pants, making them an interesting choice for a woman with a trim figure.

Booties

Elements from pumps feature in these short boots that have heels and cover the feet from the toes to above the ankles. There is a wide range of designs, with many having bows or other decorations to enhance femininity.

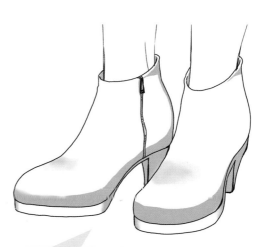

In comparison with long boots, these make the feet look less bulky and more clearly defined, which explains their widespread popularity. They work well with skirts, leggings and other clothing of a length that reveals the feet.

Engineer boots

Belts around the openings allow the size of these boots to be adjusted. Originally for heavy-duty work, they have steel caps in the toes. Add shadow in the upper sections for an even sturdier look.

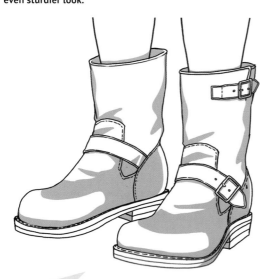

These can be used for rugged male styling, of course, but also work well to bring accents to the feet of cute female characters in skirts, dresses and so on.

Work boots

This is the collective term for any sturdy leather outdoor boot. There are various types, such as the moccasin shape shown in the illustration. Add shadow around the heel to make the leather look slightly crushed and to enhance their rugged appearance.

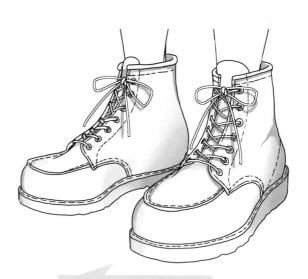

Associated with laborers, these shoes give a rugged or tough look to your character or even inject a hint of wildness.

119

Handbags

Used to carry a wallet and other small personal items, these bags are easy to carry or can be worn with a strap over the shoulders. The amount they hold varies depending on their shape.

Structure of a handbag

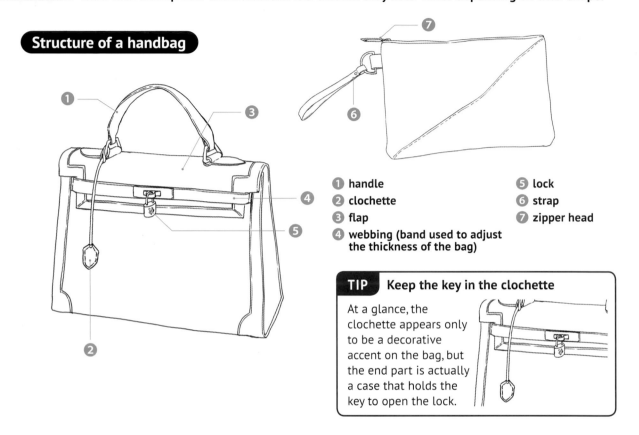

1. handle
2. clochette
3. flap
4. webbing (band used to adjust the thickness of the bag)
5. lock
6. strap
7. zipper head

> **TIP** Keep the key in the clochette
>
> At a glance, the clochette appears only to be a decorative accent on the bag, but the end part is actually a case that holds the key to open the lock.

Types of handbag

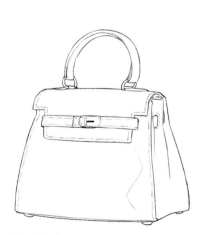

● Kelly bag

Trapezoidal in shape, the gussets taper, making the bag deeper at the bottom and shallower toward the top. There is only one handle.

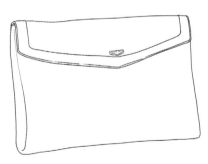

● Envelope bag

As its name suggests, this bag resembles an envelope. It is rectangular in form and creates a stylish impression.

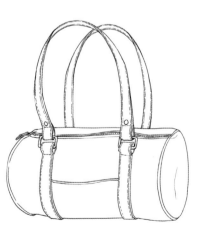

● Barrel bag

Also known as a drum bag, it has a round silhouette and is roomy, so can hold lots of items. It opens and closes with a zipper.

✒ Drawing a Kelly bag

① Draw the base of the bag

▶ With a trapezoid form in mind, draw the base of the bag, adding depth on the sides and a flap on top. Add lines of leather on either side and lines for the webbing over the flap.

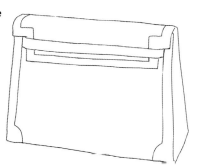

② Draw the handle and key

▶ Draw the handle on the top section and the lock in the center of the webbing. The handle is constructed of the leather that is attached to the body of the bag, metal fixtures and the part held in the hand. Make the lock quite small.

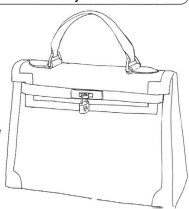

③ Add thickness overall and draw in the strap

▶ Draw in secondary lines alongside the first lines on the sides and edges of the bag to create the look of thickness in the leather. Last, add the clochette hanging from the handle for an elegant, luxurious effect.

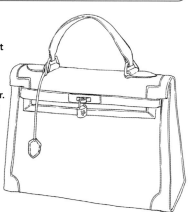

④ Completion

▶ Add shadow on the sides, near the base and on the underside of the handle. Create a light gradation of shadow on the front of the flap to convey the rounding at the top.

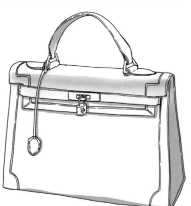

TIP Turned-in or outside seams

The Kelly bag is available either with seams that are turned in and with no stitching visible for a soft finish or with the stitching as a feature on the external edges of the bag to create a sturdy look. If the bag is the sturdier type, make sure to draw the stitches on the corners and so on.

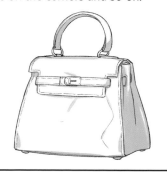

● Holding a handbag

▶ When holding a handbag with the handle over one arm, positioning the hand on that arm in a light fist and bringing it back toward the body makes for an elegant appearance.

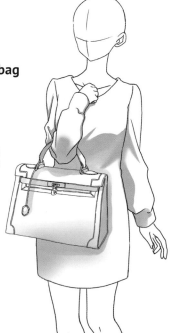

 # Examples of handbags

Clutch bag

This type has no shoulder strap or handle. It is fairly flat, so add a wrinkle in the center and shadow at the base to bring out dimension and make sure it doesn't turn out to look like it is just a rectangle.

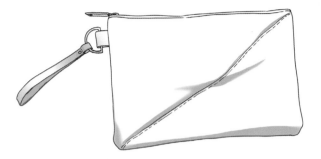

A compelling image can be created simply by a character holding one of these bags in her hand. They suit any outfit, but look more effective when paired with a slim silhouette.

Envelope bag

This bag has a flap attached, so the key points when drawing it are to add in the decoration on the flap, convey the width in the sides and so on. Use the airbrush to add soft shadow around the base.

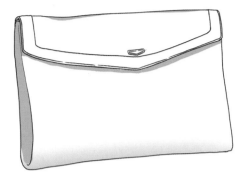

These are similar to clutch bags, but versions with straight flaps can also be carried by men.

Barrel bag

Defined by its cylindrical form. Follow the curved surfaces of the body of the bag to add in the leather bands around it and convey its roundness. Add in details such as the seams at the ends and the double lines of stitching on the leather bands to bring out the thickness of the leather.

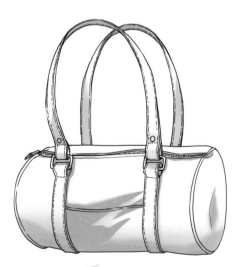

Small versions work as women's bags, or draw larger versions to suit travellers.

Terrine bag

This type of bag has a flat base and a semicircular body section with a large opening. Draw the outline to resemble a rounded trapezoid, then use soft shadow to bring out dimension.

A practical accessory, the terrine bag works for female characters wearing office casual wear or formal attire.

Shoulder Bags

These bags are worn over the shoulder, either hanging straight down or diagonally across the body. As they leave the hands free, they allow a greater range of motion than a handbag.

Structure of a shoulder bag

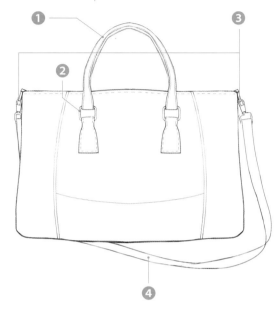

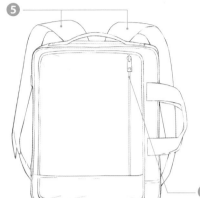

1. handle
2. handle clasp
3. swivel hook
4. shoulder strap (removable)
5. shoulder straps
6. zipped pocket

TIP Wrinkles in the bag

Bags made from light fabrics such as nylon crease easily. Drawing lots of wrinkles conveys that the fabric is thin.

Carrying a shoulder bag

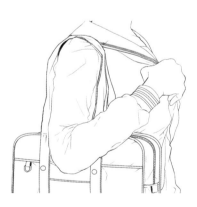

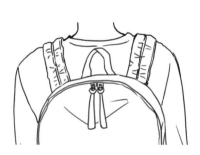

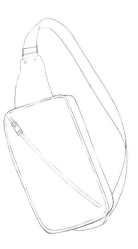

🖌 Over the shoulder

This style of bag has long straps so that it can be worn over the shoulder. If the bag is heavy, the body may lean in the same direction as the shoulder it's being carried on.

🖌 On the back

Both arms are put through the shoulder straps so that the bag sits on the back in this style, with rucksacks being a common example. Any weight in the bag is distributed evenly across both shoulders so the body's balance is not adversely affected.

🖌 Across the body

The shoulder strap is worn fitted around the body in this type of bag. It's a style that is seen in bags worn across the body.

✎ Drawing a rucksack

① Draw the rough outline

▶ Draw the outline of the rucksack in a shape similar to a piece of bread. Draw the depth of the bag in as if drawing the crust around the bread and add in the line across the bag base too.

② Draw the external pocket and shoulder straps

▶ Draw the external pocket, two parallel lines to indicate the zipper section, the shoulder straps and the handle on the top. The key to creating the look of a rucksack is to add in the strap used for adjusting the shoulder straps trailing on the floor.

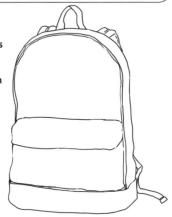

③ Draw seams and zippers

▶ Add in details such as the tabs for the zippers, lines to show the corners of the pockets, hollowed-out sections of the fabric and so on. Rucksacks are often made from nylon fabric, which creases easily, so draw wrinkles in along the sides as well.

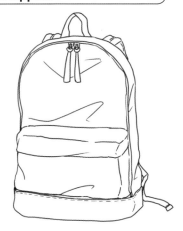

④ Completion

▶ Last, add shadow to complete the drawing, with dark shadow on the sides and in the hollows of the fabric. Add in several faint, broad shadows elsewhere to convey the look of the nylon fabric, which crumples easily.

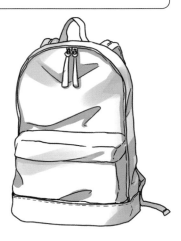

● Carrying a rucksack

▶ The rucksack is worn over the shoulders and largely holds its form. Add shadow in at the base of the bag and along the buttocks.

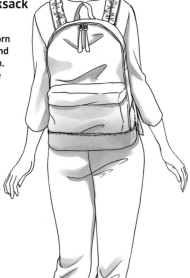

TIP The position of the rucksack on the back

In terms of balance, the best position for the rucksack on the back is at the height of the shoulder blades. If it is higher, it looks too much as if it is sticking up in midair, while drawing it in lower makes for a slovenly appearance.

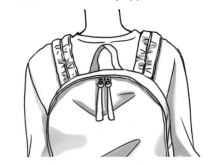

👕 Types of shoulder bags

🍃 Pochette

On this type of bag, the shoulder strap is a narrow width more like a cord. Draw two lines around the edge of the flap to evoke the thickness of the leather. As it is a bag for women, use rounded lines all over for a feminine effect.

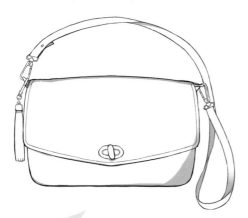

This type of bag works well with any Western clothing, and particularly suits casual outfits.

🍃 Two-way bag

A shoulder strap and handles allow this type of bag to be carried in two different ways. Draw a rounded rectangular form and add the handles to the top section and the shoulder strap on both ends. Making the shoulder strap narrow is an effective device for indicating a woman's bag.

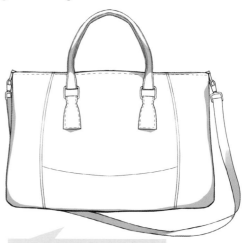

The stable, relaxed silhouette of this bag lends it to being used by women when going out.

🍃 Three-way bag

A handle, shoulder strap and adjustable straps for the shoulders allow this bag to be carried in three different ways. The outline is straight, but the corners are rounded. Draw the pocket and zipper first, followed by the handle and shoulder strap to make achieving a balanced look easier.

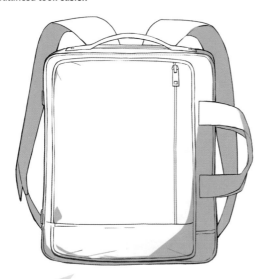

Available in many masculine designs that prioritize functionality, this type of bag looks good on a male character in a suit.

🍃 Cross-body bag

For the main section of the bag, draw a rectangle with rounded corners, then add in the zipper to complete the drawing. As the bag is worn wrapped around the body, draw the shoulder strap on a diagonal angle to sit next to the torso.

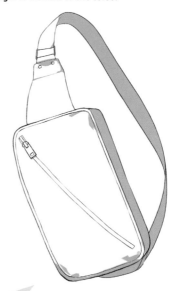

The compact, casual impression that this bag creates makes it a good fit for a male wearing a jacket or suit.

Travel Bags

As the name indicates, these accessories are for characters on the go. Most are large to allow many items to be transported at once.

Structure of a travel bag

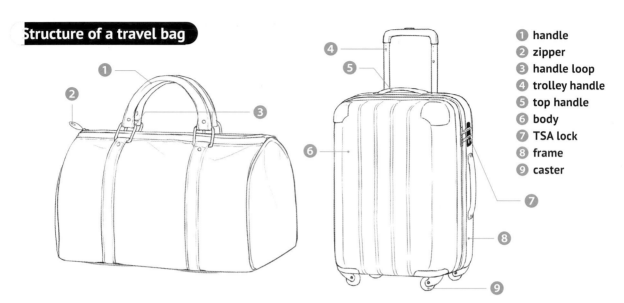

1 handle
2 zipper
3 handle loop
4 trolley handle
5 top handle
6 body
7 TSA lock
8 frame
9 caster

Types and illustrated examples of travel bags

Boston bag

Made from leather, nylon or other fabrics, this type of bag expands only as a consequence of having items placed in it. The base is flat, so it stays upright even when placed on the ground.

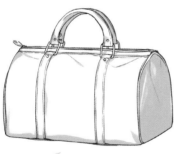

Teamed with jeans or other casual clothing, this bag creates an active look.

Pulling a carry-on bag

When a carry-on bag is being pulled along, it is not perpendicular to the ground but rather sits at a diagonal angle. Additionally, the figure's arm extends straight out, and when gripping the handle, the back of the hand faces toward the back.

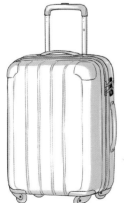

A carry-on bag with a simple design evokes a slightly chic, mature air.

Carry-on bag

The casters on the base make this type of bag easy to transport. It is available in various sizes depending on the number of days away from home. Some types have only two casters, along with numerous other design variations.

The compact, clean look means this type of bag complements a wide range of Western clothing, from suits to casual looks.

School Uniforms

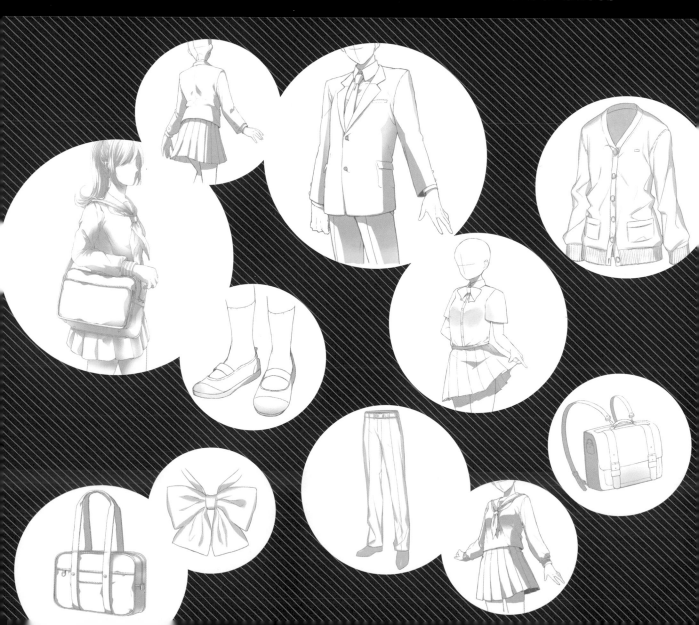

Girls' Uniforms

The finer details differ depending on the school, but the most popular versions for manga characters are sailor suits and uniforms that include a blazer.

Types of girls' uniforms and their structures

🌰 Sailor uniform

Originating from uniforms worn by sailors, the defining feature of this garment is the sailor collar. Generally a triangular scarf is worn around the neck like a tie and fastened with a toggle.

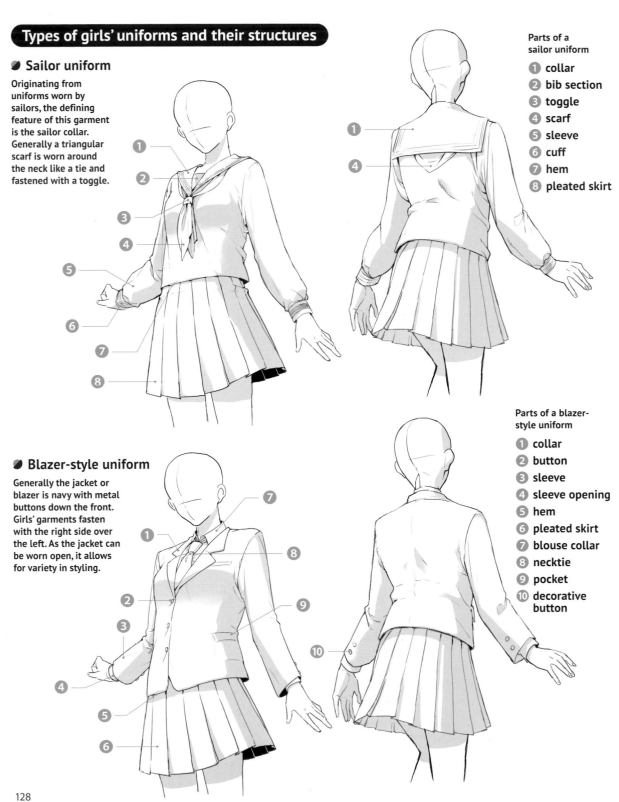

Parts of a sailor uniform

1. collar
2. bib section
3. toggle
4. scarf
5. sleeve
6. cuff
7. hem
8. pleated skirt

🌰 Blazer-style uniform

Generally the jacket or blazer is navy with metal buttons down the front. Girls' garments fasten with the right side over the left. As the jacket can be worn open, it allows for variety in styling.

Parts of a blazer-style uniform

1. collar
2. button
3. sleeve
4. sleeve opening
5. hem
6. pleated skirt
7. blouse collar
8. necktie
9. pocket
10. decorative button

✎ Drawing a sailor uniform (front view)

1 Block-in the figure and the sailor uniform

◀ Block-in the face and body and draw the center line. The center line will act as a guide when drawing the sailor uniform and the scarf. Block-in the sailor uniform so that it's not too close to the body, creating ease in the fabric of the sleeves and around the torso.

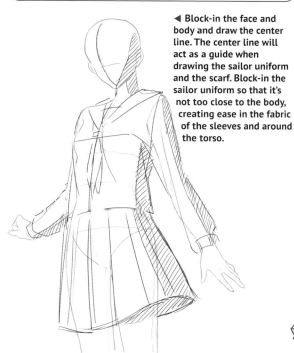

2 Refer to the blocking-in for the body to draw a rough sketch of the sailor uniform

◀▼ Roughly sketch in the uniform so that it fits to the body with some ease in the fabric. Next, follow the direction of the arrows to draw pulled wrinkles, sagging and so on in at the chest, torso, armholes, elbows and around the hips of the skirt.

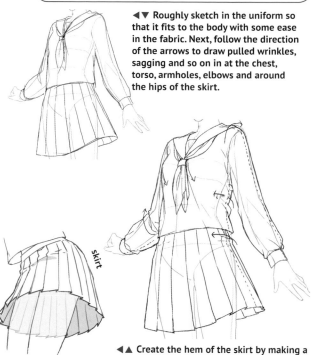

skirt

◀▲ Create the hem of the skirt by making a circle out of a jagged line.

3 Make a clean copy and add in clothing details and wrinkles

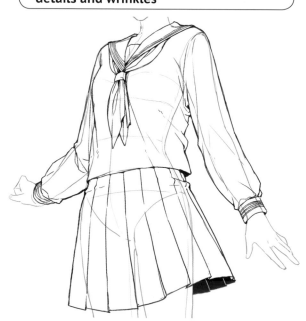

▲ Copy the entire drawing and add in the details on the collar and cuffs. Use fine lines running in the same direction to draw in shadow next to the wrinkles drawn in Step 2. Coat the lining of the top and skirt in black to create dimension.

4 Completion

▶ Add shadow beneath the chest, at the sides, along the undersides of the sleeves, at the side of the skirt and in between the pleats. The fabric below the chest is slack, so draw in some soft gradation.

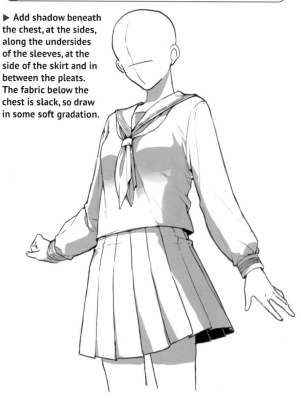

Drawing a sailor uniform (rear view)

1 Block-in the body and the sailor uniform

◀ Block-in the back of the body and the center line, using it as a reference to block-in the collar, sleeves, torso section and skirt. The uniform doesn't fit closely to the back, so create a gap between the fabric and the figure.

2 Roughly sketch in the sailor uniform using the blocking-in as a reference

◀▼ Follow the line of the body to draw the outer edges of the collar and the sleeves. Refer to the blocking-in from Step 1 to roughly draw the section around the torso and the skirt. Once the lines are connected, add wrinkles around the armholes, hips and elbows, following the direction of the arrows.

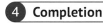

3 Add in the pattern on the collar and creases in the clothing

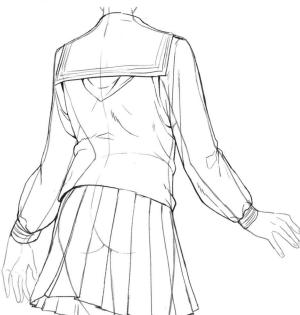

▲ Make a clean copy of the rough sketch from Step 2 and draw in the lines around the edge of the collar and the cuffs. Add short lines around the hips, under the shoulder blades, around the armholes and along the undersides of the sleeves to give the look of wrinkles and enhance the texture of the fabric.

4 Completion

◀ Add shadow, focusing on the side of the torso, beneath the sleeves, on the side of the skirt and inside as well. Add fine shadow beneath the collar and around the hips.

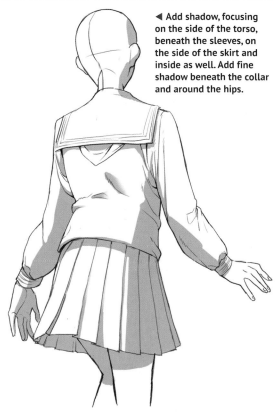

✍ Drawing a girl's blazer (front view)

1 Block-in the body and blazer

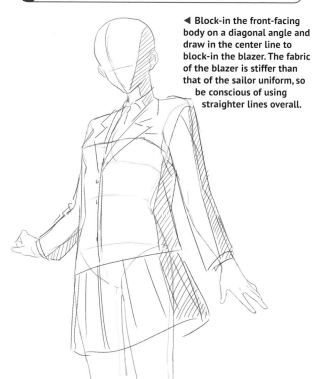

◀ Block-in the front-facing body on a diagonal angle and draw in the center line to block-in the blazer. The fabric of the blazer is stiffer than that of the sailor uniform, so be conscious of using straighter lines overall.

2 Use the blocking-in of the body as a reference to roughly sketch the blazer

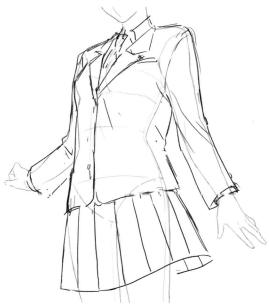

▲ Use the positions of the blocked-in shoulders, arms, chest, hips and crotch as reference points to make a rough sketch of the blazer. The garment has shoulder pads, so draw the outline of the sleeve slightly farther out than the actual shoulders.

3 Add wrinkles to the blazer and make a clean copy

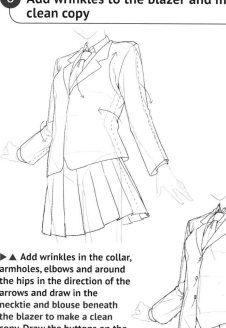

▶▲ Add wrinkles in the collar, armholes, elbows and around the hips in the direction of the arrows and draw in the necktie and blouse beneath the blazer to make a clean copy. Draw the buttons on the front, the chest pocket and side pocket at this stage also.

4 Completion

▶ Add shadow beneath the chest, along the side of the body, along the undersides of the sleeves, at the side of the skirt, across the legs concealed by the skirt, to the necktie and blouse, around the shoulder pads and over the entire figure to complete the drawing.

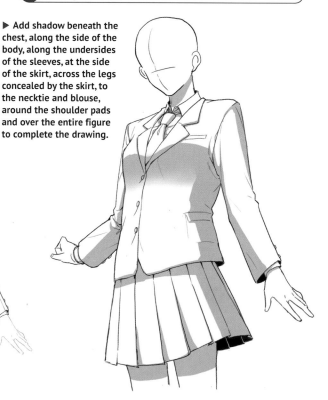

✏️ Drawing a girl's blazer (rear view)

① Block-in the body and blazer

◀ Block-in the rear view of the body and draw the center line through the head and body. Use the center line as a reference to block-in the collar, armholes, sleeves, back and skirt. Leave a large gap between the back of the figure and the fabric of the blazer.

② Use the blocking-in of the body as a reference to draw the blazer

◀▼ Refer to the blocking-in of the shoulders, arms and hips to roughly sketch the blazer and skirt. Once the outline is clear, add wrinkles around the armholes, elbows and hips and make corrections. Draw the decorative buttons on the wrist at this stage also.

③ Make a clean copy and draw the blazer and skirt

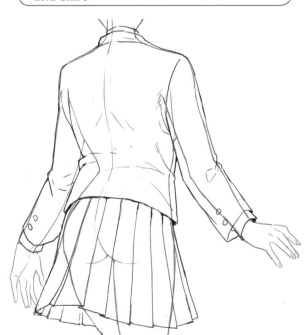

▲ Add the wrinkles around the armholes, hips and elbows. Draw the pleats in the skirt clearly and add the part at the left where the folds are flipping up.

④ Completion

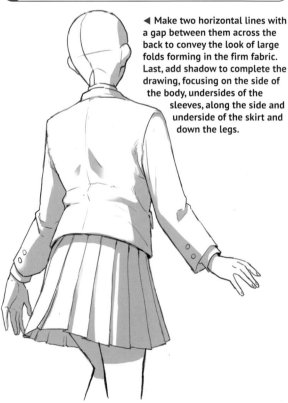

◀ Make two horizontal lines with a gap between them across the back to convey the look of large folds forming in the firm fabric. Last, add shadow to complete the drawing, focusing on the side of the body, undersides of the sleeves, along the side and underside of the skirt and down the legs.

👕 Other uniform items for girls

Tops

🔴 School vest

A vest basically follows the line of the body, with the area from the chest to the hips forming wrinkles. A slight gap appears in the underarms when the arms are raised high.

🔴 School cardigan

Usually worn with the buttons fastened. If all the buttons are done up, it creates a studious impression, becoming a bit more casual if the button at the bottom is left undone. Make the hem and section around the cuffs slightly floppy and loose for a less formal, more lived-in look.

🔴 School sweater

As for the cardigan, the overall silhouette is loose. If pairing it with a necktie, draw the necktie neatly tucked in to the sweater, but if pairing it with a neck ribbon, draw it sitting boldly outside the sweater to make it stand out.

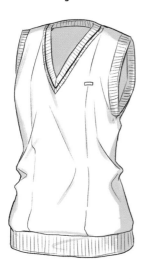 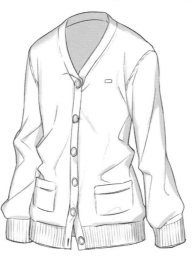 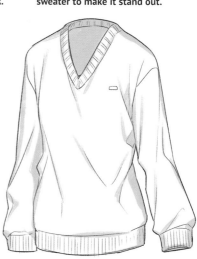

Summer uniform styling

🔴 Hem of the blouse left untucked

This creates a straight silhouette from the top of the bust to the hem of the blouse. Wrinkles form mainly around the chest. Usually, the line of the hem is close to being horizontal, with only a slight curve.

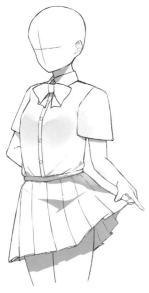

🔴 Hem of the blouse tucked in

From the chest down, the blouse basically follows the line of the body, but where it is tucked into the skirt, wrinkles and shadows form. If the hip section of the skirt is drawn higher up the body, it makes the hips look higher up and creates the effect of longer legs.

Neck accessories

🔴 Ribbon tie

This ribbon decorates the neck of a blouse. Tied in a bow, it makes for a delicate look if shown hanging softly, while using straight lines will make it look stiffer and create a sophisticated effect.

🔴 Ribbon

Worn with all types of school uniforms, the versatile ribbon is shaped into a bow. Draw the large wing sections of the bow and add wrinkles and shadow from the knot outward to create dimension.

🔴 Necktie

Worn with a blazer, this creates a mature impression. Remember to change the direction of the pattern on the main part of the tie, the knot and the part that sits around the neck to reflect how the tie is knotted.

133

Boys' Uniforms

These are worn by male students from junior to senior high school. Military-type and blazer-type uniforms are the most common, both paired with slacks.

Types and structures of boys' uniforms

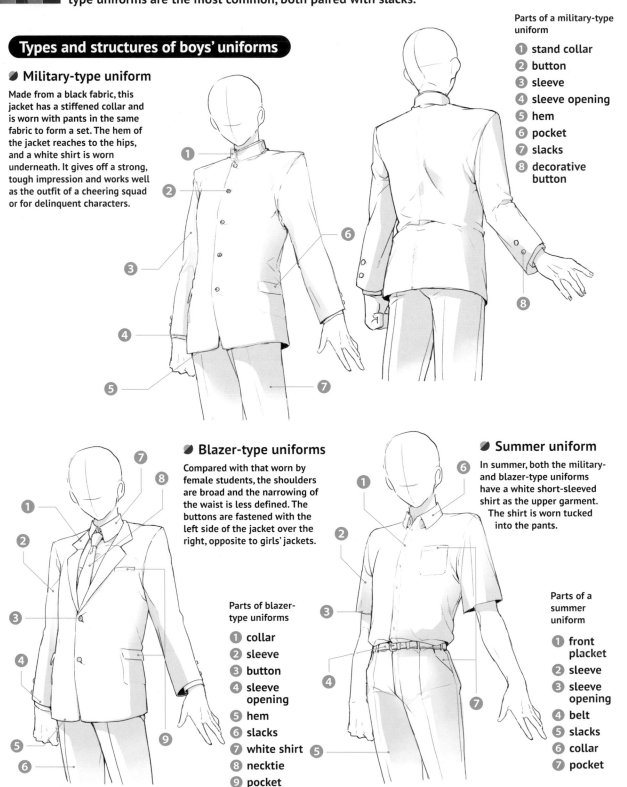

Military-type uniform

Made from a black fabric, this jacket has a stiffened collar and is worn with pants in the same fabric to form a set. The hem of the jacket reaches to the hips, and a white shirt is worn underneath. It gives off a strong, tough impression and works well as the outfit of a cheering squad or for delinquent characters.

Parts of a military-type uniform

1. stand collar
2. button
3. sleeve
4. sleeve opening
5. hem
6. pocket
7. slacks
8. decorative button

Blazer-type uniforms

Compared with that worn by female students, the shoulders are broad and the narrowing of the waist is less defined. The buttons are fastened with the left side of the jacket over the right, opposite to girls' jackets.

Parts of blazer-type uniforms

1. collar
2. sleeve
3. button
4. sleeve opening
5. hem
6. slacks
7. white shirt
8. necktie
9. pocket

Summer uniform

In summer, both the military- and blazer-type uniforms have a white short-sleeved shirt as the upper garment. The shirt is worn tucked into the pants.

Parts of a summer uniform

1. front placket
2. sleeve
3. sleeve opening
4. belt
5. slacks
6. collar
7. pocket

✍ Drawing a military-type uniform (front view)

1 Block-in the body and the military-type uniform

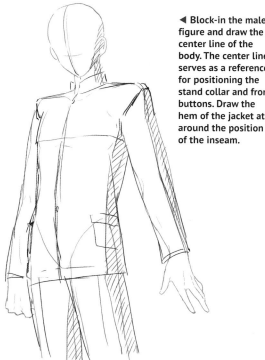

◀ Block-in the male figure and draw the center line of the body. The center line serves as a reference for positioning the stand collar and front buttons. Draw the hem of the jacket at around the position of the inseam.

2 Roughly sketch in the military-type uniform

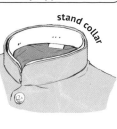

stand collar

▶ The form of the stand collar resembles a monochrome band wrapped around the neckline

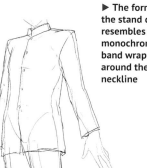

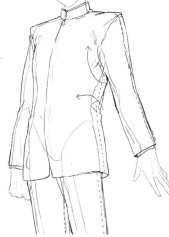

▶▲ Use the blocking-in of the body as a reference to roughly sketch in the uniform. As the armholes project out from the body, start drawing the sleeves from slightly beyond the actual shoulders. Once the outline is complete, draw in wrinkles at the armholes and hips and clean up the form of the garment.

3 Make a clean copy and draw in the buttons and pockets

▶ Copy the lines of the rough sketch and add in buttons from the base of the collar down to about the stomach. Make sure not to add them too close to the hem. Draw pockets on the outer sides and add decorative buttons at the sleeve openings.

stance

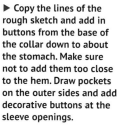

◀ The slacks have a center crease in both legs from the hips to the hems.

4 Completion

◀ Add shadow along the side of the body, undersides of the sleeves and sides of the slacks. The hem of the jacket sits away from the body so add shadow immediately beneath the hem on top of the legs

✒ Drawing a military-type uniform (rear view)

① Block-in the body and the uniform

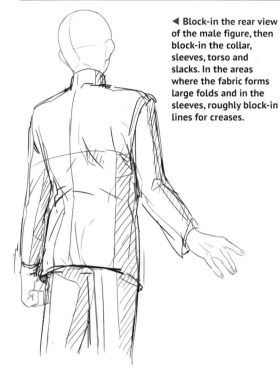

◀ Block-in the rear view of the male figure, then block-in the collar, sleeves, torso and slacks. In the areas where the fabric forms large folds and in the sleeves, roughly block-in lines for creases.

② Roughly sketch in the uniform

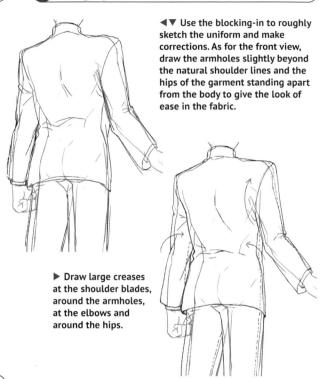

◀▼ Use the blocking-in to roughly sketch the uniform and make corrections. As for the front view, draw the armholes slightly beyond the natural shoulder lines and the hips of the garment standing apart from the body to give the look of ease in the fabric.

▶ Draw large creases at the shoulder blades, around the armholes, at the elbows and around the hips.

③ Make a clean copy and add decorative buttons and wrinkles

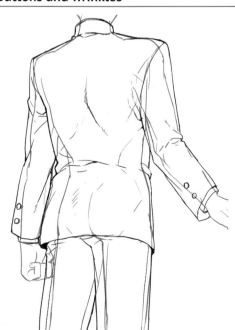

▲ Draw decorative buttons in at the sleeve openings and add small wrinkles to detailed areas such as along the back and elbows. Draw the shirt collar and cuffs to look light in comparison with the stand collar and jacket sleeve openings to create a neat, trim impression.

④ Completion

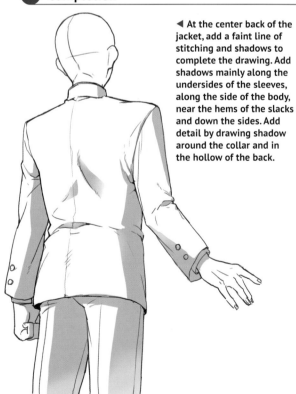

◀ At the center back of the jacket, add a faint line of stitching and shadows to complete the drawing. Add shadows mainly along the undersides of the sleeves, along the side of the body, near the hems of the slacks and down the sides. Add detail by drawing shadow around the collar and in the hollow of the back.

✏️ Drawing a boy's blazer-type uniform (front view)

1 Block-in the figure and blazer

◀ Block-in the male figure, then use the center line as a reference to block in the blazer. Draw in the shirt and tie over the center line too.

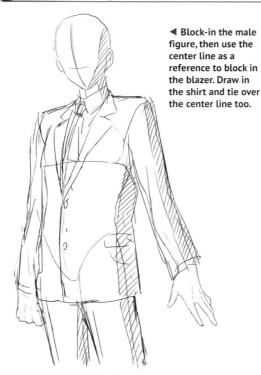

2 Draw the outline of the blazer and add creases

▶▼ Use the blocking-in of the body as a reference to sketch in the outline of the blazer. Draw the outline of the upper garment so that it forms a gap with the line of the body at the shoulders and hips. Add wrinkles around the armholes and hips and clean up the shape of the clothing.

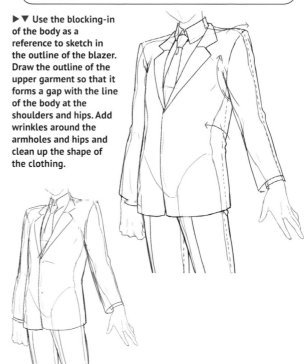

3 Make a clean copy and draw in buttons and pockets

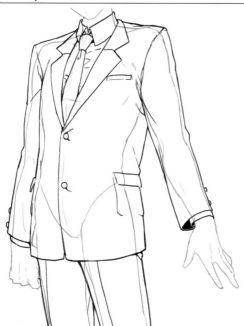

▲ Make a clean copy from the rough sketch and draw the buttons and pockets on the front of the jacket. Add in wrinkles on the part of the shirt around the necktie and around the armholes and draw the decorative buttons on the sleeve openings to enhance the overall look.

4 Completion

◀ Add shadow to the undersides of the sleeves, the side of the torso, near the hems of the slacks and down the sides of the legs. Add finer shadow in around the knot of the tie, shirt collar and the part of the hand near the sleeve opening to complete the drawing.

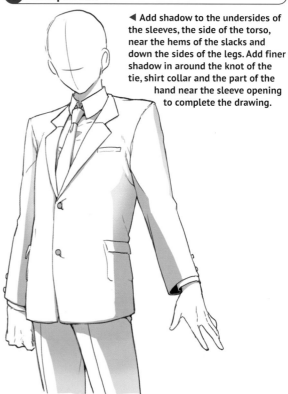

✏️ Drawing a boy's summer uniform (front view)

① Block-in the body, short-sleeved shirt and slacks

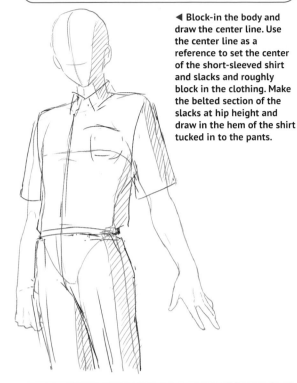

◀ Block-in the body and draw the center line. Use the center line as a reference to set the center of the short-sleeved shirt and slacks and roughly block in the clothing. Make the belted section of the slacks at hip height and draw in the hem of the shirt tucked in to the pants.

② Draw the outline of the clothing and add wrinkles

◀▼ Roughly draw in the clothing and neaten the shape down to the finer details such as the collar, front placket and creases in the slacks. Draw wrinkles under the arms and around the hips and crotch.

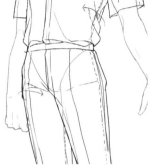

▶ The hem of the shirt is tucked in so the fabric around the hips sits close to the body.

③ Draw in details such as the pocket and belt

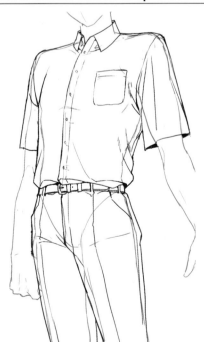

▲ Add details including the chest pocket, buttons down the front placket, belt loops along the waistband and the belt buckle to create a clean copy and complete the line drawing.

④ Completion

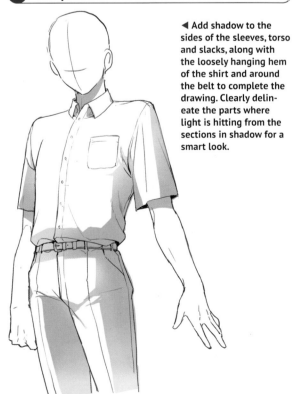

◀ Add shadow to the sides of the sleeves, torso and slacks, along with the loosely hanging hem of the shirt and around the belt to complete the drawing. Clearly delineate the parts where light is hitting from the sections in shadow for a smart look.

👕 Other uniform items for boys

● School vest

The design is the same for boys and girls. Men are broader around the chest, so the fabric is taut. Don't draw gathered wrinkles, but add in large pulled wrinkles from the chest to the hem.

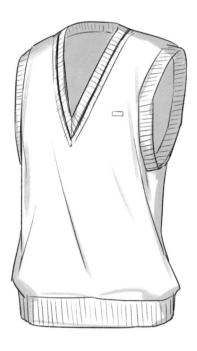

● School cardigan

Make the chest area flat with wrinkles forming from around the stomach down to the hem in order to create a masculine silhouette. The shoulders are not as rounded as girls' cardigans so make the line of the shoulders relatively straight.

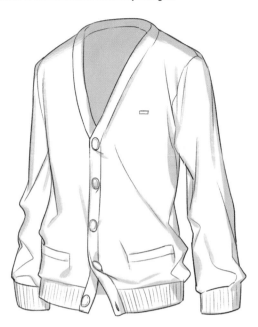

● School sweater

As there is no extra room in the chest as there would be for women, wrinkles connect the area from the collar down to the hem. Take care to balance out the wrinkles, as there are few wrinkles from the shoulders to the chest, increasing toward the hem and sleeve openings.

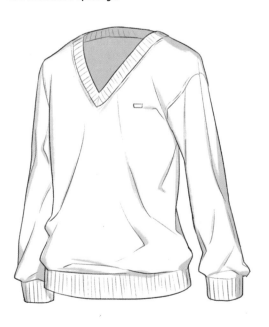

● Slacks

As the fabric is soft, few wrinkles form around the crotch. There are neat creases down the centers of both legs from the waist to the hems. From the knees down, the fabric makes contact with the feet, cinching the shape and creating hollowed-out wrinkles.

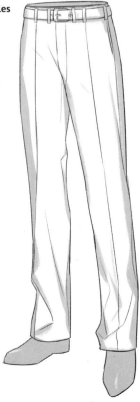

Gym Clothes

Worn for physical education classes, club activities and workouts, many have lines down the side, and come in varied colors, depending on what year the student is in.

Types of gym clothes and their structure

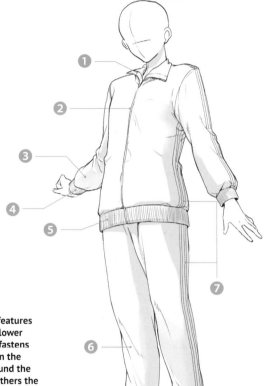

Gym clothes

Currently, both boys and girls wear short-sleeved gym shirts and shorts. As they are made from stretch fabric, small wrinkles tend not to form.

1. collar
2. zipper
3. sleeve
4. cuff
5. hem (top)
6. hem (bottoms)
7. line

Tracksuits

The same design features on the upper and lower garment. The top fastens with a zipper down the front. Ribbing around the cuffs and hems gathers the fabric in at these points.

Drawing gym clothes (front view)

1 Block-in the body and roughly draw the gym clothes

◄ Even on a young woman, the gym shirt hangs straight from the chest down, so don't worry too much about the body's curves and draw a line in from the top of the bust to the hips. Similarly, don't follow the line of the legs too closely to draw in the shorts, instead making a line from the join of the legs straight down.

2 Draw the outline of the gym clothes

◄ Use the rough sketch as a reference to draw the outline of the garments, working in the wrinkles at the chest and hips at the same time. Draw diagonal lines to show the deep creases at the shoulders and hips and indicate the softness of the fabric.

3 Apply shadow to complete

◄ Make a clean copy and draw the lines down the sleeves and the sides of the shorts. Add shadow beneath the chest and along the sides of the sleeves, torso and legs. Use black on the insides of the sleeves and sections where the reverse side of the fabric is visible to create a dynamic look.

 # Drawing a tracksuit (front view)

① Block-in the tracksuit and the body

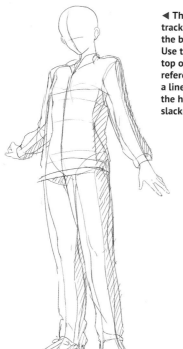

◀ The outline of the tracksuit is wider than the body at every point. Use the position of the top of the chest as a reference point and draw a line straight down to the hips to convey the slackness in the fabric

② Follow the blocking-in for the body to create the line drawing of the tracksuit

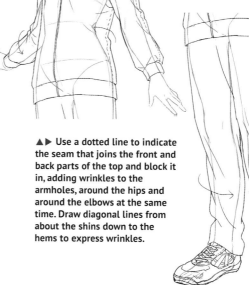

▲▶ Use a dotted line to indicate the seam that joins the front and back parts of the top and block it in, adding wrinkles to the armholes, around the hips and around the elbows at the same time. Draw diagonal lines from about the shins down to the hems to express wrinkles.

③ Make a clean copy and add details

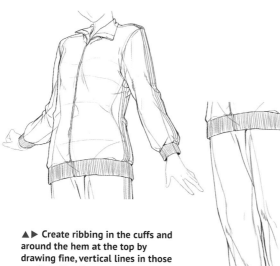

▲▶ Create ribbing in the cuffs and around the hem at the top by drawing fine, vertical lines in those sections. Use fine, vertical lines to draw in the lines at the sides of the tracksuit. Where the fabric forms large folds, such as at the hems of the pants, use curved lines to express hollows and ridges in the fabric.

④ Completion

▶ Add shadow at the side of the body, beneath the chest and beneath the hem to complete the drawing. Adding shadow beneath the ribbing in the hem of the top conveys the thick texture of the fabric.

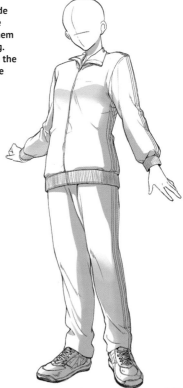

School Bags

Every student needs a bag. Most are plain and functional, but their metal rings allow keyrings and other objects to be attached to express individuality.

Structure of a school bag

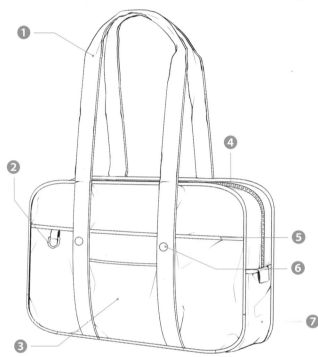

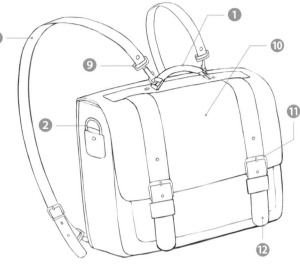

① handle	⑦ gusset
② metal ring	⑧ shoulder strap
③ pocket	⑨ clasp
④ zipper	⑩ flap
⑤ side pocket	⑪ buckle
⑥ stud	⑫ belt

Types of school bags

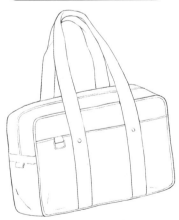

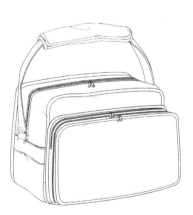

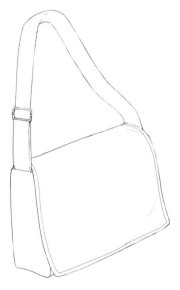

✎ Boston bag

This is the most orthodox type of school bag. Most are made of nylon, although some are made from leather.

✎ Patent vinyl bag

Made from shiny fake leather, this bag has a large shoulder strap and is often used for club activities that involve physical exercise.

✎ Satchel with a shoulder strap

An old-fashioned school bag made from sturdy, rough canvas. Some have leather on the corners to reinforce them and protect them from wear and tear.

✎ Drawing a Boston bag

① Draw the rough outline

▲ Visualize a rectangle to draw the outline of the bag. Draw secondary lines around the outline and around the corners. Make the base of the gusset section slightly concave rather than straight.

② Draw the handles and zipper

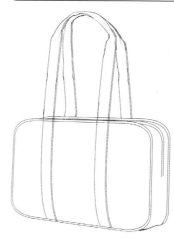

◀ Draw the lines for the bands from the base and over the body of the bag, extending them to form handles. Draw the zipper, starting at a height halfway up the side of the bag.

③ Draw the pocket and other details

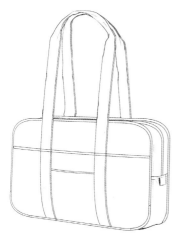

◀ Draw the lines for the pocket halfway up the front. Slightly above the pocket, draw two lines for the pocket that extend across the entire bag. On the side of the bag, draw two horizontal lines below the end of the zipper and draw in the tab.

④ Draw the creases, zipper and decorative details

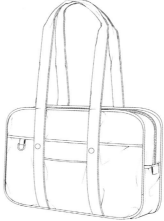

◀ Erase the lines from the long side pocket and the bands that overlap and add the studs. On the left end of the long pocket, add a tab with a loop. Draw in creases near where different parts connect and add fine, vertical lines along the fastener.

⑤ Completion

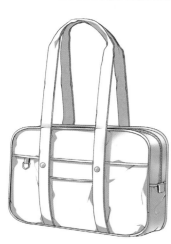

◀ Add shadow inside the outline, between the bands and fabric on the front and along the sides of the bag to complete the drawing. Apply shadow over the entire handle at the back to create depth.

● Carrying the bag

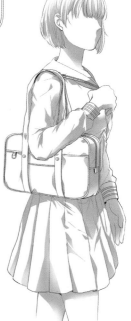

▶ When the bag is carried over the shoulder, the handle twists and shadows form. If there are items in the bag, its form hardly alters even when it is being carried.

Drawing a patent vinyl bag

1 Draw the front pocket

▲ Draw the pocket that is attached to the front of the bag. Place two squares with rounded corners and with double lines around the edges one over the other and draw two zippers in between them.

2 Draw the body of the bag

▲ Draw another outline slightly higher than the pocket from Step 1, again using double lines. Draw another outline using double lines to sit diagonally parallel to the first, connecting them to form the gusset. Use a slightly curved line for the gusset to show that it is slightly concave along the edges.

3 Draw the handle and gusset

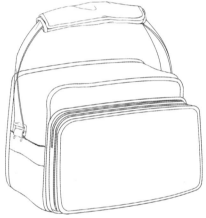

▲ Draw a thick band on the side, slightly lower than halfway up, and draw a metal ring and shoulder strap above it. Draw a piece of fabric wrapped around the shoulder strap to protect the shoulders.

4 Draw creases and add details

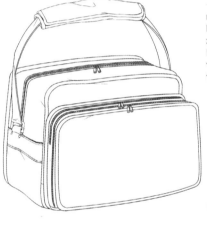

◀ Draw a few creases near the outline of the bag and add the zippers and zipper heads. Add fine, vertical lines along the zipper sections.

5 Completion

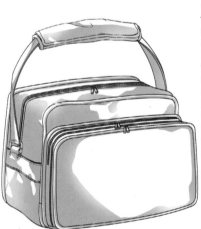

◀ Add shadow on the underside of the shoulder strap and over the body of the bag. On the body of the bag, make the shadows around the edges rounded and irregular in shape and add light gradation to render the texture of the patent vinyl.

🖐 Holding the bag

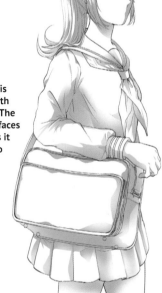

▶ As the patent vinyl bag is bulky, it is often carried with the strap across the body. The bag tilts so that the front faces up, meaning that light hits it and allows few shadows to form on the surface.

👕 Examples of school bags

🌰 Satchel type

As the whole bag is made from canvas, its form changes readily. When worn over the shoulder, the strap is pulled taut and the sides of the bag are drawn in, while the flap caves in at the center to form a hollow.

It has a retro feel, and is often treated as part of a set with the historical military-type uniform.

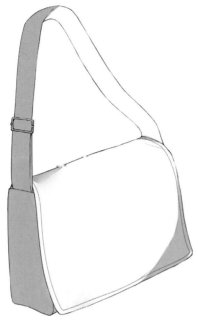

🌰 Satchel case type

Traditionally used by English students, this type is made from good quality leather that results in a firm case with no fine creases. Use thick lines to draw the outline and convey the texture of the leather.

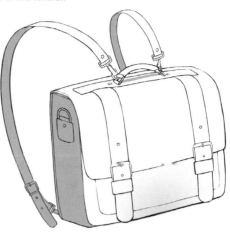

Use this type when drawing foreign students or sophisticated female students who attend an exclusive school.

🌰 School rucksack

This type of bag is light but has excellent storage capacity. Draw it to be slightly larger than the body for female students or small characters to exaggerate the mismatch.

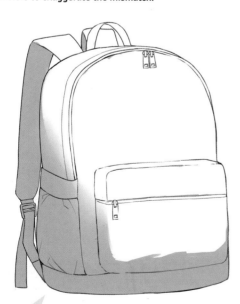

The rucksack works well on active characters such as sporty male students and bookish female students as well.

🌰 Boston bag

Basically cuboid in form, with rounded corners, the surface texture of this type of bag varies depending on whether it is made from nylon or leather. If it is nylon, fine wrinkles form close to the outline, while using strong highlights is key to bringing out the look of leather.

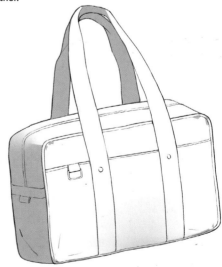

If you're having difficulty trying to work out which type of bag to use for a student character, you can't go wrong with this type, whether for a young woman or man.

School Shoes

These shoes are worn for school and rather than expressing individuality, the priority is that they fit together with the school uniform.

Structure of school shoes

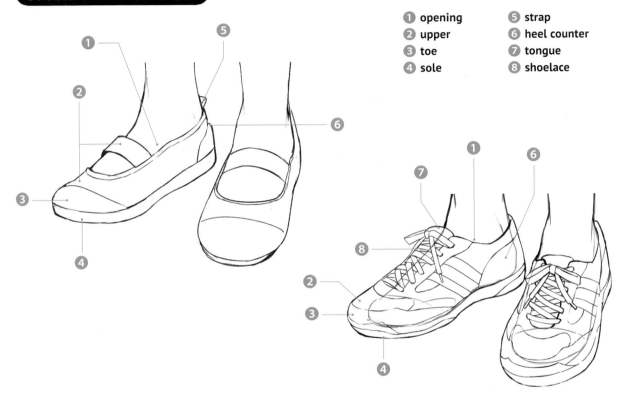

1 opening
2 upper
3 toe
4 sole
5 strap
6 heel counter
7 tongue
8 shoelace

Types of school shoes

🐚 Loafers

These are the most commonly used school shoes. Colorwise, they tend to be brown or black, with a simple design that has no decorative laces or metal trimmings.

🐚 Canvas slippers

These are worn indoors. They have rubber across the toe section that may be a certain color to indicate year level.

🐚 Gym shoes

These are worn in the gym or for other indoor exercise. Many that are for school use have lines decorating the outer sides. They are similar to sneakers in structure, but as they are made for indoor use, the soles are made from caramel-colored or white rubber so they don't leave scuff-marks on the floor.

Drawing canvas slippers

① Draw a line from where the big toe joins the foot to around to the heel

▶ Use the blocking-in for the foot as a reference to draw the outline of the slipper, making it slightly larger than the foot. The slippers are flat overall, with barely any curve in the arch of the foot. Make the toe section raised and slightly rounded.

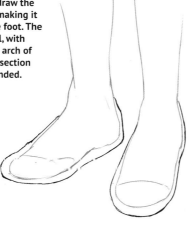

② Draw the opening and sole of the slipper

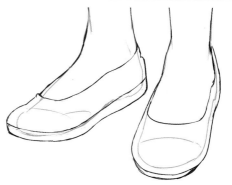

▲ Draw the opening from just above where the big toe joins the foot around to the heel. Draw the sole so that it is nearly straight from the heel to the little toe, curving the toe section to follow the blocking-in for the foot.

③ Draw the rubber sections at the heel and over the toes

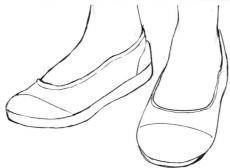

▲ Erase the blocking-in for the foot and draw in another line alongside the opening to indicate fabric thickness. Use a curved line to draw in the rubber section over the toes.

④ Completion

▶ Add the elastic tape over the top of the foot and the tab at the heel to complete the slippers. Too much shadow will make them look too thick, so use dark shadow only around the heel, keeping it light around the toes.

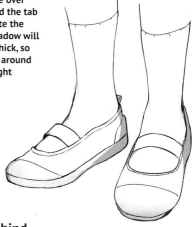

🖋 View from front

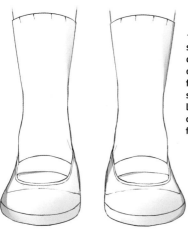

◀ As the slippers are a simple shape that only cover the feet, the ends of the toes take on a flat shape. Use an arch shape to indicate the line between the rubber over the toes and the fabric of the uppers.

🖋 View from behind

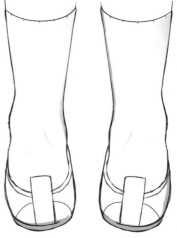

◀ The tab on the back of the heel extends beyond the opening. Draw a seam on the heel counter to keep the tab in place.

 # Drawing gym shoes

① Draw the outline from the top of the foot around to the back of the heel

▶ Use the blocking-in for the foot as a reference to draw the outline of the shoe, making it slightly bigger than the foot overall. Gym shoes are structured to envelop the entire foot, so draw the line as if you were enlarging the blocking-in for the foot.

② Draw the lines for the upper and sole

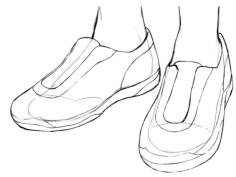

▲ Draw in the upper over the top of the foot and draw the tongue. Draw the sole as if tracing the bottom of the foot, using a sharp line. Draw in lines for the seams in the heel counter.

③ Draw in eyelets

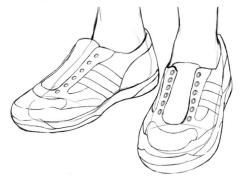

▲ Draw eyelets on the uppers and add in decorative lines along the sides. Create the look of breathable mesh fabric in the toe section using curved lines to delineate it from the rest of the shoe.

④ Completion

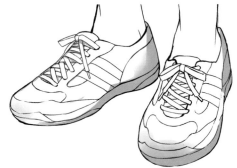

▲ Use the eyelets as a guide to draw laces in, crossing from side to side. Draw shadow on the undersides of the shoes to complete. Make the shadow at the heels and along the soles dark, with lighter shadow around the toes.

🖊 View from front

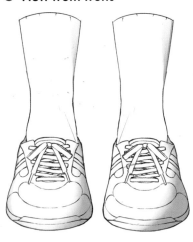

◀ The section with shoelaces is complicated, so draw the eyelets first, then draw the laces. Draw the section next to the laces, the decorative stripes and the sole at the end of the toes using clear lines.

🖊 View from behind

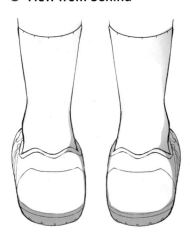

◀ When viewed from behind, the three sections that stand out are the double lines around the opening, the seam in the heel counter and the sole. Add ridges to the surface of the sole.

Suits and Formalwear

Women's Suits

This women's business wear can be styled in more ways and with more flair than men's. Here, we look at women's business wear over all, starting with suits.

Types of suits and their structure

Single-breasted suit (women's)

This type of suit has one vertical row of buttons on the front of the jacket. It is usual for all the buttons to be fastened and for no necktie to be worn.

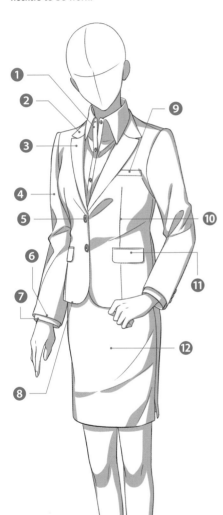

Suit jacket

Many of these have silhouettes that flatter the narrowing of the waist. There is a slit (vent) in the hem at the back for ease of movement.

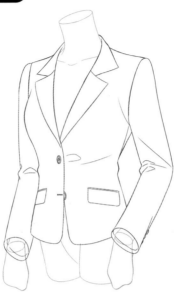

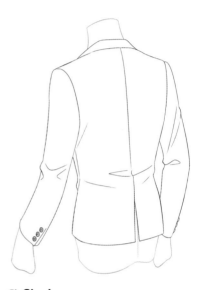

Skirt suit

This type of suit has a modest skirt with a flared or tight silhouette.

Slacks

Also known as a pants suit, this type creates a long-legged, sophisticated silhouette, evoking the image of an office worker. The pants may be slim or wide-legged.

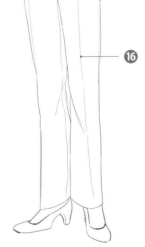

1. Shirt
2. Upper collar
3. Lapel (lower collar)
4. Sleeve
5. Button
6. Sleeve opening
7. Cuff (of shirt)
8. Hem
9. Breast pocket
10. Front dart
11. Pocket
12. Skirt
13. Pumps
14. Pleat
15. Fly
16. Center pleat

✒ **Women's business clothes**

● Shirt with regular collars

The most popular type of shirt, its simplicity serves to highlight reliability. If paired with a suit jacket, raise the collar slightly to give it the look of fitting to the inside of the jacket.

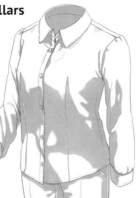

● Trench coat

A light coat made from waterproof material, the trench coat originated as military apparel, and its various features can be traced back to these origins. It is usually beige, with a belt that brings the garment in around the waist to reveal the line of the hips.

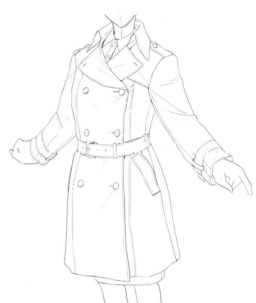

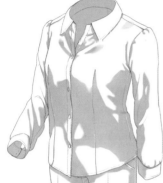

● Skipper shirt

There is no button at the top of the neck in this style, and it opens to create a V shape at the neck. When worn with a suit jacket, it is usual to spread the collar over the jacket collar. It makes for a fresh, active impression.

Office casual

TIP

Office casual is a term indicating the move from suits to more casual clothing in the workplace. Exactly what is deemed acceptably casual depends on each individual company, but generally items such as knee-length skirts, pants, shirts, blouses, jackets, cardigans and other clothing that's not revealing are worn in muted colors such as black, white and beige.

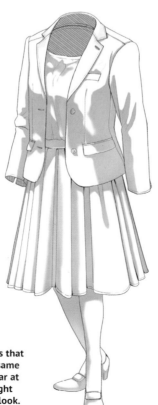

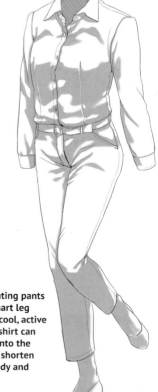

● Pants

Outfits incorporating pants create a neat, smart leg line and make a cool, active impression. The shirt can be worn tucked into the pants to visually shorten the top of the body and define the hips.

● Flared skirt

Outfits built around flared and other skirts that widen at the hem bring out charm at the same time as being sophisticated enough to wear at work. A blouse or cut-and-sewn top in a light color topped by a jacket balances out the look.

✎ Drawing a women's suit jacket (front view)

1 Follow the blocking-in for the body to draw the body of the jacket

▶ Draw the outline of the front of the jacket by following the blocking-in for the body, drawing in the neckline also. Position the armholes slightly beyond the blocking-in for the body and draw them as ovals slightly larger than the actual arms.

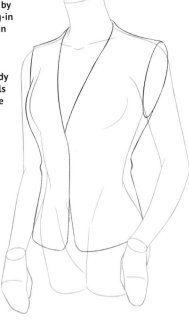

2 Follow the line of the body to draw the collar and sleeves

◀▼ Draw in the upper collar and lapels by following the neckline. Draw the sleeves slightly beyond the line of the arm.

▶ Draw circles slightly larger than the arms to form sleeve openings that have some ease to them. Use triangles and diagonal lines to indicate wrinkles on the insides of the elbows.

3 Draw the pockets, front darts and buttons

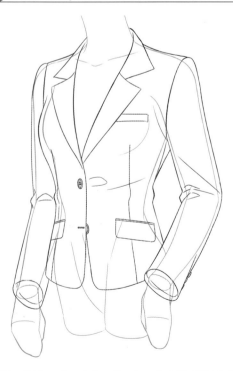

▲ Draw the breast pocket on the viewer's right of the jacket, hidden slightly by the lapel. At around the hip joint height, use rectangular shapes to draw pocket flaps. Draw two buttons at equal distance from each other below the lapels.

4 Completion

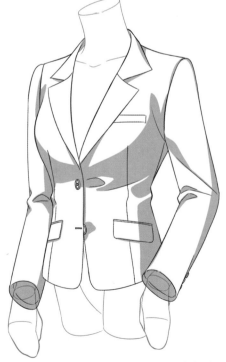

▲ Add shadow to the area from the chest down along the sides, in the wrinkles at the elbows and to the collar and sleeve openings to complete the drawing. Add sharp shadow down the side of the body to tighten up the silhouette.

Drawing a women's suit jacket (rear view)

1 Follow the blocking-in for the body to draw the body of the jacket

▶ Draw the outline of the back of the jacket, following the blocking-in for the body. Add wrinkles around the hips to slightly swell out the fabric and create irregular ridges along the sides. Draw the seam line from the collar to the hem down the center of the back.

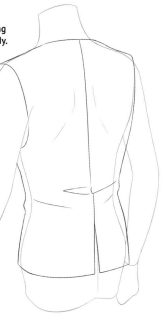

2 Follow the line of the body to draw the collar and sleeves

◀▼ Add the collar and sleeves to the body of the jacket from Step 1. Draw a smooth trapezoid shape for the collar, and use triangles and diagonal lines to draw in wrinkles around the elbows.

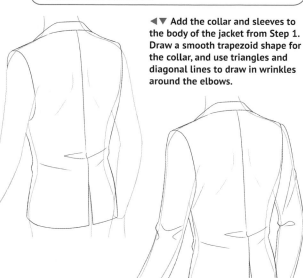

3 Add decorative buttons at the sleeve openings

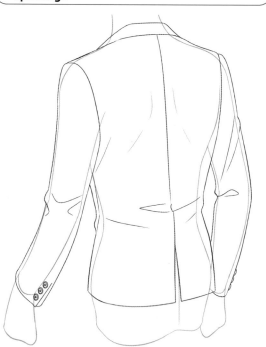

▲ Draw the buttons on both sleeve openings. For the left arm, where the side of the sleeve is visible, add in the fabric opening next to the buttons. Draw the seam line that joins the front and back panels beneath the left armpit.

4 Completion

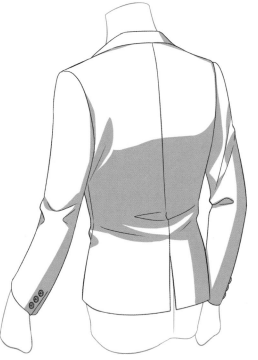

▲ Add shadow from the lower back to the hips, on the undersides of the sleeves and around the elbows. Bring out dimension by adding shadows to more detailed areas such as the sleeve openings and collar.

Drawing a ladies' suit jacket (side view)

① Block-in the body and suit

▶▼ To start, block-in the side view of the figure, then draw the upper collar at the neck, the lapels at the chest and the line of the jacket from the chest to the hips. Draw the back in, using an S shape to suggest the curve at the hips. Make sure to draw the shoulders in toward the back rather than in the center of the body.

② Make the line drawing over the blocking-in for the body

▶ Use the neck, chest, back and hips as reference points for drawing in the body and sleeves of the jacket. Draw the line for the underside of the sleeve slightly below the position of the arm to show how gravity is pulling it down. Add the seam lines joining back and front sections together as if tracing over the center line of the body.

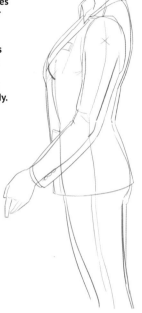

③ Erase the blocking-in and add wrinkles and details to the outline

④ Completion

▶ Add shadow, focusing on the underside of the sleeve, side of the body, back and backs of the legs to complete the drawing. Don't add too much shadow down the front of the chest, drawing it in only where the fabric overlaps, such as around the collar, to bring out dimension.

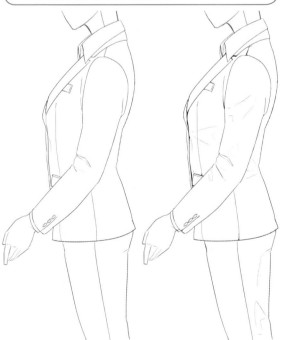

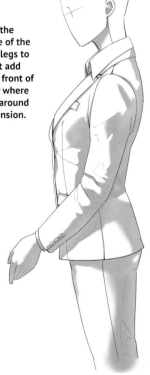

▲ Make the areas clear where fabric overlaps such as the fronts of the jacket, around the collar and around the pocket by using thicker lines. Add large creases around the elbow and buttocks, and use fine lines to express the fine wrinkles around the elbow, narrowing of the waist, front of the jacket and thighs of the slacks.

✒ Drawing a skirt suit (front view)

① Block-in the body

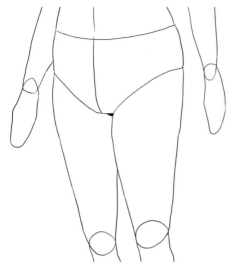

▲ Block-in the lower body, dividing it into hips, leg joints and other joints. Draw the center line from the torso to the hips.

② Use the hips as a reference to draw the outline of the skirt

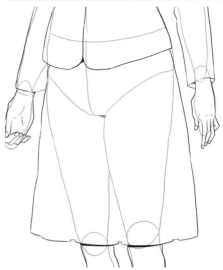

▲ Draw the outline of the skirt starting from the hips and going to knee height, flaring out toward the hem. The hem of the jacket covers half the hips. Draw ridges and hollows along the hemline of the skirt for the pleats to follow later.

③ Draw in pleats and wrinkles in the skirt

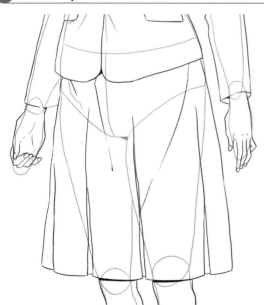

▲ Start from the hollows drawn along the hemline in Step 2 to draw vertical lines up to the joints of the legs, creating pleats. For the wrinkles in the skirt, draw long diagonal lines from around the hips toward the center in a downward direction.

④ Completion

▶ Draw the pleats in the skirt, add wrinkles over all and add shadow around the hips to complete. Mix dark and light shadows in the wrinkles around the hips to convey the softness of the skirt fabric.

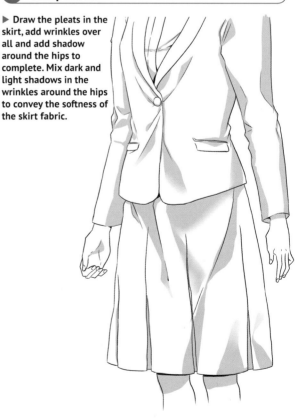

Drawing women's pants (front view)

1 Block-in the body and the pants

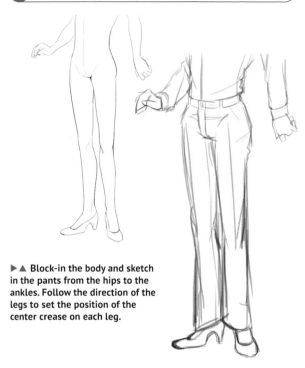

▶▲ Block-in the body and sketch in the pants from the hips to the ankles. Follow the direction of the legs to set the position of the center crease on each leg.

2 Refer to the blocking-in to create the line drawing

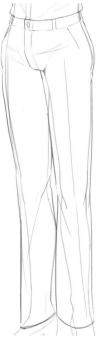

▶ Draw the outline of the pants to cover the area from the hips to the ankles. Follow the line of the body down to the thighs, but from the knees to the feet, create a straight line that doesn't follow the legs. Draw the fly in line with the center line of the body.

3 Draw the details such as the wrinkles and pockets

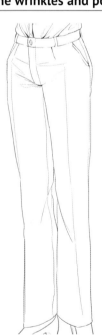

4 Completion

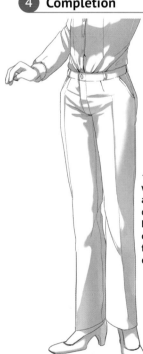

◀ Add shadow to the wrinkles, around the crotch, along the pockets and down the center creases. By adding shadow to only one side of the crease, the fold is made clearer, enhancing dimension.

🖊 Example of a rear view

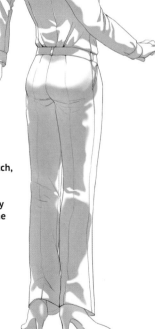

▲ Draw gathered wrinkles in the shirt where it tucks into the belt of the pants. The area around the crotch is pulled to either side by the hip bones, so draw horizontal lines outward to indicate pulled wrinkles. Draw the side seams down the sides of the pants using vertical lines.

▲ As for the front view, block in the body to use as a reference. The buttocks protrude, so don't draw in many wrinkles around them, but follow their form to add shadow. The slight swelling around the calves just below the knees is also characteristic of the rear view.

✏️ Drawing a trench coat (front view)

1　Draw a rough sketch of the figure in a coat

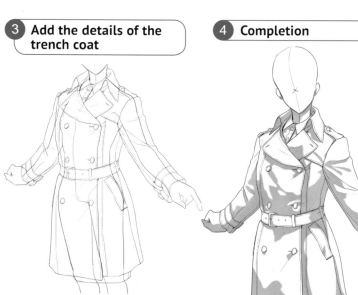

▶▲ Block-in the body and roughly draw in the coat. The epaulettes and overlapping section on the front right (gun flap) are important details, so don't forget to draw them in. On most women's trench coats, the right side covers the left.

2　Use the blocking-in for the body to make the line drawing

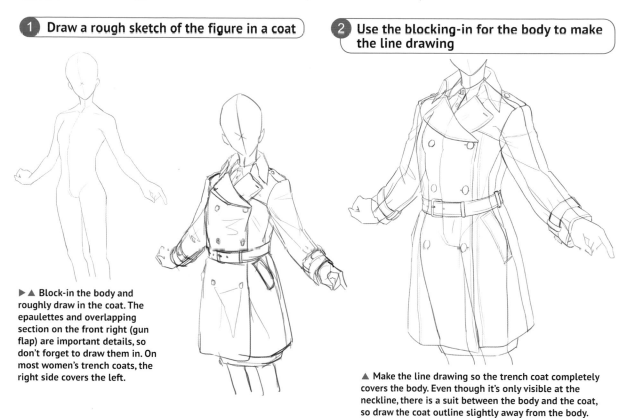

▲ Make the line drawing so the trench coat completely covers the body. Even though it's only visible at the neckline, there is a suit between the body and the coat, so draw the coat outline slightly away from the body.

3　Add the details of the trench coat

▲ Add the collar, epaulettes, sleeves, belt, buttons and line to show where the front section overlaps. Draw pulled wrinkles around the buttons and at the hips.

4　Completion

▲ Add shadow around the chest, hem, undersides of the sleeves, inside of the collar and under the overlapping front section. Also draw in fine shadow along the armhole wrinkles and in the wrinkles around the buttons.

🍃 Example of rear view

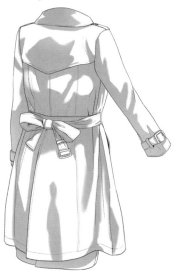

▲ The shoulders are covered by a decorative piece of fabric called the umbrella yoke, which was originally for keeping rain off. The center of the back hem section has a pleat to allow for ease of movement.

Drawing a Men's Suit

Usual attire for men in business situations, suits consist of a matching top and bottom and are worn with a business shirt and necktie.

Structure of a men's suit

Single-breasted suit

The jacket of this type has a single row of buttons down the front. Usually there are two or three buttons, with the one at the bottom left undone.

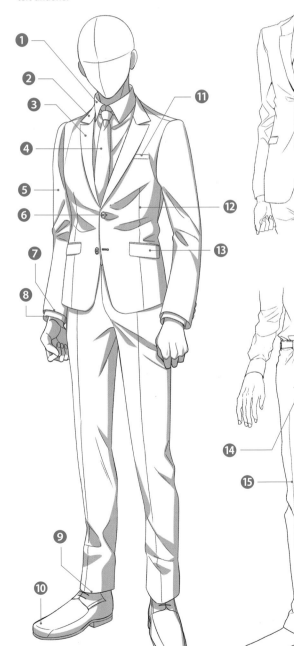

Jacket

The tailored jacket is the standard type, with a collar that is divided into the upper collar and lower collar (lapels). The waist is brought in to create a silhouette that follows the line of the body. Colors such as black, navy and charcoal gray are usual.

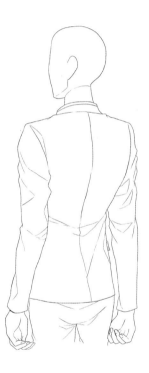

Slacks

These are formal pants that are generally tailored to form a set with the jacket. There are center creases in the legs.

Parts of a men's suit

1 business shirt
2 upper collar
3 lapel
4 necktie
5 sleeve
6 button
7 sleeve opening
8 cuff (shirt cuff)
9 hem
10 leather shoes
11 chest pocket
12 front dart
13 pocket
14 fly
15 center crease

Men's business wear

Business shirt

A monochrome shirt that is worn underneath a jacket for a neat, clean impression. Also known as a dress shirt, it is often worn starched to create a crisp look.

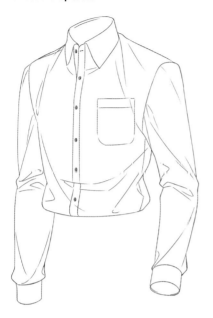

Bal collar coat

This type of coat has a collar similar to that of a shirt. As its long silhouette makes for a stylish look, it is popularly worn over the top of men's suits.

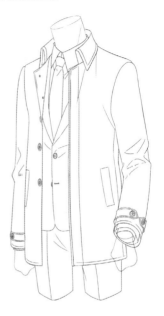

Double-breasted suit

The jacket of this type of suit has two rows of buttons, with a maximum total of six. It gives off a classical air and makes the body look larger, so works well for styling a look with a laidback, dignified feel.

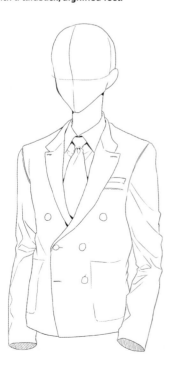

Three-piece suit

Comprised of a jacket, vest and slacks all made from the same material, this suit is usually worn with the jacket open. It is the most traditional style of suit and gives off a sophisticated air.

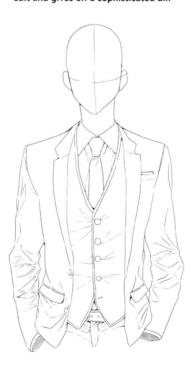

Waistcoat

The British term for a vest, this is worn with a three-piece suit or over a shirt as formalwear. It makes a strongly formal impression and creates a laidback, elegant air even when worn without a jacket.

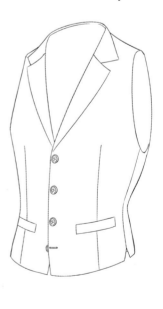

 # Drawing a men's suit jacket (front view)

1 Block-in the body

▶ Draw the center line through the head and torso and draw each jointed section separately. When drawing the jacket, use the position of the neckline, shoulders, chest and solar plexus as a guide.

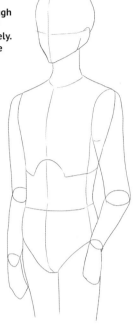

2 Follow the blocking-in for the body to draw the outline of the clothing

▶ Follow the line of the body from the neck to the shoulders to draw the shoulders of the jacket, extending the line to draw the sleeves. Extend the front overlapping sections of the jacket to cover the solar plexus.

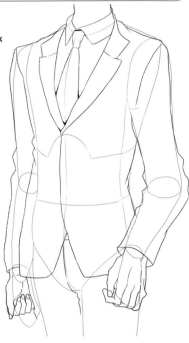

3 Draw the pockets, buttons and creases

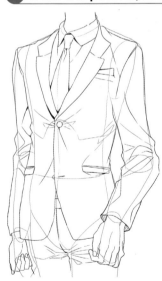

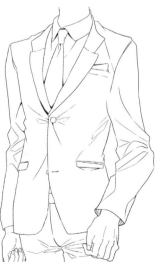

▶▲ Draw wrinkles at the elbows and around the hips and add the jacket pocket at about the height of the hips. Add wrinkles around the buttons and down the sides. Erase the blocking-in lines and check the overall balance.

4 Completion

▶ Add shadow around the collar, the top button, the wrinkles in the sleeves and the sleeve openings to complete the drawing. Adding shadow where the collar sections overlap indicates layers of fabric and makes for a more dimensional effect.

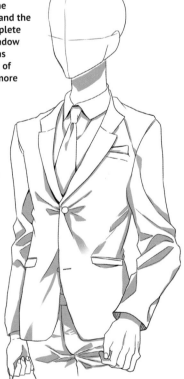

Drawing a men's suit jacket (rear view)

1 Block-in the body

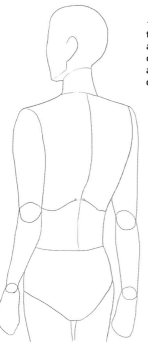

◀ Block-in the back of the body in the same way as the front. In the center of the blocking-in, make a smooth S shape for the center line.

2 Draw the outline of the clothing, following the blocking-in

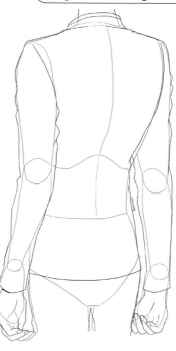

◀ Draw the outline of the jacket from the neck to shoulders as if enveloping the body. Above the wide trapezoid shape of the collar, draw another line to show a little of the shirt worn beneath the jacket. Make the outline wavy around the biceps, elbows and hips to make drawing creases easier.

3 Draw in wrinkles and details

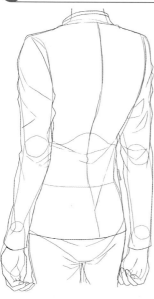

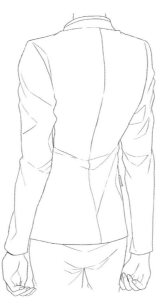

▶ ▲ Draw lines for wrinkles in the sleeves and around the waist. Follow the center line of the body to draw a vertical line to indicate the seam down the back of the jacket.

4 Completion

▶ Add shadow to the sleeves, armholes, hips and base of the collar to complete the drawing. Use several horizontal lines one over the other around the waist to show how the fabric slackens.

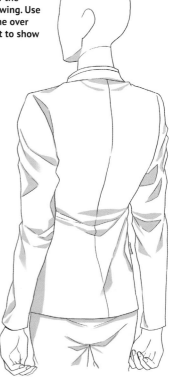

Drawing a men's suit jacket (side view)

① Block-in the body and the jacket

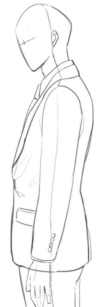

▶▲ Use the blocking-in for the body as a reference and draw a smooth line from the back of the neck down to below the chest to form the line of the collar. For the back, follow the angle of the nape of the neck draw a supple S shape, creating a slight fullness from the waist to the buttocks.

② Follow the blocking-in for the body to roughly sketch the clothing

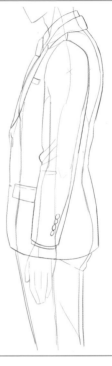

▶ Match only the chest section of the jacket to the line of the body, making the outline larger than the body at the back and stomach. Similarly, for the sleeves, make them larger than the arms. Around the elbows, make the outline a bit jagged to show the filled-out sections of the creases.

③ Draw the wrinkles and add the details to the outline

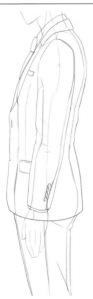
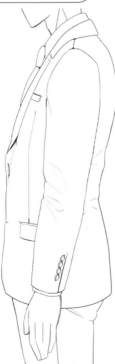

▶▲ At the same time as making a clean copy of the clothing sketch, check the overall balance and add details. Use a thick line for areas where the fabric overlaps, such as the necktie, collar, pocket and shoulder seam, so that they clearly stand out. Draw fine wrinkles at the hips and elbows.

④ Completion

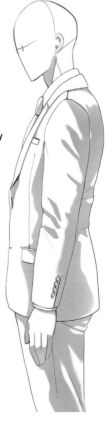

▶ Add shadow to the wrinkles in the sleeve, along the side of the body and down the back. Use a fine line to add shadow around the collar where the fabric overlaps.

 # Drawing men's pants (front view)

1　Block-in the lower half of the body

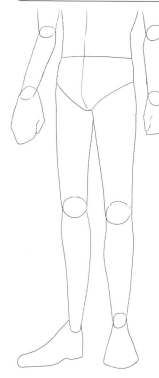

◀ Divide the body into parts to block it in and draw the center line, then decide roughly where to position the pants. Use the height of the hips, inseam and ankles as points of reference when drawing the outline.

2　Draw the outline and belt

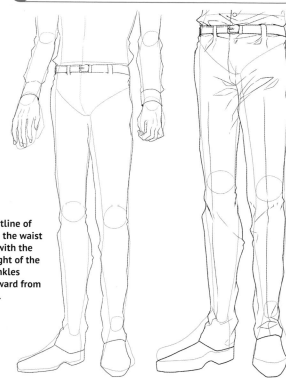

▶ Draw the outline of the pants from the waist to the ankles, with the belt at the height of the hips. Draw wrinkles extending outward from below the belt.

3　Erase the blocking-in and make a clean copy

◀ Draw the center crease down both legs and add wrinkles around the knees and hems. Draw the center crease crumpling at the knees and around the hems to bring out dimension.

4　Completion

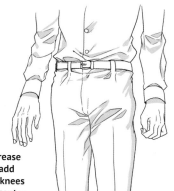

▶ Add shadow below the belt, in the hollows around the hems, on the sides, knees and in the wrinkles around the belt to complete the drawing.

🖊 Example of a rear view

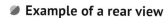

▶ There are center creases down the backs of the legs too. Wrinkles form particularly readily behind the knees and in the hems, so draw the center creases to appear crumpled at those points.

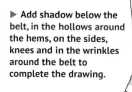

✒️ Drawing a coat with a Bal collar (front view)

1 Block-in the body and draw the lines for the body of the coat

▶ Block-in the upper body down to the inseam, then draw the outline of the body of the coat from the shoulders to the hem. Draw the front of the coat open, with the neckline toward the back folded over to reveal the lining.

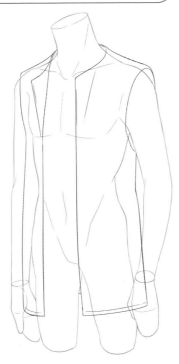

2 Draw the sleeves and collar

◀▼ Draw the sleeves from the shoulders down to the wrists. A suit is worn underneath so use the line of the arms as a reference, but make the sleeves larger to indicate the thickness of the fabric.

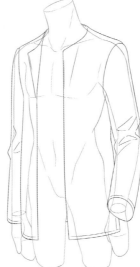

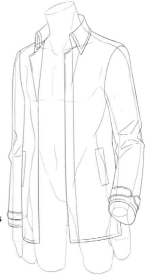

▶ Draw a tall, upright collar at the neckline. Use double lines on the front placket, hem and sleeve openings and add pockets at hip height. Draw straps in around the sleeve openings.

3 Draw buttons

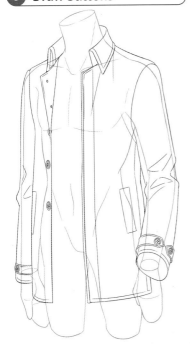

▲ Draw buttons on the front of the coat to the viewer's left and on the straps around both sleeve openings. Draw small circles on the turned-back collar section where the buttons would fasten.

4 Completion

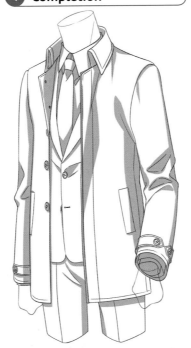

▲ Draw the shirt, necktie, jacket and slacks and add shadow to complete the drawing. Add shadow down the sides, in the wrinkles of the sleeves and the insides of the sleeves, inside the turned-back front and along the inside of the collar of the coat.

🍃 Example of rear view

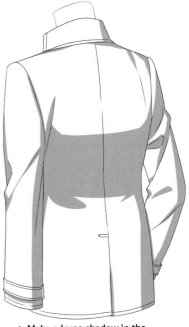

▲ Make a large shadow in the center of the back and down across the waist to bring out dimension. The Bal collar coat is designed so that the back of the collar stands up, so give the collar enough height.

👔 Details about men's suits

🔘 Double-breasted suit

Often, only the center button is done up. As there are two rows of buttons, there is a tendency to make the jacket too broad, so take care not to do this. Bring the jacket in around the hips for a clean silhouette around the torso.

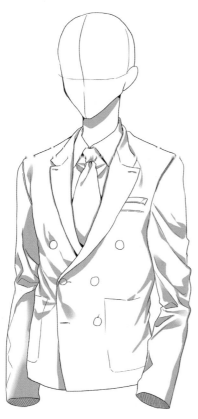

🔘 Three-piece suit

The fit of the vest is important, so draw wrinkles around the buttons on the vest. However, if the wrinkles are too long, it will look as if the vest is being pulled tight because the character is too large, so keep this in mind. The jacket, vest and slacks are all the same pattern and color.

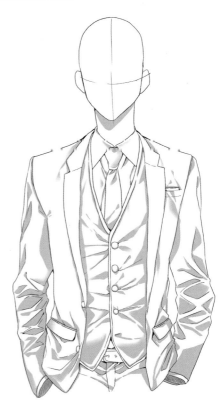

Types of lapels

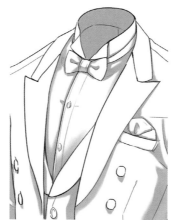

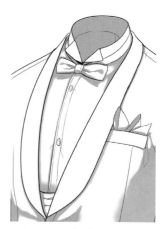

🔘 Notched lapels

The tips of this lapel type face downward. This is the most common type, and it is often used on single-breasted suits. The narrower the lapels, the more stylish and adult the impression they make.

🔘 Peaked lapels

This type of lapel is pointed at the ends and faces upward. It is often used on double-breasted suits. As it features decorative elements and has a flamboyant air, it is suited to parties and celebrations rather than business situations.

🔘 Shawl collars

There is no separation between the upper and lower sections of this type of collar, which resembles a shawl. It has a strongly formal air and is often used on ceremonial wear such as tuxedos.

Neckties

Neckties are made mainly of silk or knit fabric. There are various ways to tie them and a wealth of styles and patterns.

Structure and types of neckties

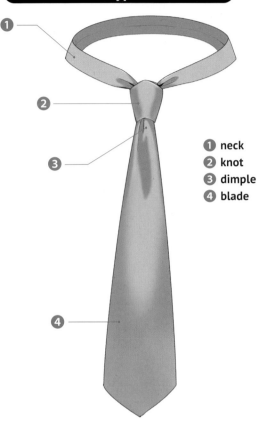

1 neck
2 knot
3 dimple
4 blade

Plain knot

This is the most basic way to tie a necktie and results in a compact knot. Its clean appearance means it complements slim-cut suits. It is used widely in both business and formal situations.

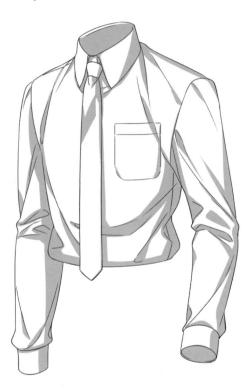

Windsor knot

Nearly triangular in shape, this is a firm, wide knot. It strengthens a classic look and suits shirts with a wide collar.

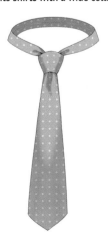

Half Windsor knot

Part of the tying process is left out, resulting in a narrower knot and an elegant, well-balanced look that complements every type of shirt.

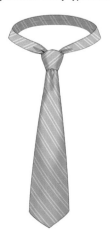

Bow tie

This necktie is tied in a bow in the shape of a butterfly. It is often worn with ceremonial dress and creates a stylish look.

👔 Tying a plain knot

① Cross the tail and the blade

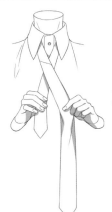

◀ Wrap the tie around the neck so the tail is on the left and the blade is on the right side of the body. Hold the blade in the left hand and the tail in the right and bring the blade to cross over the tail.

② Bring the blade under the tail once

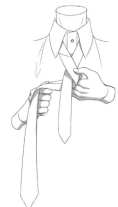

◀ Switch hands and, keeping the tail in place, bring the blade underneath the tail once.

③ Bring the blade over to grip the tail

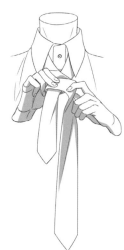

◀ Use the right hand to hold the looped-over blade around the tail and retain the shape created, allowing the end of the blade to hang down.

④ Bring the end of the blade up to the base of the neck and through the loop

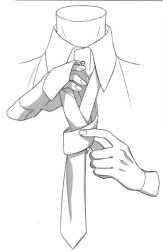

◀ Use the left hand to firmly hold the loop created by the blade and tail in Step 2 in place. With the right hand, bring the tip of the blade up to the base of the neck and work it down through the loop that has been created.

⑤ Pass the tip of the blade between the blade and the tail

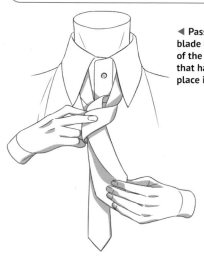

◀ Pass the tip of the blade between the fabric of the blade and tail that has been held in place in Steps 3 and 4.

⑥ Form a knot and neaten the shape

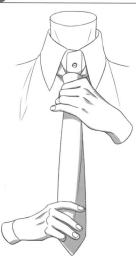

◀ This process creates the knot, so use one hand to hold it against the base of the neck, neatening the shape at the same time. Hide any excess tail length at the back of the blade so it cannot be seen.

Dress Shoes

In business situations, simple leather shoes in dark tones prevail. It is usual for the belt to match the shoes in color, creating a look that is unified and styled.

Structure of dress shoes

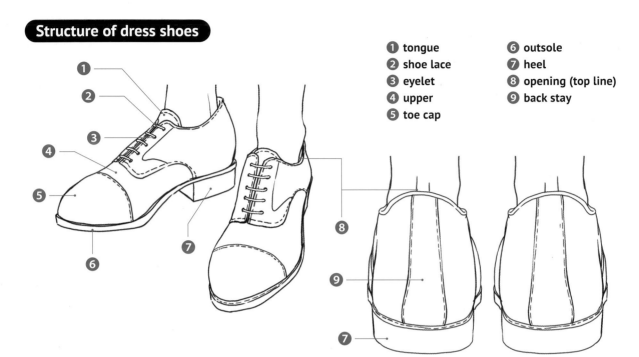

1. tongue
2. shoe lace
3. eyelet
4. upper
5. toe cap
6. outsole
7. heel
8. opening (top line)
9. back stay

Types of dress shoes

Straight tip

This type has a toe cap whose seam forms a horizontal line across the upper. The leather is glossy. Black versions with no decoration across the seam line are particularly formal, and are used not only for business situations but also for formal occasions.

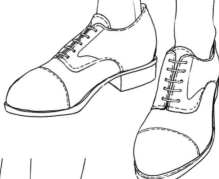

Pumps

These leather shoes for women have large openings. Those used in business settings are not embellished, but rather are simple and functional.

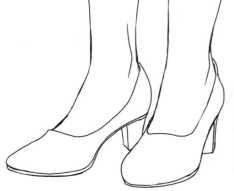

TIP | **Loafers are unsuited to business situations**

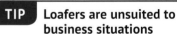
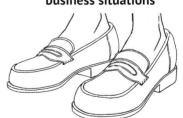

Loafers are leather shoes, but historically they were used as comfortable shoes for indoor wear, and their main feature is that they are easily removed or put on. For this reason, they are largely categorized as casual and are not perceived as being suitable for business settings or formal occasions.

✎ Drawing straight-tip shoes

① Draw the outline of the shoes

▶ Use the blocking-in for the foot as a reference and draw the opening at ankle height. Leaving room around the toes, draw around the heel to the front of the foot, keeping the roundness of the toe cap and upper in mind to draw the outline of the top of the shoe.

② Draw the tongue, outsole and heel

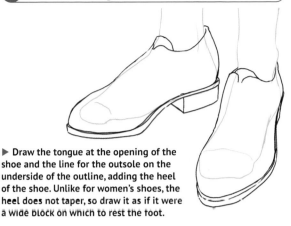

▶ Draw the tongue at the opening of the shoe and the line for the outsole on the underside of the outline, adding the heel of the shoe. Unlike for women's shoes, the heel does not taper, so draw it as if it were a wide block on which to rest the foot.

③ Draw the shoelaces and toe caps

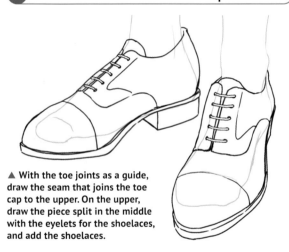

▲ With the toe joints as a guide, draw the seam that joins the toe cap to the upper. On the upper, draw the piece split in the middle with the eyelets for the shoelaces, and add the shoelaces.

④ Completion

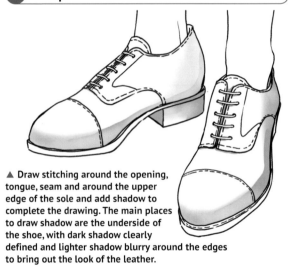

▲ Draw stitching around the opening, tongue, seam and around the upper edge of the sole and add shadow to complete the drawing. The main places to draw shadow are the underside of the shoe, with dark shadow clearly defined and lighter shadow blurry around the edges to bring out the look of the leather.

🖊 Viewed from front

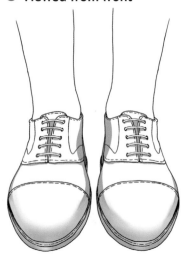

◀ The uppers and toe cap have a broad surface area, with the horizontal seam of the toe cap described by a gentle arch shape. A leather band called a welt runs around the shoe between the outsoles and the toe caps and uppers, with the stitches appearing on the upper side of the outsole.

🖊 Viewed from behind

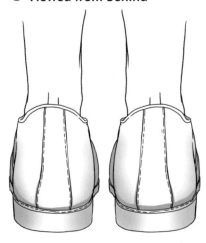

◀ A piece of leather called a backstay is stitched over the heel counter to reinforce it. The heel counter also has a leather welt running around the outside over the outsole, and the stitches of the welt are visible on the top of the outsole.

Business Bags

Bags for business situations are simple in appearance, with priority placed on functionality and durability. Just as important are the documents they keep intact and secure inside.

Structure of a business bag

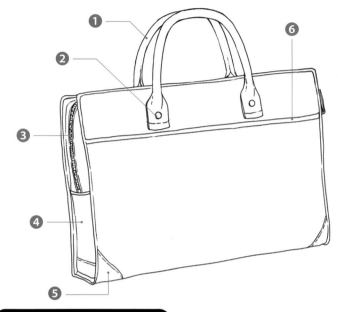

1 handle
2 stud
3 zipper
4 gusset
5 corner guard
6 side pocket

TIP Corner guards reinforce the corners

As business bags are used for carrying documents, laptops and other items that should not be folded, most have sturdy corner guards that prevent the bag from becoming crushed.

Types of business bags

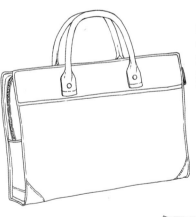

🍃 Briefcase

This type is most commonly used for business purposes. Many are made from nylon, and are sized to be able to carry A4 documents.

🍃 Tote bag

Both men and women use tote bags in chic designs for business purposes. This type can hold a lot of items and most have leather handles.

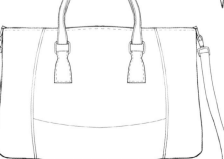

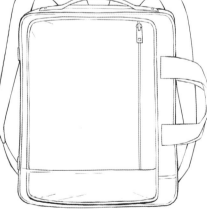

🍃 3-way bag

This type can be carried over one shoulder or used like a rucksack as well as being carried by the handle. Extremely functional, this type is popular with those who commute by bicycle, giving it an active look.

✎ Drawing a briefcase

1 Draw the rectangle of the body of the bag

▲ Draw a rough rectangle for the main part of the bag. Don't use a ruler or anything that draws a straight line, drawing freehand instead to lend the outline the look of slight curves created by leather or nylon fabric.

2 Draw the back of the bag and the handles

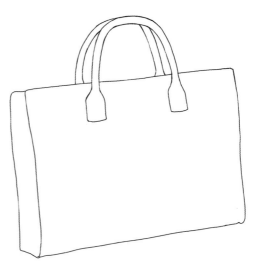

▲ On the side of the bag, draw a line to indicate its depth and then draw the line to indicate the back of the bag, creating dimension. On the top of the bag, draw the outline of the handle in front, then draw another handle to the left, as far away as the bag is wide, thereby indicating depth.

3 Draw the zipper and pocket

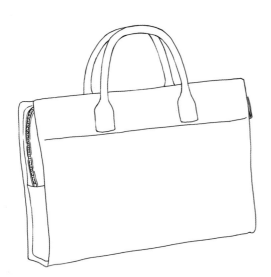

▲ Halfway up the side of the bag, draw a horizontal line with the zipper starting above it. On the opposite end of the bag, draw the zipper tab. Draw a line for the long side pocket below the handles.

4 Completion

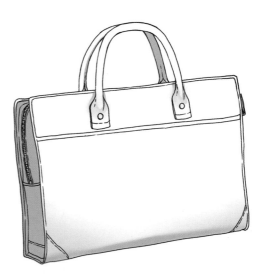

▲ Draw the studs that fasten the handles to the bag and add corner guards. Make all the lines around the bag into double lines to indicate piping. Add shadow to the side and underside of the front as well as around the studs to complete the drawing.

Formalwear

These outfits are worn on special occasions such as weddings, celebratory dinners and formal events. For your high-style characters, these are the looks you'll need.

Types of formalwear for women

Black formal

In this monochromatic style, the dress, skirt, jacket and related items are all in black. Items that are jet black and modest in design are generally recognized as mourning wear.

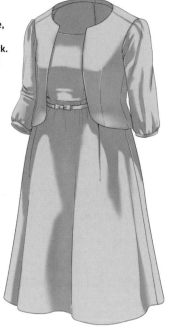

Ceremony ensemble

Designed to be worn together, these outfits comprise dresses, skirts, blouses and jackets, in colors such as white, navy and gray. They are modest in design and create a clean, elegant impression.

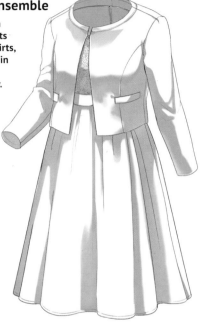

Evening dress

Formalwear for evening features floor-length skirts that cover the legs. The décolletage, back and arms are clearly on show, so make sure to create an attractive body line.

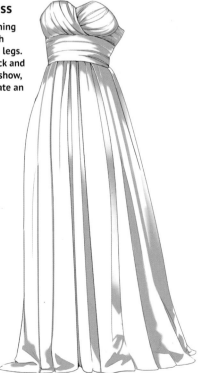

The back is on display from the waist up to the shoulder blades. Satin and other glossy fabrics are used for these kinds of dresses, so use gradation when adding shadow to bring out the luster of the fabric.

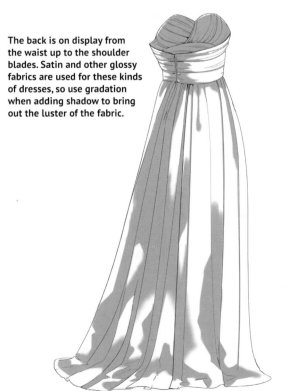

Types of formalwear for men

🍂 Tails

The back hem of the jacket is long and resembles a swallow's tail in this highly formal ceremonial eveningwear. Bow ties must be white. The front of the jacket comes to the height of the hips and is worn open. Peaked lapels are usual on this type of jacket.

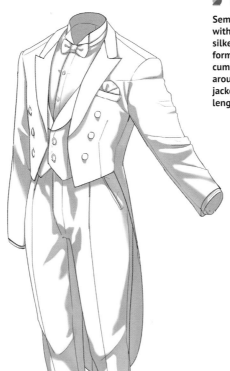

🍂 Tuxedo

Semiformal evening wear with a collar of lustrous silken fabric, usually in the form of a shawl collar. A cummerbund is worn around the waist. The jacket has the same hem length as a suit jacket.

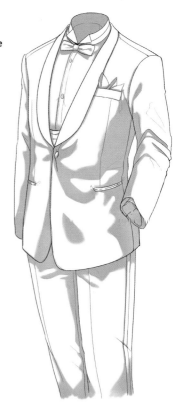

🍂 Morning coat

This is suitable ceremonial wear for functions from morning to noon. The diagonally cut front hem joins to the long back hem to form its distinctive shape. The vest and slacks do not have to be the same fabric as the coat, but it is usual that gray is incorporated into the outfit.

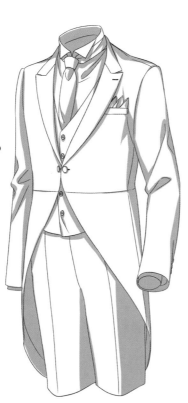

🍂 Director's suit

This is semiformal wear for during the day. A black jacket is worn with a vest and black-and-gray-striped slacks. It is often worn by the groom or people who play an important part at a wedding or other special occasion, such as the guest of honor.

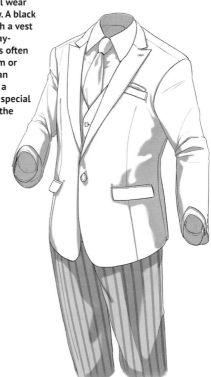

ILLUSTRATOR PROFILE

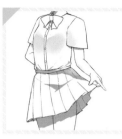

渥海潤
Illustration
123, 125, 133, 142, 145~148, 170

URL
http://www.pixiv.net/member.
php?id=18048

黒猫
Illustration
18~19, 28~33, 35~40, 44, 46~49,
56~58, 70~72, 100~101, 107~109,
123, 142~144, 159

URL
http://qqqe6pv9k.wixsite.com/krrn

桜ひより
Illustration
18, 22, 60, 63, 65

URL
http://www.pixiv.net/member.
php?id=9406623

空維深夜
Illustration
50~52, 88~90, 102~106

URL
http://tears39.com/

ちょこ庵
Illustration
53, 120, 126, 133, 139

URL
http://www.pixiv.net/member.
php?id=5955130

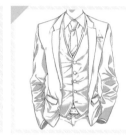

トリュフ
Illustration
20, 22, 49, 61, 155, 158~161, 163, 165

URL
http://mmk0305.web.fc2.com/index.
html

日向ろこ
Illustration
41, 110~112, 150, 152~153, 158~159,
164, 166~167

URL
http://www.pixiv.net/member.
php?id=5473862

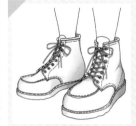

maru
Illustration
42~43, 60, 64, 66~69, 86~87,
114~124, 168~171

URL
http://marumarumarukomu.wixsite.
com/circle-circling

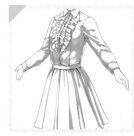

水溜鳥
Illustration
21, 23~27, 38, 62, 74~82, 150~151,
154, 156~157, 162, 165~166,
172~173

URL
https://mizutame-tori.jimdo.com/

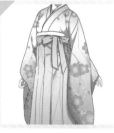

水野かがり
Illustration
83~85, 91~98

URL
http://mizunokagari.blog.fc2.com/

八つ森佳
Illustration
128~132, 134~138, 140~141

URL
http://kinomeocoshi.tumblr.com/

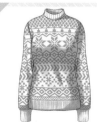

ユメサキ
Illustration
32, 34, 50, 54~55

URL
http://www.pixiv.net/member.
php?id=15558289

INDEX

Published by Tuttle Publishing, an imprint of Periplus Editions (HK) Ltd.

www.tuttlepublishing.com

Digital Illust no Fukuso Kakikata Jiten
Copyright © 2017 STUDIO HARD DELUXE Inc.
English translation rights arranged with SB Creative Corp.
through Japan UNI Agency, Inc., Tokyo

Library of Congress Cataloging-in-Publication Data
REQUESTED

ISBN 978-4-8053-1563-7

Distributed by
North America, Latin America & Europe
Tuttle Publishing
364 Innovation Drive
North Clarendon, VT 05759-9436 U.S.A.
Tel: 1 (802) 773-8930; Fax: 1 (802) 773-6993
info@tuttlepublishing.com
www.tuttlepublishing.com

Japan
Tuttle Publishing
Yaekari Building 3rd Floor
5-4-12 Osaki
Shinagawa-ku
Tokyo 141 0032
Tel: (81) 3 5437-0171; Fax: (81) 3 5437-0755
sales@tuttle.co.jp
www.tuttle.co.jp

Asia Pacific
Berkeley Books Pte. Ltd.
3 Kallang Sector #04-01
Singapore 349278
Tel: (65) 6741-2178; Fax: (65) 6741-2179
inquiries@periplus.com.sg
www.tuttlepublishing.com

25 24 23 22 10 9 8 7 6 5

Printed in China 2203EP

"Books to Span the East and West"

Tuttle Publishing was founded in 1832 in the small New England town of Rutland, Vermont [USA]. Our core values remain as strong today as they were then—to publish best-in-class books which bring people together one page at a time. In 1948, we established a publishing office in Japan—and Tuttle is now a leader in publishing English-language books about the arts, languages and cultures of Asia. The world has become a much smaller place today and Asia's economic and cultural influence has grown. Yet the need for meaningful dialogue and information about this diverse region has never been greater. Over the past seven decades, Tuttle has published thousands of books on subjects ranging from martial arts and paper crafts to language learning and literature—and our talented authors, illustrators, designers and photographers have won many prestigious awards. We welcome you to explore the wealth of information available on Asia at **www.tuttlepublishing.com**.